D0744026

BLACK HOLLYWOOD UNCHAINED

Black Hollywood
unchained : commentary
on the state of Black
Hollywood
33305234500266
1an 6/28/16

BLACK HOLLYWOOD UNCHAINED

COMMENTARY ON THE STATE OF BLACK HOLLYWOOD

EDITED BY ISHMAEL REED

Third World Press
Chicago

Third World Press
Publishers since 1967
Chicago

© 2015 by Ishmael Reed

All rights reserved. No part of the material protected by this copyright notice may be repro-
duced, stored in a retrieval system, or transmitted in any form by any means, electronic me-
chanical, photocopying, recording or otherwise without prior written permission, except in the
case of brief quotations embodied in critical articles and reviews. Queries should be addressed
to Third World Press, P.O. Box 19730, Chicago, IL 60619.

Library of Congress Control Number: 2015944083
ISBN 13: 978-0-88378-353-5 (paperback edition)
ISBN 13: 978-0-88378-714-7 (e-book edition)

First Edition
Printed in the United States of America

20 19 18 17 16 15 6 5 4 3 2 1

Exterior Design: Relana Johnson
Interior Designer: Solomohn N. Ennis-Klyczek

To the memory of
Vonetta McGee, Amiri Baraka, Jayne Cortez,
Hariette Surovell, Walter Cotton, and Bill Gunn.

CONTENTS

Part Two
Comments on Hollywood and Film

Contributors

INTRODUCTION

Hollywood's War on Black America | Ishmael Reed

"[Chester] Himes lived in Cleveland before moving to Los Angeles where he went to work for Warner Bros, the movie studio. That was until Jack L. Warner, president of Warner Bros, reportedly declared he didn't want any 'niggers' on the studio's movie lot."

—*The North Star News and Analysis*

"It's a white industry."
—Chris Rock, *The Hollywood Reporter*

In 1942, then president of the NAACP, Walter White, went to Hollywood to begin a dialog with Hollywood producers about the demeaning portrayals of blacks in film. Except for a few victories like getting the black rapist removed from *Gone With the Wind*, he didn't get very far. Hattie McDaniel had already got the producer, David O. Selznick, to drop the word "nigger" from the film, even though McDaniel was one of those who opposed White's efforts. White even tried to educate David O. Selznick by recommending that he read W.E.B. Du Bois' *Black Reconstruction*. He didn't. Because the final cut did much to copy the Confederate line that the war was a war of Northern invasion (a line repeated in Ken Burns' *The Civil War*). In *Gone With the Wind*, like in *Django Unchained*, blacks were either passively accepting of plantation life or loyal to the slavery system. Flash forward: At a party held to honor the publication of an anthology of critical essays about the work of August Wilson, I asked Tony Kushner, who wrote the script for the film *Lincoln*, to read Lerone Bennett's *Forced Into Glory*. It's obvious that he didn't read it. Maybe because Steven Spielberg, a serial maligner of blacks, wanted to omit the racist history of The Great Emancipator.

Selznick responded to White's disappointment by vowing to contribute to the NAACP yearly, in the amount of one hundred dollars. Spielberg, Tarantino and the producers of *The Color Purple, and Django Unchained* contribute much more to cover their profiting from recycling the tired clichés about black life and abusing black history. Contributor Gerald Hobson says as a child, he rooted for the Cowboys. An article head-lined "Native Actors Walk off Set of Adam Sandler Movie After Insults to Women, Elders," (Vincent Schilling, *Indian Country Today*, 4/23/15) indicates that

things haven't changed for Native Americans in Hollywood.

Similarly, thousands of blacks enjoy Hollywood abuse and are fond of *The Wire*, which even *The Wire* actress, Sonja Sohn, denounced. She said on Melissa Harris Perry's show (5/2/2015), that "*The Wire* conveys the impression that people don't care about their neighborhoods," and that "all of them are lazy and just allow their neighborhoods to go dilapidated."

Walter White expected that some of the producers, being Jewish immigrants, would be liberals. But so are Steven Spielberg, David Simon, and Dave Zirin, David Mamet, and the late Saul Bellow, who are or were in the business of defaming black men. Of course, members of other ethnic groups conspire to promote stereotypes about blacks, but then as now, blacks expect more from those whose people have been persecuted even before the Europeans entered Africa. And Jews expect blacks, a persecuted people to avoid the trashy pitfalls on Anti-Semitism.

White was wrong. Two new books[1] report that while Louis Mayer and other producers had little time for White, Mayer had time to party with representatives of the Hitler government. He gave them more respect than to Walter White, the head of one of the country's oldest Civil Rights organizations. In his book, *The Collaboration: Hollywood's Pact With Hitler*, author Ben Urwand, quotes from an interview with Budd Schulberg. The late author and screenwriter said that in the 1930s, the head of MGM, "would show movies to a German consular official in L.A. and they'd agree on cuts." Louis Mayer's defenders say that he "collaborated" with the Nazis out of greed. How far did this greed go? A representative of MGM in Germany under pressure from the Nazis divorced his Jewish wife. She ended up in a concentration camp. Urwand adds, "Louis B. Mayer had the biggest stake in Germany. His man in Berlin was Frits Strengholt, a Dutchman and a non-Jew who left for Holland when things got hot, but returned when the situation calmed down—that is, when the first wave of Jew-purging violence had achieved the desired effect." Hal Roach Jr., who was the producer of *The Little Rascals*, was a good friend with the Italian dictator Mussolini's son.

White was offended by Mayer's film, *Tennessee Johnson*, which honored Andrew Johnson, a vulgar alcoholic who brought the Confederacy back to power. His support for the city administration of New Orleans, which was led by ex-Confederate soldiers, resulted in one of the worst massacres in American history. The victims were Black men, who had convened in New Orleans to discuss their right to vote.[2] This atrocity was captured in Thomas Nast's artistic masterpiece, "Amphitheatrum Johnsonian—Massacre of the Innocents at New Orleans, July 30, 1866," which showed Johnson as a Roman Emperor sitting on his throne watching the massacre.

The Confederacy was the model for Nazi Germany because it was a dictatorship based upon an economy worked by slaves and based on white supremacy, though many of the planters had children by their kidnaped African captives. Such race mixing reached the very top of the Confederate government judging from a photo taken to commemorate the marriage between Varina Howell and Jefferson Davis. (See Fig. 1) The Confederacy and its philosopher, Thomas Jefferson, and their descendants, the Nazis, justified the use of slaves and used theories about racial superiority that appeared during The Enlightenment. It was a slave country where

Fig. 1. Wedding photograph of Jefferson Davis and Varina Howell, 1845.

slaves were used in medical experiments like those conducted by Dr. Josef Mengele.[3] Dr. Helen Washington's magnificent research demonstrates that this is not a far-fetched conclusion. I remember David Duke's last press conference. He had been running for president on a platform of "a growing black underclass." He complained that Clinton had co-opted his program. The KKK can make the same complaint about Hollywood and television whose images of blacks fit right in with those KKK websites. Hollywood is stealing its white lightning. Like *Precious*, where lazy lay-about blacks chisel the welfare system and spend their time eating chicken, watching TV and having sex with their children. Barbara Bush loved this movie so; she invited people to a viewing. (Ronald Reagan had a viewing of *The Color Purple* in the White House; he gave it five stars. For him maybe "Mister" was one of these big "black bucks" that he won the presidency campaigning against.)

One of those in charge of merchandising the film *Precious* said that its model was *The Color Purple*; she said that the film would provide her studio with "a gold mine of opportunity." If this is true, it was Steven Spielberg who discovered the gold mine. Maybe he noticed how Willie Horton, the GOP's Black Bogeyman, elected a president.

GOP strategists, among them Roger Ailes, who is now using Fox News to carry on his bizarre vendetta against black men, used the image of a convicted rapist, who raped a white woman, to win the White House. Spielberg's rapist, "Mister," who even offended the author of *The Color Purple*, has been looped endlessly in one form or another to create a "gold mine" for publishers, theater and television producers, and the many forms of media that exists today. One thing that these products have in common: white men create and manufacture these products, whether it be films like *What's Love Got To Do With It*, *The Color Purple*, *Precious* or any number of television products like *The Wire*, or *The Corner*. Whichever role that white men play in creating the racist atmosphere that blacks, men, and women undergo each day is eliminated. Indeed, one of the editors of Henry Louis Gates Jr.'s Norton series on African-American literature, blames black men for racism!

Here's the pull quote from *The Norton Anthology of African American Literature*, Third Edition, Vol. 2, written by one of the editors, Cheryl A. Wall, Board of Governors Zora Neale Hurston Professor of English, Rutgers University. She writes of some black women writers: "The interracial conflicts at the heart of narratives by black male writers from Frederick Douglass to Ralph Ellison to Amiri Baraka did not take center stage. Racism remained a major concern. But for these writers, the most painful consequences of racism were played out in the most intimate relationships." This line promoted by Gates and Norton Company has led to the rise of what critic C. Leigh McInnis calls the Black Bogeyman genre, which, he says "sells better than sex." It follows Gate's blast at black male writers as a group, which has led to black

male writers becoming pariahs in the publishing industry, an issue covered by the great writer Elizabeth Nunez in her magnificent novel, *Anna In Between*.

Hundreds of millions in profits have been obtained by producers, directors and scriptwriters from black Bogeyman culture—the latest being Danny Strong whose television series is called *Empire*. They plunder the black experience with stereotypical portraits of black men as brutes who prey upon innocent saint-like women. These white men exempt male members of their ethnic communities from sharing the blame for the malignant crimes against women that pervade all ethnic groups regardless of what a guest told an MSNBC moderator. She said that white men don't engage in such practices. MSNBC has become Black Bogeyman central where black men are singled out for such behavior, and feminist Melissa Harris-Perry is the C.E.O. of the Black Bogeyman genre. Her white feminist producer even instructs her to divide and conquer black shooting victims by gender, even in death! Mrs. Harris-Perry complained that the death of Trayvon Martin received more attention than the murder of Renisha McBride, who was shot by a white man while seeking help. Her murderer received some stiff jail time. Martin's killer George Zimmerman was acquitted as a result of his Attorney Mark O'Mara's scaring the white women on the jury with the specter of black rape. Even though his smearing of Martin was based on lies, he got a job as a CNN "legal" analyst.

On Mrs. Harris-Perry's show, each week black men, even those who haven't been charged, are given fifteen-second trials and convicted for their alleged abuses against women. She gets paid by Brian Roberts, who supports ALEC, an organization that supports voter suppression and Stand Your Ground laws. Before that she was paid by General Electric which built the Nuclear Reactors at Fukushima and, according to an author whom I published, Yuri Kageyama, signed a contract that would hold them blameless for the catastrophe that continues. While Mrs. Harris-Perry and her panels blast Ray Rice and his stupid violence against his wife, she never mentions that fifteen thousand people have died as a result of the Fukushima meltdown. The radioactivity leaking from the nuclear plant is affecting the sea life on the west coast. The media have ignored this story; they're too busy covering youngsters in cities in where the police are a kind of Tonton Macoute. These youngsters are expressing their rage and frustration by stealing six packs.

Once in a while, the strategy of acquitting white men of misogyny and their buffer individuals, privileged and academic feminists, is exposed. A white filmmaker named Bob Bliss directed a woman named Shoshana Roberts to walk the streets of Harlem. The idea was to show the catcalls that women face in daily life. Shoshanna Roberts, who was called a white woman, though she seemed to be of Middle Eastern origin, was catcalled by Hispanic and black males, who made comments that were sometimes lewd. Harlem was chosen as the site for the film instead of the Upper East Side or Wall Street. It was revealed that the film director had edited the white men out. Facing a firestorm of criticism, he tried to lie his way out of it. The group that hired him, Holloback, however, apologized. Nevertheless, Brittney Cooper, an academic feminist, appeared on MSNBC to justify the video, regardless of its racist omitting of white men. According to *Slate* magazine (Oct. 29, 2014): "Participants voiced their frustration that white men had apparently been edited out of the original

catcalling video (a move Holloback later apologized for), explaining that the edited video stereotypes men of color and suggests that harassment by white males is rare. But the damage had been done. The video received 30 million hits and once again treated blacks and Hispanic men as sexual predators."

One could compare those who endorsed this video to those Jews in Europe whose task it was to list the names of those to be sent to the camps. Moreover, during April 2015, the same organization issued a study that showed that 85 percent of women have experienced street harassment. Black and Hispanic men don't have the manpower to be involved in such massive ogling! Similarly, one out of five college women claim that they have been assaulted, sexually. Black men are more likely to be in jail than in college so who is the typical perpetrator against college women? *The New York Times* singled out a black football player, Jameis Winston. He was subjected to an "investigative report" that nearly took up a whole issue of the newspaper, even though, no charges have been brought against him. Nevertheless, Melissa Harris-Perry slimes his reputation each week. Since the condition of poor women black, white, yellow, brown and red are the same as they were before the advent

of the modern feminist movement, which piggy-backed off the Civil Rights, the main purpose of this educated and privileged group is to protect the group to which their employers belong from charges of misogyny. They blame it all on minority men.

Someone should write a book about why some of those, the owner of MSNBC, Brian Roberts, David Simon, Matt Lauer, Steven Spielberg and David Mamet are promoting the Black Bogeyman in a manner that the Nazi press depicted Jewish

Fig. 2. Anti-Jewsih cartoon from German school book for children (c 1935).

males. (See Fig. 2) When I compared the film, *The Color Purple*, with the kind of film that the Nazi film makers did about Jewish males in Germany, it was based upon research. My novel, *Reckless Eyeballing* was influenced by the San Francisco Holocaust Museum, which issued a pamphlet accompanying the showing of the film, *Jud Suss*. This film depicted Jewish men as sexual predators and was shown to get Nazi soldiers fired up before taking their positions at the front. The writer of the pamphlet pointed out that the way that Jewish males were exhibited in Nazi Germany was similar to the way black men are shown in the United States. Those who were offended by my comment should read Julius Streicher, Nazi Editor of the notorious anti-Semitic newspaper, *Der Stürmer*, and they will find a perfect match in the Nazi media for the portrayal of black men in recent film and television. I was misquoted when Professor Victoria Bond lashed out at me on behalf of *The New Republic* for my remarks about *The Color Purple*, the ancestor of the Black Bogeyman genre. She said that I called both the book and the movie "a Nazi Conspiracy." She said she got that from Professor Jacqueline Bobo, who made this comment in a film magazine called *Jump Cut*. I asked Dr. Bobo where she heard it. She didn't answer. I wrote a letter to *The New Republic*, seeking to clarify my position. Dr. Bond's editor Chloe Schama said that they didn't print letters, but I could write an article. I wrote

the article from Paris. She answered.

> Mar 26
> Dear Prof. Reed,
> Thank you for sending—I did receive it. Unfortunately, the piece is not right for our site, and I'm afraid we don't have the resources to edit it into a form that would be appropriate for us. I encourage you to publish it elsewhere.
> Best, Chloe

The new billionaire publisher of *The New Republic*, Chris Hughes, described as a "spoiled brat," has found that he can entertain his readers by promoting a gender and class civil war by using intellectual cannon fodder. Dr. Bond created this impression by omitting the names of prominent black women scholars who were also critical of *The Color Purple*. Not as marketable as painting all of those who opposed the movie and the book, *The Color Purple,* as disgruntled black men. Among the critics were Toni Morrison and Michele Wallace. An early critic, Trudier Harris, co-editor of *The Oxford Guide To African American Literature*, said that she received such a backlash from white feminists, "the privileged and educated" women whom Harriet Fraad claims co-opted the feminist movement that she stopped talking about it. *The Nation*'s young proxy, chosen by them to channel their views about the black situation said that I'm still mad at *The Color Purple*. Well, now that *The Color Purple* has been revived as a musical, the idea of John Doyle, a Scotsman, maybe *The Color Purple* is mad at me and other black men.

The great novelist Diane Johnson was correct when she predicted that "largely white audiences" would support Black Bogeymen products, especially the ones that involve incest.

Moreover, I believe, given the historical tensions between many white and black men, which has seen them turning guns on each other even during wartimes, when they were supposed to be comrades, turning black feminist products over to Steven Spielberg is like turning over a story about Native Americans to Custer. Indeed, one black feminist scholar said that when white men transfer Black Bogeyman projects to the screen after white men get finished with them, the black male characters come off even worse.

Also why are Hollywood Television and their handpicked feminist auxiliary reaching back to the Confederacy to promote images of black men that have gotten them lynched? It was Hollywood that glorified the Confederacy with movies like *Shane*, a hymn to the Confederacy during which a poignant rendering of "Dixie" is played in the background. It's Hollywood that has celebrated Andrew Johnson and Confederate killers Jesse and Frank James, members of Confederate irregulars known as Quantrill's Raiders, who burned and pillaged towns loyal to the Union along the Missouri-Kansas border. Their strategy paid off. The Confederacy that made a comeback in the 1870s has been aided by Hollywood's effort to clean up some of its most notorious killers and sympathizers; Confederate sympathizers now control Congress and can stifle the policies of a black president, but haven't been

able to expel him from office, which was the fate of black officeholders during Reconstruction. Give it time. Both the James brothers and Andrew Johnson have been portrayed by some of Hollywood's lead male actors. Henry Fonda, Brad Pitt, Van Heflin and Gregory Peck. Quantrill was killed after a black blacksmith pointed to the hideout of him and his men. This blacksmith wasn't hanging around awaiting rescue by a Talented Tenther, who, in Tarantino's movie, *Django Unchained,* is "one in ten thousand."

Walter White believed that some of those Jewish producers with whom he had discussions had rejected the race science of the time. He was wrong. Since then Hollywood has rolled out films in which blacks play the traditional roles of "buffoons, servants, craven characters," and those who played such roles in the 1940s were opposed to White, whom they saw as cutting in on their income. It's gotten worse. While Hollywood's light has grabbed millions of fascinated eyeballs of millions of white Americans by shaming blacks, a big revenue enhancer for the media since the 1800s, for others, Black, Asian-American, Hispanic, Native American and Italian Americans, Hollywood's light has been poisoned.

While *Birth of a Nation* cast the black male as a rapist, and as incapable of governing,[4] within the last decades, black men have been profiled as sexual predators and child molesters in films directed, produced and written by white men as well as on corporate feminist shows like Melissa Harris-Perry's. The studios also use blacks to cover for films that black audiences might find objectionable. The studios give a black director or producer screen credits for movies that might offend blacks while the real directors and producers remain in the background. This strategy was used in the case of *Monster's Ball,* in which a black woman becomes the lover of her husband's executioner. They gave a black man screen credit as the director while a white shadow director did the actual directing. This was also the situation with *Precious,* where fake black producers fronted for the film while the real producers remained in the shadows. Even some academics fell for the decoy. On a show moderated by the brilliant Esther Armah, three male academics, and the host treated Oprah Winfrey and Tyler Perry as though they were the actual producers. (Oddly, they also failed to mention that Hollywood's profiting from black dysfunction was escalated in this film because not only was the black male treated as a sexual predator, which is the usual case, but the mother as well.) The Oscars did not acknowledge these black producers as producers because they were designated as producers after the film was made. They were there to take the flak. The distributors would only sign on to the project after Oprah Winfrey agreed to be "producer." Some blacks were not offended by the movie, which dramatizes all of the talking points that the far right, Neo-Cons and members of the Talented Tenth at Harvard and Yale have aimed at blacks for decades. Talking points that blame the victim. One of the Yale Talented Tenthers said that racial profiling was justified in some cases. Wonder how he feels after the murder of Trayvon Martin?

Quentin Tarantino's *Django Unchained* used black academics and pundits to give their okay, but in the case of *The Help,* adapted from Kathryn Stockett's book with the same name, the black actors were put up to take the heat. Viola Davis, a black actress who appeared in *The Help,* was put forth to defend the film, when black

authors accused Kathryn Stockett of muscling in on their gig, The Black Bogeyman genre. Kerry Washington saluted Tarantino for his "courage." Bloggers who responded to my review of *Django Unchained* requested that that I lighten up, after all, *Django Unchained*, was only a movie. They were wrong. It has become an alternative text about black history and is being ranked alongside if not higher than those of great black historians like John Hope Franklin, Benjamin Quarles, Lerone Bennett Jr., John Blassingame, Gerald Horne, Annette Gordon Reed, Helen Washington, John Henrik Clarke, Ida B. Wells, or Isabel Wilkerson, not to mention the historical fiction of Margaret Walker, and Arna Bontemps. Now that those institutions that chose Henry Louis Gates Jr. as the leader of black intellection have abandoned him, questioning his morals (Bruni, *NYTIMES*,4,22,'15) and calling him a "Liar" (Ryan, *Paste Magazine*,4,23,'15) as a result of his capitulation to Ben Affleck's request that his slave owning ancestor be removed from his show "Finding Your Roots." There is a free-for-all going on, for who will succeed Gates as HNIC. This brawl is taking place in *The New Republic* and other east coast media which have traditionally anointed the Token for The Day: *The New Yorker, The New Republic, The Nation* and the *Times*, which made Gates the HNIC, after he was manufactured as a token by feminist editor Karin Durbin, but now disowns him. Will the new HNIC follow the Gate's example? Endorsing Hollywood's ugly racist products? Casting black male writers, who have consistently challenged racism and injustice as pariahs? Will they, like Gates, include insults like *The Wire* and *Django Unchained* as subjects of courses in the colleges where they teach? Colleges that don't have great black historians listed in their catalogs. *Django Unchained* only a movie? In *The New York Times*, January 11, 2013, it was reported that Tarantino's history was dignified by being associated with a Civil War exhibit at the Library of Congress. The same treatment has been accorded *The Wire*, David Simon's fraudulent depiction of a Baltimore district as merely a drug mart. As in the case of *Django Unchained*, white students are also lining up to take courses about *The Wire*. In one episode of *The Wire*, promoted by *The New York Times*, youthful black gangs engage in combat using cellophane bags containing their urine as weapons. His use of teenage black actors as drug dealers can be seen as an act of cinematic child molestation. Drake Bennett wrote in *The Baltimore Globe*:

> Academics, on the other hand, can't seem to get enough of 'The Wire.' Barely two years after the show's final episode aired—and with Simon's new show, 'Treme,' premiering next month on HBO—there have already been academic conferences, essay anthologies, and special issues of journals dedicated to the series. Not content to write about it and discuss it among themselves, academics are starting to teach it, as well. Professors at Harvard, U.C.—Berkeley, Duke, and Middlebury are now offering courses on the show.
>
> Interestingly, the classes aren't just in film studies or media studies departments; they're turning up in social science disciplines as well, places where the preferred method of inquiry is the field study or the survey, not the HBO series, even one that is routinely

called the best television show ever. Some sociologists and social anthropologists, it turns out, believe "The Wire "has something to teach their students about poverty, class, bureaucracy, and the social ramifications of economic change.

The academic love affair with 'The Wire' is not, as it turns out, a totally unrequited one. One of the professors teaching a course on the show is the sociologist William Julius Wilson—his class, at Harvard, will be offered this fall. Simon has said that Wilson's book When Work Disappears, an exploration of the crippling effects of the loss of blue-collar jobs in American cities was the inspiration for the show's second season, which focused on Baltimore's struggling dockworkers.

Wilson's class, a seminar, will require students to watch selected episodes of the show, three or more a week, he says. Some seasons, like the fourth, with its portrayal of the way the public school system fails poor children, will get more time than others.[5]

Wilson says that *The Wire* says more about black urban life than any sociological treatise. Karl Alexander, John Dewey Professor and chair of the Department of Sociology at John Hopkins in his book, *The Long Shadow, Family Background, Disadvantaged Urban Youth, And the Transition to Adulthood*, would disagree. He writes that these neighborhoods are not "open-air drug markets," but inhabited by working class and poor blacks and whites. He quotes Andrew Hacker (1995, 100) "Neither sociologists nor journalists have shown much interest in depicting poor whites as a 'class.'" He continues, "In large measure the reason is racial. Among blacks, it comes close in being seen as a natural outgrowth of their history and culture."

In light of Professor Alexander's debunking David Simon's *The Wire*, which has drawn millions of fans, blacks and whites, I asked Drake Bennett whether he had changed his mind. And why would the country's leading academics including Prof. Wilson endorse this distorted view of black Baltimore life.

On Monday, Aug 11, 2014 at 11:11 AM I wrote:

Hello, Mr. Bennett,
I'm finishing a piece about *The Wire*, being taught in colleges. Now that the Prof. Alexander, head of the Department of Sociology at John Hopkins has challenged David Simon's depiction of a Baltimore district—he says in his new book that it's not a drug mart but a district of working class whites and blacks—are you still enthusiastic about *The Wire* being taught?
Thanks, Ishmael Reed

He replied:

Dear Ishmael Reed,
Thank you for the note. Just to clarify, though, my story on academics teaching *The Wire* wasn't a celebration of the fact, it was an exploration of why it was happening.
Yours sounds like an interesting article, and I'm looking forward to reading it.
Best, Drake

Simon's interview, in *Jewish Week*, indicated that my 1997 call to KPFA-FM where he appeared on a program was still on his mind in 2006. He was accompanied by a young black ghetto dweller, whose purpose was to authenticate Simon's *The Corner*. I accused him of exploiting the youngster. Callers backed me up, including Dr. Julia Hare of the Black Think Tank. Afterward, he complained about me to *The New York Times* and *Jewish Week*. Simon told Virginia Heffernan of *The New York Times*, "Ishmael Reed was against him writing about blacks because he was a white man." I told her that the series about black gang bangers was a cliché. Later a *New York Times* critic agreed with me. During a panel held at Aix en Provence, I criticized pro NYPD television writer Richard Price for his role as a writer for *The Wire*. His writer friends from New York, who were present at the conference, got upset. One of them criticized me for bringing up a local issue before this august French audience. Local? There was a full-page ad for *The Wire* in *The International Herald Tribune*, which was available at the conference. Later, Price tried to do a *Wire* clone for CBS called *NYC 22*. Writing in *The New York Times*, Neil Genzlinger[6] voiced the same complaint that I'd made about *The Wire*. He wrote: "The show may not help Harlem's efforts to improve its image. Gangs, drugs, robberies and arsons abound, and the series flaunts its New York locations to irritating excess, with a close-up of a street sign or a reference to a subway stop never far away, lest you forget where you are." He concluded that the series exploited a cliché or in his words "just a not very successful attempt to find a new angle in an exhausted genre." Simon told the *Jewish Week* that his success had been mixed with unhappiness because of critics like Ishmael Reed. I wrote and told *Jewish Week* that Simon and writers like him might try to do a fresh series. Something new. Maybe about the family life of a suburban gun dealer who is flooding inner city neighborhoods like mine with illegal weapons. Issues that are not included in the blame-the-victim coverage of the underclass. Suburban gun dealers and absentee owners who rent out their property to criminal operations, placing at risk not only those who dwell in underclass neighborhoods but black middle-class neighborhoods as well, are rarely mentioned in the media. I didn't obtain this information by hanging out at the faculty clubs of Princeton and Harvard, but from living in a "high-risk inner city neighborhood" for thirty-five years.

Tarantino's using Foxx and Washington to give him props as a purveyor of black history reminded me of David Simon, traveling throughout the nation with that black kid to give his products, *The Corner* and *The Wire*, authenticity, which reminded me of Buffalo Bill touring with real live Indians. I got the same comment

from the bloggers at the WSJ. Blacks like *The Wire* too, judging from the mail that I have received criticizing me for criticizing a series that includes stereotypes about blacks that the Nazi media used to lay on Simon's ancestors.

Simon used the same strategy as the producers of *Gone With the Wind*, and *Django Unchained*. Like these producers, they got some blacks to endorse these products. Some of those who answered my review at the WSJ cited their blacks as liking the movie.

On December 11, 2014, Reverend Al Sharpton reported that hackers had exposed private emails between two Sony executives. They show that Hollywood, like television, are outfits devoted to segregation, for whom there are products geared to a black audience and others manufactured to appeal to white audiences. There are some black actors like Sidney Poitier, James Earl Jones, Morgan Freeman, and Will Smith, who have universal appeal. The emails were exchanged between two executives, Amy Pascal, Co-Chair of Sony and producer Scott Rudin, were joking about President Obama's trip to Hollywood and the kind of movies they'd screen for him. "Would he like to finance some movies?" Rudin asked.

They asked would the president like *The Butler, Django,* or *Think I Like a Man,* or actor Kevin Hart. They apologized. On the same program, Sharpton noted that of the Golden Globe nominees, sixty-four actors were white and six non-white. The catering to an audience that pays money to see blacks brought low earns hundreds of millions of dollars for studio's headed by people like Pascal. I would love to have been a fly on the wall when the marketing decisions about *Precious* were being made.

This is why I have asked some of the most prominent scholars, intellectuals, and artists to respond to this film and others. Those who put forth propaganda efforts disguised as entertainment must be made aware that they are being reconnoitered.

The Urwand book for this anthology is *William Styron's Nat Turner: Ten Black Writers Respond,* edited by the great John Henrik Clarke (Jul 23, Praeger, 1987). Some of the responses to critics of *Django Unchained,* by defenders of the film, are reminiscent of those responses to Clarke's anthology. Aren't you grateful that Styron resurrected a hero whom you had forgotten, Eugene Genovese, argued in the pages of *The New York Review of Books*?[7] Similarly, Tarantino, the mind behind *Django Unchained,* says that he wanted to give black men a hero. Like many who believe that they can get away with false black history and feel comfortable with addressing audiences who know less than they, Genovese didn't believe that blacks read *The New York Review of Books,* a place where second and third generation white ethnics take Anglo lessons.

He must have been shocked when Professors Vincent Harding and Mike Thelwell, who, in polite replies, pointed out that blacks had not forgotten Nat Turner and that his memory had been kept alive in scholarship, folklore, poetry and other avenues of expression. Genovese was a Marxist at the time, but by the time of his death, he had become a Catholic and a defender of the antebellum South.

Like Genovese, many prominent progressives still haven't met Stalin's challenge that they overcome their "white chauvinism." The progressive bloggers who were upset with my review of *Django Unchained,*[8] printed in *The Wall Street Journal,* were challenged by a white blogger who identified himself as "Roy," a conservative. He

wrote:

> 3:25 pm December 31, 2012
> This movie is also testimony to the hierarchy within the liberal collective. If you changed the black characters to either Asians, Native Americans, Arabs, Iranians, East Indians, Hispanics or God forbid gays and lesbians the liberals would not be raving about how 'entertaining' this movie is. They would be protesting the bloodlust of the psychotic person behind this sadist porn. Instead, since it is black Americans whom the liberals view as the bottom rail in the liberal/progressive collective, you hear praise of this movie. Liberals do not view sadism directed towards blacks with anywhere near the same disgust that they would with their more esteemed ethnic groups. Liberals do not recoil at sadism directed towards blacks because blacks are the lowest group in the liberal/progressive cabal.

Both progressive magazines and progressive zines *The Nation, Mother Jones* and Salon.Com, ran favorable comments about *Django Unchained* and the writer for *Mother Jones*, Adam Serwer, said that I was against white people—what the right wing think tanks refer to as "reverse racism"—writing about slavery, even though, in my *WSJ* review I cited Eric Foner, Leon F. Litwack and James Loewen as those whites who write well about slavery.[9] This led me to believe that the problem of racial misunderstanding might be best handled by the field of Neuroscience. Why else would a smart person like Serwer fail to perceive evidence that was right in front of him?

Nowhere in my article did I say that white people can't write about slavery (an assertion that was repeated on NPR's "Talk of the Nation," who got it from Serwer). And if he and other progressives believe that Tarantino knows something about black history then progressives still haven't done their homework about "The Negro Question," another challenge made to them by Joseph Stalin, who recommended that American progressives consult a list of books written by black authors and black magazines.[10] Joseph Stalin!! Wow!

The progressive and liberal bloggers who challenged my article, "Black Audiences, White Stars," also believe that like the 1940s and 1950s, black writers are dependent upon them. The careers of great writers like Langston Hughes, Richard Wright and Chester Himes show what happens to black writers who are dependent upon mainstream publishers, who judge black writers by marketable trends. Right now it's Black Bogeyman books (and for that matter film and theater), but Kathryn Stockett has taken over that genre to the consternation of some black women writers who have made a fortune writing Black Bogeyman books in which saintly, do no wrong women are besieged by cruel men, which amount to cardboard cutouts. Didn't they know that an Elvis, in this, case Kathryn Stockett, would eventually co-opt their formula? She's making more money than all of them combined. Though

the film takes place during the time of the Medgar Evers murder, the white men in the film don't belong to the Klan or The White Citizens Council. They're shown helping a black woman with her groceries or being awkward on dates. The villain of the film is a Black Bogeyman, a wife batterer, named "Leroy," who doesn't even get an appearance on camera. The black and white male characters were delineated by Tate Taylor, a white writer. The producer is Harvey Weinstein, rescuer of women from black men whose name showed up recently in a sexual harassment scandal. To show how low Henry Louis Gates Jr. has sunk, the critic who cast black male writers as pariahs in *The New York Times*, the Sony emails that were hacked by Wiki Leaks reveal that Gates begged Sony head, Michael Lynton to give Weinstein an award. This is ironic because in the 1990s, Henry Louis Gates Jr. traveled around the country and Europe calling me a misogynist but recommends that Harvey Weinstein, who has been accused of sexual harassment (MARC SANTORA and AL BAKER NYTIMES,3/30,/'15), receive an award. His being appointed HNIC by *The New York Times* and *The Washington Post* enabled him to control millions of dollars of patronage, which was supposed to go to black writers. However, the money that was supposed to be directed to writers by his Inkwell Foundation went to his Harvard colleagues. One of most intellectual of this country's writers is homeless. She is a genius. She and other black women writers who labor in obscurity are as good as anyone writing today. She could have used that money. Harvey Weinstein like Steven Speilberg is known as a political progressive. It figures.

Progressives were responsible for *Gone With the Wind,* whose script was written by Sidney Howard, a left winger. They are the ones producing, directing and distributing black Bogeyman Books and films for a market that can only get a dopamine boost by viewing blacks as dysfunctional, a multi-billion dollar industry.

One progressive, Rabbi Michael Lerner, has made a habit of blaming all of the conflict between blacks and Jews on Minister Louis Farrakhan, who brought in a Jewish teacher to assist him with Mendelssohn's Violin Concerto in E minor, Op. 64 "to say in music what he could not say in words." His performance with the Oakland Symphony Orchestra under the baton of Michael Morgan is on YouTube. In an exchange with Rabbi Lerner, I challenged him to write a *Times* Op-Ed about some Jewish intellectuals embracing Charles Murray's The Bell Curve, which was funded by The Pioneer Fund.

Wickliffe Draper, a Nazi collaborator, founded the Pioneer Fund. I also challenged him to include his opinion about Saul Bellow, Philip Roth, David Mamet, David Simon and other Jewish writers, scriptwriters, directors and producers producing images of black men that are consistent with those about Jewish men in the Nazi publication *Der Stürmer*. I recommended the *Times* because when I challenged Henry Louis Gates Jr. about his sensational Op-Ed about the last residue of anti-Semitism existing among blacks, he said that the Times would do a follow up about racism among some Jews. It never appeared. Rabbi Lerner isn't going to write one. Maybe his friend and collaborator Cornel West can persuade him to write one. Men of other backgrounds also create stereotypes.

These are some of the men, mostly, who create perceptions about black men and women that influence how they are treated in everyday life. Like their friends in

television, they hide white pathology, a tendency that I noted in *The Nation*, in which I suggested that the media have a "no snitch" policy when addressing the social crises in segments of the white community. No money in it. One of the few film directors who tackle white pathology is Debra Granik. Her film about a rural white community for whom the main industry is methamphetamine is called *Winter's Bone*, 2010. Her first film, *Down to the Bone*, 2004, is about heroin addiction among white low wage workers in upstate New York, a trend that the *Times* and other newspapers and cable operations like MSNBC only caught up with this year.

When I debated Cameron Bailey, a programmer of the Toronto International Film Festival, who was responsible for bringing *Precious* to Toronto, he cited *Bastard Out of Carolina*, a film about a white child molester, as somehow balancing *Precious*. What he failed to mention was that the film was only broadcast because of actress, Anjelica Huston. Ted Turner, a Confederate sympathizer, tried to prevent it from being shown because it was "too graphic." What he didn't find "too graphic" were the crimes committed against black slaves by his hero, Robert E. Lee. Of his film, *Gods and Generals*, critic Stephen Holden wrote: "the movie's undiluted adulation of Lee's and Jackson's machismo appears to put it on the Confederate side. *Gods and Generals* goes out of its way to follow the example of *Gone With the Wind* in sanitizing the South's treatment of African-Americans. Its one-sided vision shows freed and about-to-be-freed slaves cleaving to their benign white masters and loyally serving the Confederate army."

How did Lee treat his slaves? As a slaveholder, the late historian Ms. Elizabeth Brown Pryor said, "Lee was a cruel master, once forcing a runaway slave to endure 50 lashes and then have brine poured on the wounds. He routinely sundered slaves' families if selling a slave was expedient, and by 1860 "he had broken up every family but one" on his Arlington plantation," she wrote. Ted Turner's worship of this stateside Nazi may explain CNN's coverage of blacks. The lies about mayhem and rape after the Katrina flood. A black surrogate correspondent calling black kids, who were disturbed by the state-endorsed killing of black kids, "savages." The hiring of George Zimmerman's lawyer, Mark O' Mara, who smeared Trayvon Martin as a thug. The round the clock defense of Freddie Gray's murderers.

Some of those responding to my *WSJ* piece tried to help me to understand a history that I already know. They wanted to give me a patronizing helping hand. They're always looking over our shoulders helping us with our homework like some who tried to make a false equivalency between Tarantino's *Inglourious Basterds*, and *Django Unchained*. In *"Inglourious Basterds* it took more than a talented tenth fake hero, Django played by Jamie Foxx, to ambush Hitler in a theater and murder him.

To have *Django Unchained* resemble *Inglourious Basterds*, the Foxx character would have had to kill the head of the fascist slave state, Jefferson Davis, but that would have killed the Southern box office because Jefferson Davis is still the spiritual leader of the South. Hollywood and television have catered to Southern audiences for decades, which is why Nat King Cole lost his TV show and Hattie McDaniel wasn't welcome at the Atlanta premiere of *Gone With the Wind*, a film that would have been a tepid Confederate romance had it not been for her presence. Margaret Mitchell's book, *Gone With the Wind,* called for a mammy who was "an inferior who

mimicked her owners and accepted her place, never aspiring to anything more than to lovingly serve white people," according to Jill Watts, author of *Hattie McDaniel, Black Ambition, White Hollywood.*

Hattie McDaniel commandeered Margaret Mitchell's pro-Confederate script and subverted it. McDaniel's mammy was "bossy, intelligent, loud and opinionated." Film scholar Donald Bogle notes, "not once does she bite her tongue."

Someone pointed out that Jefferson Davis had yet to become head of state, teaching me and helping me. Of course as an author of a novel, *Flight to Canada*, for which I coined the term, "Neo-Slave Narrative," a concept that's become a big academic hustle, required me to research the Confederate leader who tried to evade capture by getting up in his wife's clothes; I knew this. My blogging teacher didn't point out that Tarantino includes the Klan in his movie, who are the subject of a joke that goes on too long even though the Klan hadn't been founded yet. It was founded by Nathan Bedford Forrest, who massacred over three hundred black and some white soldiers at Fort Pillow on April 12, 1864, even after they had surrendered. He was redeemed in *Forrest Gump*, from the novel penned by Confederate sympathizer Winston Groom, another example of Hollywood's supporting "The Lost Cause." In *Forrest Gump*, the Vietnam War is "The Lost Cause." In this film, the 1960s are Reconstruction, during which black men corrupt a white woman. Groom is their idea of a historian. He dismisses Forrest's actions at Fort Pillow as "controversial." At least he didn't go as far as Shelby Foote, who was made famous by Ken Burn's celebration of the Confederacy in his documentary, *The Civil War.* Foote, whose grandfather was Jewish, likened the Klan to the French Resistance. To show another example of their spite and the meanness that is rotting them on the inside, some Southerners erected a statue to Nathan Bedford Forrest in Memphis; they're way of thumbing their noses at the Civil Rights movement.

So Tarantino's free Negro is so free that he has a German make moral choices for him, like ordering him to shoot a man in front of his child. Django's relationship with Shultz is like that of Frankenstein's connection with the Frankenstein Monster. Though the monster gets to roam around for a while, it's Dr. Frankenstein who supplies the electricity. Are some black intellectuals so hard up for a hero that they accept Django's gift, a hero whom the character Schultz says is an "extension" of himself?

After Black History has been maimed for a couple of hours, black ticket buyers get a big old visual sugar rush as Django gets to blast a whole bunch of people and rescue his woman who has been passed around among some Mandingo. Some critics called this cathartic. After an hour, I was still hungry for a catharsis. Others were lured into supporting this film because it was promoted as a black love story.

The Haunting in Connecticut included a superior black love story and this story about the Underground Railroad was better researched. But is this surprising that some blacks would support a product that shames Spike Lee's ancestors and theirs by portraying their ancestors as a bunch of unfeeling Sambos, who stand around dumbfounded as others decide their fate? Like in *Lincoln*, where they sit in the gallery watching white men discuss their fate while they look on as one would follow a tennis match. But would this be the first time that victims purchased their humiliation?

Julius Streicher, editor of the notorious anti-Semitic Nazi newspaper *Der Stürmer*, said that his newspaper couldn't have survived without Jewish support.

Tarantino, during a bizarre interview, cited black support for his movie and dismissed his critics with the back of the hand. After all Jamie Foxx, the "star," lubbed it. Jamie Foxx had to get up at the Golden Globes Award and the Oscars and endorse this film like Viola Davis had to authenticate *The Help* and the youngster who accompanied David Simon authenticated *The Corner*.

They liked *Django Unchained* at Henry Louis Gates Jr.'s post-race site, TheRoot, a front for *The Washington Post*, which got some ads for their support from Weinstein Company, a fact that Gates didn't mention when he supported the film during an appearance on NPR's "Talk of the Nation."

And why is the African American Studies Department at Harvard where he teaches dignifying this movie "Django Unchained" by having it taught there? Before that, they invited black dysfunction entrepreneur, David Simon, and cast to come and discuss a series that had Neo Nazi representations of blacks, the kind of images of blacks that you find on "Stormfront," the Neo Nazi website. Gates, in his lectures and his Norton anthologies, has it in for The Black Arts Movement. Is he saying that Tarantino and David Simon have a better grip on black history than Haki Madhubuti, Kalamu ya Salaam, Carolyn Rodgers, Aishah Rahman, Amiri Baraka, Sonia Sanchez, Askia Toure, etc.?

Was Harvard paid by Simon and Tarantino? Just as Gates gave *Django* a powerful endorsement, which is one of the reasons that it's been given respectability. TheRoot accepted ads for *The Wire*, whose view of blacks' jibes with his. Gates wasn't the only one who endorsed *Django Unchained*. Tarantino also received support from black pundits. Black pundits appearing on CNN and MSNBC defended the film.

Jamie Foxx was first billed the star, but the evolution of the ads showed the impotency of black Hollywood. At first he was shown as the star on billboards that proliferated in inner city Oakland, where I live. But by January 11, Leonardo DiCaprio became the star in the ads when the producers, Weinstein Company, started to go after awards and some serious money.

One blogger, who was helping me and looking over my shoulder, examining my homework, said that he is going to use the movie in his classroom, maybe along with *Gone With the Wind*, another propaganda effort in which, as in *Lincoln*, a high school pageant, blacks are denied credit for their role in liberating themselves. W.E.B. DuBois had it right. Without a work slowdown; a general strike by the slaves, hundreds of uprisings and revolts—not only in North and South America, but over a thousand ship mutinies on the way over here, there would have been no Emancipation. Add to this the day to day subversion, not to mention blacks fighting with the British,[11] with the Union army, thousands running away, there would have been no Emancipation.

Were black slaves content with the "peculiar institution" and passive with only a Talented Tenther here and there resisting the chains? Check this out: "The Richmond Sentinel" reported this response from slaves to the appearance of Yankee ships: "The negroes at once threw down their hoes, axes and spades, and quitted their plows, and flocked to the Yankee steamers and other craft by tens of thousands." Does that

sound like blacks clinging to the plantation and waiting for a black superhero to come rescue, well at least, his wife?

In *Lincoln*, Abraham Lincoln wears the cape by freeing the slaves, but there was a catch. Unlike General Fremont, who issued the first Emancipation Proclamation in Missouri where he had control, Lincoln emancipated blacks in territories over which he had no control.[12]

When the great black historian and American Book Award winner, Lerone Bennett Jr. entitled his book, *Forced Into Glory*, about how Lincoln was caught up and pushed by a black rebellion, he got it right. In fact, the first Emancipation Proclamation was delivered by General Fremont on August 30, 1861. Unlike Lincoln's later proclamation, which applied to states over which he had no control, Fremont controlled the Missouri Territory where his proclamation was issued. Lincoln overruled it and according to Fremont's wife, Jessie Fremont, was furious with Fremont.[13] She said that during her visit with Lincoln, he was so angry with Fremont; he didn't even offer her a seat. She said that he lectured her as "some schoolmaster would lecture a child who had overstepped his bounds." He complained "The General should never have dragged the Negro into the war. It is a war for a great national object and the Negro has nothing to do with it." Forced into glory is right!

W.E.B. Du Bois got it right. But unlike black writers, and historians, Tarantino's Sambo thesis about slavery got an audience of twenty million thanks to his receiving a Golden Globe Award and later the Oscar.

Now that the Golden Globes and the Oscars and other awards have done damage by honoring *Django Unchained* before another audience that had the complexion of those who use to attend presidential inaugurals in pre-Mandela South Africa and the support of Henry Louis Gates Jr. and other black intellectuals and academics, Tarantino version of black history has been canonized.

Though Andrea Mitchell congratulated the Golden Globes for "empowering women," by having two women co-host, rich middle-aged white men run the thing and just as Jamie Foxx was used to front *Django*, they elected woman named Aida Takla-O'Reilly as president of the Hollywood Foreign Press Association, the group that oversees the Golden Globes, which honored Quentin Tarantino. She teaches Pan-African Studies at the University of Paris!! She has to fend off charges made by a former publicist Michael Russell who indicts the Golden Globes for the following:

- Accepting money, vacations, and gifts from studios in exchange for nominating their films.
- Selling media credentials and red carpet space for profit.
- Accepting payment from studios and producers for lobbying other members for awards nominations.
- [And] consistently directed Russell to bury stories in the press regarding HFPA's unethical practices.

But at least the Golden Globes has an Egyptian, Ms. Takla-O'Reilly, who pretends to have influence over who receives awards, and like the fake black producers and directors, is there to take the heat while white men call the shots. The Oscars have no minority spook that sat by the door.

Calling the Oscar voters overwhelmingly "white and male," The *Los Angeles Times* reported on February 19, 2012 that of the 5,765 Oscar voters "94% Caucasian and 77% were male, the *Times* found. Blacks are about 2% of The Academy, and Latinos are less than 2%. Oscar voters have a median age of 62."

Wendell Willkie, the Republican candidate for president and Walter White's ally, made the observation that Hollywood's portrayal of blacks was similar to the portrait of Jews in Nazi films. In light of the new revelations about the cooperation between Hollywood producers and Nazis, he didn't know how close he was to the truth.

Those black intellectuals who've stood up to this movie, Armond White, and Cecil Brown, are heroes. They've taken heat from defenders of the film, some of whom have been paid. In the old days it was cheaper to stifle dissent. All Darryl Zanuck had to do to soften the criticism of *Gone With the Wind* was to invite its opponents to lunch at their Cafe de Paris. Kerry Washington, who plays the usual sexual toy role assigned to minority actresses by Hollywood, saluted Tarantino's "courage" for mounting the film, which means he braved the protests of black critics and theatergoers.

Since Brown's review was published in *Counterpunch,* it's been cited in the African and English press, which is probably why Tarantino had a crack-up on English television when subjected to an intense grilling by English critics, who, unlike the cooperating fawning interviewers here, persisted until Tarantino broke. First he said that he made the film to give black men a hero, but toward the end said he was interested in sales. Selling blacks as dangerous buffoons has made billions for Hollywood over the years.

Some of the Hip Hoppers, who began their careers selling crack, have also figured out that TV marketers, Hollywood marketers and MP3 CD producers desire and oblige by serving up stereotypes against which the NAACP use to oppose. Use to. Just as a black comedian's remark made it possible for the media mob to swarm Bill Cosby, using the feminist posse owned and operated by the men who pay their salaries, the NAACP's endorsement of *The Color Purple,* and it's ugly step child *Precious* gave the segregated Oscar's Board of Governors the green light to honor the film.

Another thing that I found offensive was Tarantino's taking a swipe at those of our ancestors who worked in the house. His script says that a house slave is lower than a black slaver. Here are some facts that he missed. *The Daily Mail Reporter,* June 2011, ran the headlines: "The 'Slaves' who were spies: How black men and women risked their lives by going undercover during the Civil War." It's about how black slaves, house and field, undermined the Confederacy by providing the Union Army with Confederate battle plans. Like Genovese, who thought that he would be immune from being caught red-handed at his distortions of black history, the Confederates own delusions about the intellectual inferiority of blacks helped to defeat them. *The Daily Mail Reporter* quoted General Robert E. Lee, who was considered a loser by his contemporaries, but later exalted through a vigorous propaganda effort by his supporters. He said, "The chief source of information to the enemy, is through our negroes." Does this sound like people waiting around for an automaton operated by a German to rescue them? *The Daily Mail,* June 20, 2011:

Confederate officers thought slaves were powerless and oblivious—they were dead wrong.

Leaders in the South would openly discuss troop movements and battle plans and leave important documents right under their noses, without any fear they would comprehend and relay the information. Who would they tell? They were just butlers, deckhands on a rebel sympathizer's steamboat, or field workers.

But some weren't just slaves—they were also spies working undercover as Union intelligence officers.

'The chief source of information to the enemy,' General Robert E Lee, commander of the Confederate Army, said in May 1863, 'is through our negroes.'

Little is known about the black men and women who served as Union intelligence officers, other than the fact that some were former slaves or servants who escaped from their masters and others were Northerners who volunteered to pose as slaves to spy on the Confederacy.

There are scant references to their contributions in historical records, mainly because Union spymasters destroyed documents to shield them from Confederate soldiers and sympathizers during the war and vengeful whites afterward.[14]

Does the class struggle that Marxists applied elsewhere apply to the period of slavery? Ayn Rand's family, part of the Russian bourgeoisie, was comfortable with the status quo. Her bitterness and her later adopting of a philosophy of selfishness, which has influenced the American right, arose from the seizure of her family's assets by the Bolsheviks, while in the South both field blacks and house blacks were united in their quest for Emancipation. During the 1990s, ex-Marxists, who'd become Neo-Cons, invented the term "underclass." They'd forgotten that their ancestors were regarded as the "underclass," and subjected to the scorn of anti-Semites like Henry James. Their ancestors were radicals who would be ashamed of their political views. They would be horrified by the way their sons, daughters and grandchildren are using the ugliest portrait of blacks in order to make money. They can't sell *The Great Debaters*, or *Miracle at Santa Ana*, but they can sell *Precious* and *The Color Purple*. So now segregated Hollywood receives 430 million in tax write-offs as a result of their contributions to the Obama administration. All of us who have been defamed by Hollywood are like those Jewish subscribers who supported the anti-Semitic newspaper, *Der Stürmer*. Our taxes are being used to support our defamers.

Have black filmmakers been passive like the Sambos in Tarantino's imagination? No. In fact since at least 1912, black filmmakers like Bill Foster, founder, in 1920, of the Foster Photoplay Company in Chicago. His film, *The Railroad Porter*, showed "that black characters can not only be porters for whites but also waiters in respectable black cafes in middle-class African-American communities."[15] It is credited with having broken with the "coon" tradition established by Thomas Alva Edison's *Ten Piccaninnies* (1904) and *The Wooing and Wedding of a Coon* (1905) as well as Sigmund

Lubin's "Sambo" and "Rastus" series (1909, 1910, and 1911). According to the authors of Darkest America Black Minstrelsy, Yuval Taylor and Jake Austen, Gangster Rap is a descendant of the Coon tradition. The Lincoln Motion Picture Company, founded in 1916, was the second black film company established in the United States. The hero of the company's two-reeler, *The Realization of a Negro's Ambition* (1916), was James Burton, a Tuskegee graduate. The most popular of the black independent filmmakers was Oscar Micheaux, who in 1918 founded the Micheaux Film and Book Company. His aim, according to Mark A. Reid in his valuable book, Redefining Black Film, was to create films that "were imaginative reflections of a proud, aggressive New Negro whose new morality condoned retaliatory action against white racist aggressions." By the late 1920s, the black independent film companies were in a state of decline. Some of those who'd been stars in the independent black movies were lured by Hollywood. The other problem was the cost of equipment.

That's changed. In 1981, Steve Cannon, the late Walter Cotton and I produced *Personal Problems*. It was the last film directed by Bill Gunn. It premiered at the Centre Georges Pompidou in Paris and in 1990 played at the Whitney Museum as part of a Bill Gunn retrospective and most recently at BAMcinematek, April, 2012. It is part of the Schomburg Library's permanent collection. In the spring of 2015, it will be shown at the film Society of Lincoln Center. Our budget was under $50,000. Gunn had been exiled from Hollywood for being "too difficult" and for exposing the corruption a powerful film producer, a story that he fictionalized in Rhinestone Sharecropping, a novel that I published in 1981. The stars of *Personal Problems* were Verta Mae Grosvenor, the late Walter Cotton, and the late Jim Wright, who played Dollar Bill in black filmmaker W.D. Alexander's *Souls of Sin*, the last of the 500 Race Films produced between 1915 and 1952.

Though this book emphasizes Hollywood's treatment of blacks, I've included essays and comments by Alejandro Murguia, Geary Hobson, Lawrence DiStasi and Sam Hamod, members of groups that also have grievances about Hollywood. I include these writers so that some readers won't accuse our contributors of "victimization" or "paranoia" "playing the Race Card," or "Political Correctness," and slogans that are used to pre-empty debate. The most devastating essay about *Precious* was written by Hariette Surovell, the late New York intellectual, who was Jewish. They act as witnesses on behalf of the plaintiffs, the black contributors to this book, as they make their case against the defendant, Hollywood. How do you think Muslims felt about Hollywood's gushing all over *Homeland* and its Muslim Bogeymen? Professor Sam Hamod; former Director of The Islamic Center in Washington, DC and professor at Princeton, Michigan, Wisconsin, Howard and at other major universities in America and the world writes: "Americans are being brainwashed by such shows as *Homeland*; we need to realize we are all humans, and that the media in America does what it wants, to make money, and, in this case, it demonizes Muslims and others who are not what they think of as 'typical Americans.'"

Yet, we are all typical Americans, immigrants of all sorts, Africans, Chinese, Latinos, Arabs, Japanese, Native Americans, Poles, Jews, Italians, Irish, and more, built this country—not the media people nor the politicians who got rich from our work, nor the bankers who cheated us in the Depression and lately during the 80s, 90s

and today, nor the media people who keep making money from their demonization of minorities in America.

I asked the great writer Frank Chin, who has paid dearly for being smeared as a misogynist by the Sister Police about the roles granted Asian Americans by Hollywood. He wrote:

> Hollywood has manufactured the Yellow woman as White man's sex toy—Nancy Kwan, France Nuyen, Hana Ogi, Lisa Lu, Irene Tsu, et al.—all but the first from silents Anna May Wong, and Tina Chen co-starring with Charlton Heston in THE HAWAIIANS. She doesn't sleep with a white man. Mako is her husband. She ages. She acts a pivotal role in the movie. I can't think of another Yellow beauty who acted rather than oozing her looks over a white man and licking his lips.

It's important for black intellectuals, who often are absorbed by black studies, justifiably, that they are not alone. That they are not whining or complaining about imaginary things, which is the line of think tanks and a Jim Crow media, which is the puppet of the one percent.

Finally, *The New Republic's* response to my complaint about being misquoted by feminists Victoria Bond, and Jacqueline Bobo, shows how black opinion is occupied by outsiders. During the last year, Nicholas Kristof wrote a series of articles admonishing whites about how to relate to blacks, which is like an Ebola patient lecturing a scientist about its cure. One columnist like this has a worldwide audience and has more power to define black issues than any one hundred black intellectuals. Of course, *The New Republic, The Nation, Commentary,* MSNBC and CNN all have their in-house blacks, but their bosses determine how they frame the black experience. A book like this, which refutes the idea promoted by the token manufacturers, who have been dividing and conquering for two hundred years by posing that black cerebral talent is rare, is seen as a conspiracy. Only Third World Press would have published it.

With the new technology and the lower costs thanks to the digital and computer technology, smart phones, and YouTube for creating and distributing images, this might be the last book that protests Hollywood's ongoing war against black America. A new generation of black, Asian American, Native American and Hispanic filmmakers are employing this technology. They are telling their stories without middle persons who are hostile to their interests. As George Bernard Shaw said: "For unless you do your own acting and write your own plays, your theater will be of no use; it will, in fact, vulgarize and degrade you." This is true of the film as well.

Endnotes

1. Urwand, Ben. *The Collaboration Hollywood's Pact with Hitler.* Cambridge, MA: Belknap Press a Division of Harvard University Press, 2013. Doherty, Thomas Patrick. *Hollywood and Hitler, 1933-1939.* New York, NY: Columbia University Press, 2013.

2. Holladsworth Jr., James G. *An Absolute Massacre*, Louisiana State University Press, 2001

3. Boulard, Garry. *The Swing Around the Circle: Andrew Johnson and the Train Ride that Destroyed a Presidency.* Bloomington, IN: iUniverse Incorporated, 2008.

4. Vaughan, Bernard. "Judge approves suit tying Morgan Stanley to toxic lending in Detroit." *Reuters Magazine* 25 July 2013, late ed.

5. Bennett, Drake. "This will be on the Midterm, You feel Me?" *Baltimore Globe.* 24 March 2010.

6. Genzlinger, Neil. "Hitting the Streets in a Harlem Precinct: 'NYC 22' on CBS, Looks at Rookie Officers." *The New York Times* 13 April, 2013.

7. Harding, Vincent, Thelwell, Michael, "In Response to: Genovese, Eugene D. The Nat Turner Case from the September 12, 1968." *The New York Review of Books* (1968).

8. Reed, Ishmael. "Black Audiences, White Stars and 'Django Unchained.'" *The Wall Street Journal* 28 Dec. 2012, early ed.

9. Serwer, Adam. "In Defense of Django." *Mother Jones* 7 Jan. 2013, early ed.

10. Draper, Theodore. *American Communism and Soviet Russia: The Formative Years.* New York, NY: Viking Press, 1960.

11. Genzlinger, Neil. "Hitting the Streets in a Harlem Precinct: 'NYC 22' on CBS, Looks at Rookie Officers. *The New York Times* 13 April, 2013.

12. Egan, Ferol. Fremont, Explorer for a Restless Nation. New York, NY: Knopf Doubleday Publishing Group, 1977.

13. Gates, Henry Louis, Jr. "Reclaiming Their Tradition, Review of 'Invented Lives: Narratives of Black Women 1860-1960' by Mary Helen Washington." *The New York Times* 4 Oct. 1987: 3.

14. The Daily Reporter http://www.dailymail.co.uk/news/article-2005864/Civil-War-secrets-Slaves-joined-freedmen-help-spy-bring-South.html

15. Horne, Gerald. Negro Comrades of the Crown: African American and the British Empire Fight in the U.S. Before Emancipation. New York, NY: NYU Press, 2012.

PART ONE
DJANGO REVISITED

Django: Where You Been? | Amiri Baraka

You wonder why the big noise about *Django Unchained*. Though now, I see they've removed the principals from the ads and now feature only the film maker, Quentin Tarantino's face. (What dat mean?)

I thought the film was entertaining, in a way over the top fashion. It was obviously this over the toppish style that allowed it to be made. The actual tale of Black people and slavery, what it was to them and what it made its owners, has still mostly never been told. By the time Black slaves were "emancipated," in those states at war with the union, they were Americans, and had been since sometime early in the 19th century. They were American slaves not Africans.

What remains is the distinct madness slavery created both in the arrogance and ignorance of the descendants of the slave owners and the deeply exploited state of the slave descendants. Though that struggle goes on, it is as DuBois characterized it, the Sisyphus Syndrome, where our continuous efforts busts the bottom loose periodically and we make clear progress, but immediately after, the slave owners push back and stop the upward motion and push us back, not all the way, but in obvious ways.

The proposed Reconstruction, just after the civil war, was met by the creation of the KU KLUX KLAN! After Obama's victories, the Tea Party and that part of congress which shed its robes and rushed into the Republican ranks in the House appear.

Seeing the Klan caricatured, when shown rushing a hundred strong to massacre Django and his white bounty hunter mentor, by comically whining about their masks not fitting and deciding to turn around is hysterically unfunny, when you think of the real Klan or Medgar Evers or Chaney , Goodman and Schwerner. But I think that kind of "cool out" is the only way the slave owners let such a movie be made.

Not to mention the hundreds of the need to be wiped out that Django and his white bounty hunter mentor-employer who calls himself Dr. King, (though his real name is Schultz) actually do dispose of. We wish that did happen, but it didn't and the routed comic Klan, we wish that had happened, but it didn't.

The point is that what actually happened is what has not been allowed to be shown. After a hundred years of *Birth of a Nation, Gone With The Wind* and all the rest of the confederacy supporting Hollywood epics, we had to wait till the "Black

Exploitation Films" of the Black Art's 1960s (probably titled such so as to steer young folks away from them) to see something like *Buck & The Preacher*, Sidney Poitier, Harry Belafonte and Ruby Dee's anti-confederacy romp.

We must pause here for a minute to mention the monster Uncle Tom played by Samuel Jackson, who probably has been waiting all his life to play this. I'm sure glad Jamie Foxx killed him, he need to start an agency in unreel life offering the same service. But even so, the white boy wasted Leonardo DiCaprio who was the major villain (and the best actor in the film).

Some people , even in my own family, said they dug the flick because it was a love story, since Django wasted half the crackers in the South to reunite with his fine wife, and while that's hard to argue with, check the flick closer and you'll see that while that noble wife liberating effort was being accomplished , that as Saladin Muhammad stated in a Black Left Unity blog, Django did next to nothing to free the rest of the slaves (in fact he let one get wasted by a Republican dog). I submit that this is another reason the flick could actually be seen.

The Duality of Violence in *Django* | J. Douglas Allen-Taylor

There should be no mystery why *Django Unchained* is so compelling and emotionally releasing to so much of the African-American movie-going population. Director Quentin Tarentino's latest film has some of the most realistic—and horrific—scenes of the true violent nature of American slavery that have ever appeared on American screens, while at the same time providing the catharsis for a half-millenium of bottled-up, inherited Black anger by an immediate and equally bloody orgy of African-American revenge.

Why would anyone think this would not be compelling to Black audiences?

To be honest, *Django* has no real competition in the American film industry in the depictions of the violence against African captives on American plantation soil during the slavery years. There are only a handful of such scenes in film history: the boiling death of Mede and the bleeding to death of his half-white child in *Mandingo*, Denzel Washington's magnificently-acted whipping scene in *Glory*, the slavery-in-a-mirror's-reflection killing of the baby Beloved by Sethe in *Beloved*, and in the various film depictions of *Uncle Tom's Cabin*. But all of these films were done before the modern evolution of graphic violence in film, and of today's American filmmakers, few depict violence more horrifically real than Tarentino.

In his exposition of the real violent character of American slavery in *Django*, Tarentino is at his most brilliant. That is to say, many of those scenes are difficult for African-Americans to watch without feeling that we are at the point of bursting.

None are more agonizing that the collective scenes of brutality against the enslaved woman Hilda, played by actress Kerry Washington. Whether it is in the whipping scene, or the face-branding, or the naked release from the hot-box ground-hole prison, or the slavemaster's threat to bash in her head with a hammer, Tarentino and Washington combine to demonstrate the horror by Hildy's reactions—her screams and tears, the unbelievable look of fright in her eyes, the agonized arc of her back as she strains against pain, the crumpling of her body as she is released from it—all of which serve to suddenly make the violence of slavery not something which happened to "some of them folks way back then," but to someone among us right now, to someone who we know and love, to our sisters, to our wives and mothers, to ourselves.

To Hildy's rescue, Tarentino sends her enslaved husband Django (Jamie Foxx),

as we all want to be rescued, or might fantasize about risking our lives and all to be saviors.

For me, by far the most powerful scene in the movie is the bullwhip beating of the slave overseer Lil Raj Brittle by Django on the Tennessee plantation, taking revenge for and almost exactly mirroring the Brittle brothers' beating of Hildy. Foxx makes his character appear to almost grow in size as his anger and emotion overflows and his whipstrokes rise in mounting fury, an avenging Black angel, the perfect circle of giving back the slavemaster exactly what he has given us, and in equal measure.

One can only daydream of what type of movie *Django* would have been had Tarantino chosen to stop there, to simplify his film into a more compact form, to have Django return to the plantation where he and Hildy were enslaved and to rescue her there, from the same slavers who beat them and forced them apart. With Tarantino's talents and the soaring abilities of the major actors and support staff and money he can attract, *Django Unchained* might have become both a revolutionary piece of art and a classic of American cinema, simultaneously, an honest depiction of American slavery, from the viewpoint of the enslaved, where the enslaved Africans win.

But Tarantino, being Tarantino, could not stop himself there, even if that had been in his mind. Instead, from the Tennessee whipping scene on, Tarantino takes *Django* into fantasy excess, becoming almost a parody of its first third, and thus largely negating all of the good work that it had and could have accomplished.

First is the transformation of Django himself from a realistic portrait of a product of his history to the transportation of a modern man back in time so he can wreak havoc on the tormentors of his ancestors. To be sure, Tarantino is not nearly the first American movie director to fall into this trap. Recent films abound with characters of 2000-era sensibilities imposed upon a previous world. Particularly egregious is the cinematic transformation of women's roles from what they actual were in earlier times—both their actual vulnerabilities and their actual power and powers—into caricatures of sword-fighting, ass-kicking post-modernists who are, incredibly, better at all these feats of battling than the boys.

But that makes it no less sad when one sees it in *Django Unchained.*

From the whipping scene on, Foxx's Django begins to rapidly transform into a transported hood-boy from Deep East Oakland or Detroit or Philly's South Side. By the time he and his bounty-hunting mentor Dr. Schultz have reached the Mississippi plantation where Hildy is enslaved, Django has donned shades and is increasingly and pointedly flippant in his comments to the white plantation underlings, whether it's telling main the plantation owner's bodyguard that "you don't wear a hat in the house, white man" or, when the plantation secretary explains his subservient position to the master, remarking that "you could almost say you're a nigger," or his increasingly-belligerent remarks to the plantation master himself, Calvin Candie (Leonard DiCaprio). At one point, when he feels himself disrespected by one of the overseers, Django feels free enough to pull man and horse to the ground, and then pull his gun on the other overseers who seek to intervene, telling one, "you better watch who you're talking to, white boy." At this point, in case the audience has not yet grasped that Django is a b-boy in disguise, Tarantino introduces the first of afterwards-continuing gansta rap music tracks.

What is so insidious about this sort of cinematic historical revisionism is that a modern character dropped into a historical period can always be drawn back into their own time again when the need arises, obscuring the real heroism of those of that previous time who actually resisted and had no way of getting out of it but by their own hands or the slow and natural passage of the calendar and events.

Django the individual's descent from historically-based character to caricature is mirrored in the movie by Tarantino's decision to simultaneously begin to throw out the historical realities of slavery time for the sake of mood or plot or whim. Django reads aloud an arrest warrant to Schultz, but Tarantino thinks it unnecessary to explain how such a thing could be in a time when most enslaved Africans were forbidden reading ability. Though the rise of masked white terrorist night-riders did not come until after the end of the Civil War—there was no need for slavers or slave catchers to hide their faces before that—Tarantino has them ambushing Django and Schultz two years before slavery ended, compounding that anomaly by turning the Klan raid into a *Blazing Saddles*-like parody, complete with an argument over the proper placement of the eyeholes of their hoods.

The performance of Samuel L. Jackson as Stephen, the Black head house hand of the Candieland Plantation where Hildy is enslaved, is both chilling and absolutely brilliant at times. But while it is credible that Jackson's character would have challenged his slave master, perhaps even repeatedly, it is highly doubtful that even a head house hand would have returned his master's "hello" with a contemptuous "hello, my *ass*!" in private, much less in front of guests and enslaved Africans and white overseers as Tarantino portrays in the movie. And regardless of Stephen's special close relationship with the master Monsieur Candie in which Stephen wields considerable power and influence, a situation that was fairly common during slavery, it is unlikely to the point of impossibility that the Black enslaved Stephen, in real life, would have been able to order the white overseers around after the master's death, as Tarantino would have us believe in his movie.

The gun battle in which virtually everyone in the plantation parlor is hit except Django, his unbelievable Bro' Rabbit-type escape from the transporters of the Lequint Dickey Mining Company, and his return to Candieland where he literally blows away Monsieur Candie's sister, kneecaps Stephen with a pair of well-aimed shots, and then blows up the Candieland Big House itself, all serve to end Tarantino's movie on a train that rolls further and further away from reality.

I believe that *Django Unchained* has the chance to become a seminal American motion picture not on its own merit, but because it opens the door to an honest cinematic view of the violence of American slavery. Future filmmakers have two ways to respond. They can use slavery violence as set-piece background to plots that have only a vague resemblance to the actual reality of slavery. Or some enterprising director can roll the dice, assemble the talent, borrow the money, and give us what Tarantino did not. I hope at least one of them does the latter, even though we might find it too explosive and honest a depiction for the American screen—and current American society—to contain.

Innocent Plantation Seductions:

Quentin Tarantino's *Django Unchained* | Houston Baker Jr.

When the trailer for Quentin Tarantino's *Django Unchained* hit the screen amid endless previews fronting a feature film I had signed on for, my response was: "Note to self: Do not see this film." I am not a fan of Jamie Foxx, Leonardo DiCaprio, or Quentin Tarantino. So that was an automatic three strikes. Subsequently, I learned that Spike Lee had objected to *Django Unchained* and urged a boycott. I maintained my resolve to avoid Tarantino's most recent offering until a friend who is a brilliant and trustworthy critic reported his experience of the film. He and his family had seen *Django Unchained* and they loved the work. My friend thought it was a compelling account of black manhood. So, with some foreboding, I suggested to my wife and son during the Christmas holidays that we go to see *Django*. We did, and I must confess, we had a fine time.

But, I have been asked to turn scholarly attention to Tarantino's most recent opus. I have been solicited, that is to say, to write in the person of a professor who is currently offering a course titled "Black Diaspora Literature and Theory." This mandates more than having "a fine time." What I would offer, then, is that *Django Unchained* is a grand spectacle. It is not, however, leavened by analytical precision vis-à-vis chattel slavery in the U.S. Rather, the film is a flamboyantly puffed-up groaning board of historicist and pop-cultural pastiche. It is "signature" Tarantino. The film combines generic spaghetti westerns with a stew of stereotypes and clichés, and is seasoned from an herb rack of Blaxploitation and comic book archives. Christoph Waltz performs deftly his role as a wizard of rhetorical flourish and legal murder. Jamie Foxx provides the best nuanced performance available given the script he is dealt. Kerry Washington floats limbless and diaphanous through the movie's mists of light. She is a *Nibelungenlied* cameo.

Two months have passed since I watched *Django*. The film has garnered a king's ransom in box office, and at the 2013 *Academy Awards*, Tarantino and Waltz left the building with critical hardware. In my "Diaspora Literature and Theory" class, we have arrived at the syllabus moment of Saidiya Hartman's *Scenes of Subjection: Terror, Slavery, and Self-Making in Nineteenth-Century America*. I think Professor Hartman offers fit terms for a critique of the spectacular "pleasures" of *Django*. In *Scenes*, she writes of the "seduction" and legal constraints that mark chattel slavery's "plantation romance" as follows:

The confusion between consent and coercion, feeling and submission, intimacy and domination, and violence and reciprocity constitutes what I term the discourse of seduction in slave law. The discourse of seduction obfuscates the primacy and extremity of violence in master-slave relations and in the construction of the slave as both property and person.

First note: Tarantino's protagonist, Django, is legally as much a slave at the close of the film as at its commencement. Second note: Broomhilda and Django are located in Mississippi plantation country when they ride into a Deep South sunset at the film's close. These two notes are relevant to an understanding of the legal take away from the discourse of plantation seduction. In that discourse, slave women have no legal rights that a white (or black) man is bound to respect. In slave law black women are seductresses, deemed so lascivious by nature and so passionate in their lust for carnality that they are *always* dangerously willing to give themselves to lust. They are thus *legally* incapable of being "raped." Similarly, the plantation romance insists that masters *loved* their slaves; they only lashed, tortured, tormented, mutilated, and deprived them of life as "correctives" for their slaves' own good. By turn, this same plantation romance writes black slaves as sentient, dependent children who seduce their masters into co-dependence. These childish, enslaved sprites gladly lay down their lives for Ole'Mas. Of course, merely by re-reading Hartman's subtitle, we know that such legal and social characterizations of black males and females were nothing other than a Master Class's defense against the real and justifiable *terror* that all and any black slave harbored a nearly unappeasable desire to exterminate them utterly. Samuel Jackson's performance of the role of Stephen, Senior Black Slave of *Candyland Plantation* is a brilliant exemplar of what Hartman describes as the "intimacy and domination … violence and reciprocity of seduction in slave law."

From any serious black psycho-historical reflection, one would have to declare *Django* a hot mess of plantation seduction. (Remember, I am now reading the film not as a moviegoer in search of a "fine time." Later, I shall have more to say about such "amusement.")

The affections that lead Django and Broomhilda to believe they can marry and make their way from the plantation to a "free" space are no more than fantasy and desire. Here, "free" is the operative word to be appended to "legal" and "safe." Slave couples such as William and Ellen Craft did flee the South and make their way to a Northern form of "fugitive freedom." But in *Django's* spectacularly weird glow of black "Mandingo Fighters," the fantasy of Broomhilda and her slave apprentice in matrimony is but a fanciful and distorted mirroring of plantation seduction. It is a pathological *mimesis* of "legitimate"desire that leads to disaster. And in Mississippi?

On a recent *Saturday Night Live* episode the black comedian Kevin Hart quipped that not only is he fearful of going out after dark in Mississippi, but also on a cloudy day. Unlike her Norse counterpart Brunhilde, Tarantino's Broomhilda occupies no mountain of sacred, protective fire. She is a black woman brutally scarred by the lash for even attempting a free marriage. She is made abjectly aware of her impotence when Django is sold into the "internal slave trade." There is *no* actual, legal "romance"

here, but only the titillation, I would argue, of the slave "wench" raped by the whip wanly awaiting "her man" for murderous rescue.

Enter now Leonardo DiCaprio as Calvin Candie, plantation owner, exhibitionist, bon vivant, patron of brown-skinned concubines, and merchant promoter of "Mandingo Fighters." The elaborate ruse that Shultz and Django concoct to reclaim Broomhilda from the clutches of Candie and *Candyland* are, in one reading, broad farce worthy of Groucho Marx and his brothers. Somehow, this farce elides the horrific complexities of Django's complicity in Mandingo Fighting, his ease in the lavish city club of the slave owner, and his stoic "cool pose" when the refusenik Mandingo Fighter is torn to pieces by Candie's slave-tracking dogs.

What kind of black man is this? Well, a black slave he is, one who only wants his "gal," to sample *Porgy and Bess*. He seems as void of what we know as "slave revolt" in the Americas as those other *Django* slaves in a barred prison car. When the cage doors are opened and their oppressors are dead, Django's fellow slaves have no idea of a "next move." They stare fearful, mute, and presumably afraid. They are but the redux of the shackled black captives whom we see on Django's first appearance. When their owners are nullified, they stand paralyzed and mute before the white King Shultz, a murderous emancipator. Shultz even has to identify for them the North Star!

In *Scenes of Subjection*, Hartman defines as "innocent amusements" those pastimes where slaves congregated to share the company of their like-color and compatible histories. The "amusements" included dance, brush arbor worship, quilting sorority, and shared storytelling. Hartman reads these "innocent amusements" as always under the surveillance and absolute domination of the masters, whether the masters were embodied presences or not. Amusements, like a "fine time," provide, according to Hartman, no *permanent* liberation, or sure avenue toward community. Innocent amusements are never, of course, "innocent" under the freighted edicts of abjection and legal disfranchisement. They are, instead, exemplars of Frederick Douglass' nineteenth-century judgment. Douglass persuasively charges that masters provided "slave holidays" merely as temporary escape valves for their bondsmen who labored under an all-encompassing reign of terror and domination. When *Candyland* goes up in spectacular flames at the close of *Django*, we might want, as cinema amusement seekers, to think of the film as liberation. The *end* of the plantation—heroic freedom and romance securely achieved. Go Django!

However, the notion that the Civil War (*Django* is set two years prior to the war.) wiped out abject economies of "The Plantation" is but a fantasy. Life got a *lot worse* for the Black Majority after the war. They struggled without resources, were dragooned into convict lease labor, rack rent tenancy, and the dread hells of Plantation Sharecropping.

When Martin Luther King traveled through Mississippi in 1965, he was astonished to find blacks on Mississippi plantations that had never seen a dollar bill ... or *any* U.S. paper currency. Not only were southern blacks in the majority *conscripts* of enduring plantation terrors and deprivations, they were often, in quite woefully legal fact, convicted *criminals* to an implacable system of white greed and indifference. They were compelled to trade not in liberatory dollars, but in plantation

"script." Tarantino's *Django Unchained* is "plantation script."

In the streets of America today, avatars of Mandingo Fighting lock arms in killing rhythms on a daily. (Chicago is prime exemplar where they are exterminating one another by the hundreds.) Arguably, to fail to view black resource-less-ness and continuing structural disfranchisement and criminalization as an historical and sociological sedimentation of the plantation is a crime in itself. At the very least, it is a moral lapse that produces a certain blank carelessness. We tend to allow what is called "news" to deteriorate by the hour into "amusement." This will perhaps make us sit mute and powerless before claims that will surely be made for the bold progressiveness of *Django Unchained*. Tarantino will be anointed a man of "legitimate authority- and -expertise" on chattel slavery. Who cannot envision the travesty of Piers Morgan interviewing the screenwriter on the dynamics of plantation slavery? Scholarly analysis may disrupt such a fantastical cable television charade. However, the recent demotion by CNN of Soledad O'Brian for seeking the truth puts a damper on even that prospect.

Truer to the actual state of present day black affairs are the enduring ghosts and economics of a system of global commerce that birthed the slave ship and the plantation alike. Surrounded as we are by the systemic exterminations of black youth murdering black youth in the cities, and a Prison Industrial Complex taking care of all others who are avatars of the plantation what can we take as "only a movie"?

Django Unchained was filmed on a Mississippi plantation. Its cinematics are about as efficacious for the interests of black liberation and the Black Majority as Mississippi has historically been for the welfare of Black America.

And Django? The fact that Tarantino's protagonist (drawn from his Italian filmic forerunner) commences the film dressed in shabby slave blankets, quickly changes to Gainsborough blue, then dons cowboy buckskin bounty-hunting duds, and ends clothed in the weeds of the Master tells all. These "changes" signal a *deathly black mimesis and perverse romantic individualistic desire* as the real endgame of *Django Unchained*. Clothes signal the nature of the man, and like Mississippi, there is nothing racially "innocent" about Django's wardrobe. Today, he would surely have his own reality cable show: *Post-Black Bounty Hunter Unchained!*

"Whup, the Motherfucker!" | Herb Boyd

My wife and I, after several days of serious debate, decided we'd venture out and check out *Django Unchained*. Our curiosity had been thoroughly whetted and there was enough controversy to lure even the most reluctant public intellectual. We also decided that we'd deliberately choose to see it at the Magic Johnson Theater in the heart of Harlem where we knew the audience would be almost exclusively African American.

We arrived late and had to settle for seats toward the front of the theater but not exactly where you have to look up at the screen and leave the show with a crook in your neck. Even before the film began the chatter was underway, and you know how Black patrons, particularly the young and restless ones, like to talk back to the screen.

As a kind of preview of the rap to come, two women who arrived even later than we did carried on a conversation across the theater as they struggled to find seats near each other. "Come on ovah here," one of them called. "Dere two seats and maybe this gentleman will move ovah and let us sit together." The gentleman did and the woman, armed with the biggest container of popcorn imaginable, a huge drink, and heaven only knows what else, excused herself down the aisle and clumped down next to her friend.

"Ain't we kinda close?" I thought I heard her ask her friend.

"Yeah, but dese was the only seats left, plus we up close to the action," she answered.

And it didn't take long for the action to unfurl from Quentin Tarantino's script and under his direction. The first scenes and the music cued the Spaghetti Western motif we'd heard about and my mind went hurtling back to the Sergio's of the past— both Corbucci and Leone—and that was a good sign because I totally enjoyed those films, particularly *The Good, the Bad, and the Ugly*, and it was hard to think anyone could get any uglier than Eli Wallach, yellow teeth and all.

A coffle of shuffling slaves immediately grabbed your attention, the whelps the size of ropes on their back like those scarring the back of Caesar who is depicted in so many history books about slavery. Later, we will see them tattooed on the back of Broomhilda (Kerry Washington). One of the slaves chained together is Django (Jamie Foxx) and it's a set piece that introduces King Schultz (Christoph Waltz) who comes out of the wilderness like a snake oil salesman on his buckboard concoction

that reminded me of the first scene of Marlene Dietrich as the gypsy woman in *Golden Earrings*, which should give you an unmistakable clue to my age since I saw it long before it got to TCM.

I've heard that Tarantino is a real film buff but I doubt if he knew anything about that old movie, though I wouldn't be surprised given the similarity to the haunting love story his film and the old movie have in common.

Right away you knew this was not going to be a friendly encounter since Schultz is singularly concerned in purchasing one of the slaves. Most disconcertingly amusing about the exchange between Schultz and the white slave traders is Schultz's language, or Tarantino's.

"Among your company, I'm led to believe," Schultz begins, "there is a specimen I hope to acquire." His words would not have been any more astonishing had he uttered: "Whither thou goest with those disheveled souls?" The tone and terminology of the request is as funny as it is deadly earnest and at its conclusion we have the first spilling of the buckets of blood that will make this one of the goriest flicks since, well, Tarantino's "Inglorious Basterds."

Having properly exterminated the traders, the slaves are left to their own devices and Django, like a bewildered Tonto, rides off with Schultz and after they kill the sheriff in a town they are passing through viewers get a gander at the narrative theme and you wonder how the two of them will possibly wiggle out of a very desperate situation in a town without pity.

To mollify an angry posse, with nothing but lynching on their minds, Schultz approaches them and unsheathes a paper indicating that the sheriff was really wanted for murder and that he had every right to capture him dead or alive. It was an incredible ruse but effective and it would be their modus operandi as they traveled from dry gulches to the snow-laden, freezing terrain of Wyoming, or somewhere in the chilly West. They were bounty hunters unchained and as they rode across the prairie I was expecting Count Basie's band to pop up as it did in *Blazing Saddles*.

The first half of the film is Schultz and Django as serial killers; mainly Django seems to be along for the ride until he drops his quest on Schultz that in exchange for continuing service they take time out to rescue his wife from a Simon Legree-like plantation owner. Aha! Now we have the subplot presented and it resembles one of the oldest of Western clichés—rescuing the damsel in distress, only this time it's not the Durango Kid it's Django the man! (Remember John Wayne in *The Sundowners*?)

When they arrive at Candie Land, named for its master Calvin Candie (Leonardo DiCaprio), its reminiscent of those panoramic, long shot scenes from *Gone With the Wind*, with slaves scattered about in forced labor in cotton fields and other duties. But it was their confrontation with Stephen (Samuel L. Jackson) the HNIC and the beloved house Negro, the proverbial Uncle Tom in all his nastiness that is most commanding. Jackson has said of the portrayal as one of "the most despicable characters in cinematic history." And he takes the fawning, sycophantic groveling right down to the last "yassuh." It brought to mind that famous passage from one of Malcolm X's speeches about the master and his house Negro.

"If the master's house caught on fire, the house Negro would fight harder to put out the blaze than the master would," Malcolm said from his "Message to

the Grass Roots." "If the master got sick, the house Negro would say 'What's the matter, boss, we sick?' We sick! He identified himself with his master, more than the master identified with himself." Now the audience in the theater had another enemy, someone to hiss at and deride.

Much of the remaining action happens in the Big House where we meet such extras as Franco Nero, the original Django who has a brief conversation with the other Django over a drink at the bar, though the subtleties of their exchange probably meant little to the average movie-goer. It was a nice little touch much in the same way that Richard Roundtree has a cameo role in John Singleton's redux of Shaft, starring Samuel L. Jackson.

But after some rather tame chit-chat the gratuitous violence approaches its apex, with a fight between slaves as a preface. With a possible nod to today's ultimate fight events, two muscular Black men tear into each other in a battle royal. Aha! Is this Tarantino's *Mandingo* moment? Again, I was transported back to the novels and subsequent films based on the books by Kyle Onstott, especially *Drum*, and *Mandingo*. Historians will certainly have a field day on the veracity of this fight, much in the same way they debated whether there were actually slave-breeding plantations. If the scene had taken place outdoors it could have come straight from Cecil Brown's novel *The Life and Loves of Mr. Jiveass Nigger*. In this book the fight is cast in a folkloristic manner, conjuring the Trickster trope. When the less than formidable Efan faced with a gigantic opponent named Kocomo walks over to the carriage and slaps Miss Ann, his opponent takes off running down the road, apparently any Black man who slaps a white woman in the state of Georgia in front of her husband and his master is more than he wants to deal with. It's a hilarious moment without the bloodshed that results from Tarantino's combatants.

Intrigue enters the film when Stephen begins to suspect that Broomhilda and Django know each other. He's absolutely right and the marks of the branding on their cheeks is a dead give-away, though Stephen doesn't seem to be aware of it. This is perhaps his way of toying with her or Tarantino's idea of creating a dynamic interplay between contending elements of Black culture.

The shootout at O.K. Corral pales in comparison to the slaughter in the Big House and the carnage soon reaches a point of inane excessiveness. But vengeance is mine sayeth Tarantino and *Reservoir Dogs, Kill Bill,* and *Pulp Fiction,* are merely dry runs for the blood and gore at Candie Land. Even so, there's a quick instance of laughter when Candie's sister is killed. She is blown from the scene like something out of *Poltergeist,* suddenly as if snatched from the room. The audience almost laughed as loud as when Stephen got his comeuppance or when Django took the whip from an overseer or slave driver and administered his own vicious lashes. "Whup, the motherfucker," someone cried in the theater setting off a chain reaction of the phrase.

In this moment of retribution I recalled the passage from Frederick Douglass's autobiography when he was no longer going to take any more abuse from Covey the slave-breaker. For nearly two hours Douglass and Covey fought each other and finally Covey had to concede he was defeated. Douglass wrote: "The battle with Mr. Covey was the turning point in my career as a slave. It rekindled the few expiring

embers of freedom, and revived within me a sense of my own manhood." This, among hundreds of others, is the film we're waiting for.

With bodies strewn all over the place (and the only thing more excessive is the N-word), Django's revenge is partially fulfilled; however, there's still the man who threatened to relieve him of his private parts as he was suspended upside down in a barn; there was still the quest to rescue Broomhilda, who, for the most part was little more than a Pauline tied to the railroad tracks waiting for her prince to come.

Okay, the ending was predictable but at least it was a Black hero riding off into the sunset with his wife, and you'll notice she is armed with a rifle as if now ready to be an agent of her own liberation. There is a moonwalk from Django's horse and the two lovers are off to the sequel, huh?

Well, we don't need another Tarantino film to remind us of what needs to be done cinematically. *Django Unchained* is, overall, a mixture of Spaghetti Western, blaxploitation, satire, slave narrative, lampoon, send-up, and fairy tale, as my wife concluded. No, it wasn't a history lesson, just pure entertainment. But the question is: have we, as a people, reached a level of progress and tolerance to laugh at the horrific moments of our past? Probably not, despite the hilarity from the audience, because so much of the past is still with us. There's too much mass incarceration of Blacks and the author Michelle Alexander has noted that we have more Black men and women in correctional control than were in bondage in 1850, about the time period of the film's depiction. Too many Black men stopped and frisked, harking back to the slave codes and Jim Crow laws; too much police brutality almost equal to the beatings administered by overseers patrolling the plantations. Other ethnic groups may be able to enjoy their troubled past, but there is not enough variety of our experiences in popular culture, too few films of merit or worthy television shows for us to relax and laugh at our torture and oppression.

There is no way we can stop the Tarantino and others from mining the richness or the grotesque aspects of our culture, particularly when he is aided and abetted by Foxx, Jackson, Washington, and producer Reggie Hudlin. So, what's to be done?

The only real answer is for us to make our own films; films that begin to depict and articulate the glorious struggle we've waged for total freedom and liberation. We have the resources and the talent, but the will doesn't seem to be there. It may take another generation or two before we're completely "unchained" and ready to tell our own magnificent story where Douglass, Tubman, Robeson, Truth, and others can recount what they endured and overcome without interference from those with the wherewithal but a different agenda.

Meanwhile, "Whup, the motherfucker!!!"

Hollywood's Nigger Joke: Tarantino's *Django Unchained* | **Cecil Brown**

I had little dog, his name was Dash
I'd rather be a nigger than be white trash
—African American saying

In order for a joke to work, Mary Douglas, the eminent British anthropologist, wrote that one had to have a social context for it to operate in. "We must ask what are the social conditions for a joke to be both perceived and permitted," she asked in her wonderful little essay, "Jokes."

"My hypothesis," she writes, "is that a joke is seen and allowed when it offers a symbolic pattern of a social pattern occurring at the same time."

With *Django Unchained*, the symbolic pattern—I'd call it historical context–is Hollywood itself. "If there is no joke in the social structure," Douglas observed, "no other joke can appear." In Hollywood, there are lots of jokes in the system!

The social pattern that allows Quentin Tarantino's "Nigger joke" to work is set in the South, two years before the Civil War, but my point is that this is only a pretext for Hollywood itself.

Some critics, like Betsy Sharkey in the *Times*, think this film is a masterpiece. Sharkey calls it, "the most articulate, intriguing, provoking, appalling, hilarious, exhilarating, scathing and downright entertaining film yet."

African American critic Wesley Morris hated it. He called it "unrelenting tastelessness—[...] exclamatory kitsch—on a subject as loaded, gruesome, and dishonorable as American slavery."

Ishmael Reed, the novelist, pointed out how the Weinstein Company promoted an advertising campaign to get a black audience by promoting Jamie Foxx as the star. In fact, Foxx is only one of the stars, along with Christoph Waltz and Leonardo DiCaprio. As Reed points out, Foxx spends most of his time looking at Mr.Waltz and then looking at Mr. DiCaprio, with a puzzled look on his face, as if to say, *What's dese white folks, talkin 'bout?*

My aim in this essay is to examine the way in which the symbolic system is a reflection of the social system. My goal is to probe the question, "What are the social conditions for a joke to be both perceived and permitted?" that Mrs. Douglas wrote in that little essay, "Jokes." What are the social conditions that would permit *Django*

to be the big howling, empty nigger joke that it is?

One of these social conditions, certainly, involves the relationship between black actors and Hollywood as a symbol of the plantation system.

In his review of the film, for example, Mr. Reed said that Sam Jackson, in the role of the conniving, omnipresent, evil slave, is "playing himself."

If Jackson had not dominated the Hollywood system in such a sly way, then his role as Stephen, the master-worshipping house slave to Calvin Candie (Leonardo DiCaprio) would not have its loaded, edgy, uncanny realism. The plantation is called CandieLand (Candyland) and is meant to refer to Hollywood itself as a producer of entertainment (Candy). Get it?

If Jamie Foxx were not known in Hollywood as a resourceful hustler, who will play almost any role, then his part as the "bad nigger" Django would not be so compelling (and lubricous). If he were not the "New nigger on the block," then the confrontation between him and Sam Jackson's character, Stephen, the off-the-hook house slave, the scene would not be powerful (and dumb) at the same time.

The *dramatis persona* forms a homology with the enacted characters on the screen. The key that unlocks Tarantino's sensationalistic mosaic is that it reveals the inner game of how the Hollywood studio and the plantation slave institution exploited black people.

Unwittingly and unconsciously Tarantino has provided us with a scenario that makes the plantation system the symbolic equivalent of Hollywood. It is a *film a clef*. In other words, Hollywood forms a homology with the slave plantations system in both cases making money is being underlined as the goal, and it does not matter how many people are hurt or offended.

Tarantino approaches Hollywood that is the Weinstein Brothers production company as if it were a plantation, and as if he were an aspiring poor white trash overseer trying to get into the closed system by manipulating the slave code.

Instead of presenting the Weinstein Company with a script, Tarantino screened a film—*Django* (1966), a Spaghetti Western.

How hard was that? In an age where even Hollywood execs don't read, Tarantino made it easy for them. As it turns out, *Django* (1966) was itself a take-off of the Spaghetti Western, *Fistful of Dollars*, a film (and a genre) invented by the Italian director Sergio Leone.

Tarantino's task (as he probably explained to the Weinstein Company) was to map characters, incidents, and plot points from the original *Django* (1966) onto the target, his proposed plantation script, *Django Unchained* (2012).

Let us now compare the original *Django* (1966) directed by Sergio Coerbucci with Tarantino's *Django Unchained* (2012). In mapping, some things are easily transferrable and some things are not. What Tarantino took from the original films were the characters, plot, and gross details of violent acts. What he added—and what was *not* in the original—was African American nigger humor, the joke. Tarantino ransacked Black folklore for the Trickster, the slave John, and the Bad Nigger, and the Jezebel. For music, he takes some of the original Italian, but for the most part, he overlays the film with James Brown's "The Big Pay Back" and hip-hop music.

If we compare the plots with each other, as summarized in the IMDb, we can

see what Tarantino transferred over from the original source the target: "A coffin-dragging gunslinger enters a town caught between two feuding factions, the KKK and a gang of Mexican Bandits. Then enters Django, and he is caught between a struggle against both parties."

The plot of *Django Unchained* is: "With the help of his mentor, a slave-turned bounty hunter sets out to rescue his wife from a brutal Mississippi plantation owner." And: "Former dentist, Dr. King Schultz, buys the freedom of a slave, Django, and trains him with the intent to make him his deputy bounty hunter. Instead, he is led to the site of Django's wife who is in the hands of Calvin Candie a ruthless plantation owner."

In the opening scene of the original movie, a beautiful woman (Loredana Nusciak) is rescued from rape by Django (Franco Nero). This female character is mapped over by changing the name and character to Broomhilda Von Shaft (Kerry Washington).

Imitating the original scene of desperation, Tarantino opens his film with a slave coffle. First, a long shot of the slaves chained together. Then, close-up shots of the shackled ankles. Then, overlay of the moanful voices, "Aint Nobody Gonna Hold My Body Down." Next, close-ups of raw stripes of blood lashes on a black backs.

It makes for a painful, depressing sight, and it is photographed in a realistic mode. The audience is taken in, because the scene depicts the holocaust for many blacks who sat in the audiences across the country. We see the strips from the whips across the backs of the slaves.

Then, there is an incident: a light in the dark. Who goes there? The owner of the slaves calls out.

"Just a fellow traveler," returns a Dr. King Schultz (Christop Waltz), a bounty hunter. Dr. Schultz examines the slave, picks out Django (Jamie Foxx), and when the slave owner tries to prevent him from talking to Django, pulls out a gun and shoots him dead. Shooting the white slaver point blank, Dr. Schultz laughs and turns the gun over to Django, who is miraculously transformed from a lowly slave to—Presto!—into a "Bad Nigger" with a gun and a mean attitude. Now we are rolling!

As a spokesman for the director, Dr. Schultz is a white Negro. His action and trickster character lift the action out of serious mood; and suddenly, we hear the pounding music of James Brown's "The Big Payback!"

We are roaring with laughter at the punch line in an ethnic joke. Some of Django's lines include, as he shoots a poor white man, "I like the way you die!" When Dr. Schultz offers him a deal of working with him as a bounty hunter, Django exhales the punch line, with panache, "Kill white folks and get paid for it?"

We realize that all that had gone before, the shots of the black slaves, the sad music, the spiritual music and lyrics—all of that was just a set-up, a pretext. The real text, the underlying message was the punch line that Blacks in slavery were fools and cowards.

Throughout the rest of the film, this is Tarantino method: begin with a serious treatment, suck the audience in, and then, he hits you—Bang!—with a punch line that catches you off guard. The problem with the ethnic joke is that the joke is always on the black man, who has no recourse to respond.

Jamie Foxx as a slave agrees to help him if he will help him go back and get his wife (Kerry Washington) out of slavery. Tarantino centers on the exotic notion that the beautiful slave's name is Broomhilda and speaks German. *Mein Gott!*

We know that there was a KKK in the original model. That was easily mapped over to slavery, but Tarantino makes a mistake here. He choses 1858, two years before the Civil War, as the fictional time for his film. But the Ku Klux Klan wasn't until some 20 years later, in the 1880s, after the Civil War.

Just because it was in the original source, Tarantino included it in the target material. He wasn't following Black history, but rather he was following his original template.

In the original, *Django (1966)*, the hero is an "anti hero, " but Tarantino mapped him over to the target as the "bad nigger." Black culture is full of images of the "bad nigger," including Stagolee, Deadwood Dick, and Dolomite. They all are screaming, "I'm a bad motherfucker and I don't mind dying!" (And all of them signified by a large brimmed hat.)

Tarantino didn't limit himself to lifting the characters, incidents, and plot elements from the Spaghetti Western, but the grossness of imagery as well.

In the original Django material, for example, the hero cuts the bandit's ears off and forces them into his mouth. Tarantino has one of the sadistic slaver turn Django turned upside down so he can cut his testicles (symbolic equivalent of ears) off. In another scene, he has dogs eat a black man to death on screen. In yet another scene, DiCaprio's Calvin Candie is watching his Mandingo fighters kill each other; Calvin offers the winner, a hammer to beat his brains out.

There are 5 or 6 instances where I had to look away from the screen, because it was so violent and the violence was so gratuitous.

The film is soaked in pretentious drivel. For example, in one scene, Calvin Candie instructs his overseer to set a pack of dogs on a black slave and we (the black audience) watch the dogs eat the slave alive (on screen). Dr. King Schultz wonders what Alexander Dumas, the Black French writer, would have said of that scene.

This gross and ludicrous non sequitur is meant to show how hip Tarantino is to Black history. Here is notion that Tarantino really knows something about French literary history, Dumas was black! No shit?

I'm willing to bet that when Jamie Foxx read this in the script, he turned to Tarantino and asked, "Who the hell is Dumas?"

Tarantino proposed to the Weinstein Company to deliver an audience on Christmas Day that would make them a lot of money. An equivalent was the poor Irishman who approached the plantation owners with the proposal to save the plantation money by managing his slaves (through beating them and yielding a profit).

What was this audience that Tarantino promised to deliver to the Weinstein Company?

Where I saw the film, at the AMC Theater, in Emeryville California, the audience was the same one that had voted for Obama. When I waited in the long line to see the film, people's faces were glowing with expectation. The hype about Jamie Foxx and Sam Jackson and Kerry Washington was like voting for a Black man for President.

But after seeing the film, their faces were empty, their eyes were blank. Sure, they had laughed at the scatological humor, had flinched at the gruesome ugly scenes, had been insulted by the self-deprecating humor, and had been lifted up by the antics of the "bad nigger" And don't forget the ending—with the hero and his slave bride ridding off into the sunset and the glowing flames that consumes the Candyland Plantation! And all this, with this synched to beat of rebellious hip-hop music. *Burn, Hollywood, Burn!*

For many of them, Tarantino had delivered. In essence, they had their cathartic laugh, and yet they still felt dirty from the guilty pleasure. Their empty faces were drained understanding. They had been used, and they were beginning to know it. You could see that they had been bamboozled.

In one revealing scene, the slave master, Calvin Candie shows his dinner guests the skull of a Black slave, Ben. "Old Ben never revolted against the white man? Why didn't he? Because when you cut his skull open, you find that there is something in his brain that won't allow him to rebel against the white man."

What Tarantino is asking in his meta-language, why don't blacks take over Hollywood? Why do they allow the likes of him and the Weinstein Company along with Sam Jackson and Jamie Foxx to run a game on them?

I ask myself the same question. Why do Blacks, who can elect a President, not prevent themselves from being exploited by Hollywood? Why can't they demand more black directors and better scripts from the likes of the Weinstein Company?

Why do we continue to allow Sam Jackson and Jamie Foxx to clown us?

As I watched the long line of Blacks queue up for the movie, and as I listened to their guffaws in the darkened theater, I realized that nobody likes a "nigger joke" more than Black people themselves. Are Black people themselves deeply masochistic? Would a Jewish American audience tolerate a film that makes fun of their history and their holocaust? I doubt it. Would the Weinstein have made a film about the Jewish Holocaust that ridicule and belittled the Jewish experience during Hitler? I doubt it.

Much of the problem has to do with Black people themselves. You would think that Samuel Jackson would have enough clout to produce his own films. Every Hollywood black have their own "company," but they never produce any films.

Even though we have rich black men, they do not have the intellectual heft to confront Hollywood, which is supported by a culture of literacy. After four hundred years of being told that you can't write, blacks tend to stay with "acting" and sports. They do not have the respect of their own authors to use their work in films. The literary codes that Hollywood uses depend on a culture that reads books, but for Blacks, literature is not a high priority.

Blacks seem contented to be consumers of the movies and not producers of them. In the past, Blacks attended film schools and produced Spike Lee (New York University) and John Singleton (UCLA), but there are few Blacks attending film schools. This year at UCLA, one of the most important film schools in the country, admitted not one single Black student.

You can't present a project to a studio about Black Dumas if you never heard of Dumas? How can you talk to a Hollywood producer if all you know is the lyrics from Snoop Doggy Dog?

In reality, both Hollywood (Weinstein Bros) and the plantation systems are closed systems, despite the fact that slave-owners say they're taking good care of the slaves and despite the fact that Hollywood says that the success is based on talent alone.

Another important similarity between Hollywood and the Plantation is that they are both controlled by literacy. On the slave plantations, no black is allowed to leave the plantation without a pass.

In order to get a pass you have to consult the white man since no black can write one, as Blacks are not allowed to read and write. Therefore, literacy controlled the plantation and the enslavement of enslaved Africans–enslaved mainly because the technology of writing was withheld from them. The attending rhetoric was that Blacks were too stupid to learn to read and write.

I read Mick Lasalle's review of the film in the *San Francisco Chronicle*. He loved it, "entertaining" for every minute. While putting down Spike Lee's *The Red Hook Summer* as one of the worst films of 2012, he puts *Django:Unchained* at the very top of his best list (second to Lincoln). He didn't like Roberto Benigni's *Life Is Beautiful*, which is about a Jewish man who uses humor to survive a Nazi death camp.

Even if he is a fan of white male racist jokes against blacks, he should have warned African American readers that the film is racially offensive in its exploitation of black humor.

The 4th Estate, in a recent study of American newspapers, "Bleached, Lack of Diversity on the Front Page," claimed that 98 percent of all newspapers headlines are written by whites. At the *San Francisco Chronicle*, the study found that there were no Black writers at all. Given the social conditions in Journalism, LaSalle was obliged to tell black readers what was really inside the wrapper.

Whites control the newspapers, like Hollywood, and use their print to keep the public stupid and dumb. Like the black ancestors on the plantation, African Americans are held in check so that the pockets of the cultural producers (ruling class) can be filled.

Django Unchained:
Hollywood Recreates History, Again | Ruth Elizabeth Burks

The time will come . . . when the children in the public schools will be taught practically everything by moving pictures. Certainly they will never have to read history again All the work of writing, revising, collating, and reproducing will have been carefully attended by a corps of recognized experts, and you will receive a vivid and complete expression.

—D. W. Griffith

There haven't been that many slave narratives in the last 40 years of cinema, and usually when there are, they're done on television . . . and frankly oftentimes they just feel like dusty textbooks. . . . When slave narratives are done on film, they tend to be historical with a capital H, with an arms-length quality to them. I wanted to break that history-under-glass aspect, I wanted to throw a rock through that glass and shatter it for all times, and take you into it.

—Quentin Tarentino

The moment the final credits of *Django Unchained* (2012) began the predominately white audience, comprising 75 percent of the theater's total capacity, zipped up their down coats, pulled on their thinsulate gloves, and left. No one applauded or exhibited any approbation or exhilaration while lackadaisically exiting the theater. Based on his own criteria, "If the audience isn't cheering at the end, then I haven't done my job," Quentin Tarentino's pretentious postmodernist re-envisioning of slavery through the now defunct Blaxploitation and Spaghetti Western paradigms failed.

Tarentino's highest-grossing movie to date replicates a plethora of 21st century Academy-Award winning films—*Monster's Ball* (2001), *Training Day* (2001), *The Last King of Scotland* (2006), *Precious* (2009), *The Blind Side* (2009), and *The Help* (2011)— made in Hollywood and obsessed with recreating white supremacy. Like its archetype, D.W. Griffith's *The Birth of a Nation* (1915)—the first full-length feature film actually completed in Hollywood and the only film on record in which the audience actually stood up and cheered—*Django Unchained* reinvents history to play upon white fantasies and fears.

Mirroring *Mandingo* (1976), Tarentino's film opens with half-naked black male slaves slogging barefoot across a blistering desert as blood red credits, an upbeat

soundtrack, and an unidentified landscape vie for our attention. Similar to a ghost or a god, Dr. King Schultz, a German immigrant dentist turned bounty hunter who abhors slavery while recognizing its practical implications, emerges out of nowhere, "in 1858, two years before the Civil War, somewhere in Texas." Since the Civil War began in 1861, Tarentino, a Tennessee native, presents the Southern perspective that Lincoln's election triggered the War of Northern Aggression.

Assured that he's found the Speck brothers, the same slave traders who purchased their cargo in Greenville, Tennessee, Schultz begins to question the enchained men. Unlike *Mandingo*, where the most private parts of slaves' bodies are brutally and physically invaded by their examiner whose only concern revolves around getting the best price for his dollar, Schultz's gentlemanly interrogation of the five slaves who survived the trek irritates the Specks. When Ace Speck refuses to negotiate because of Schultz's attitude—a peculiar position for a slave trader to assume since it undercuts the economic basis for American slavery—Schultz shoots Ace and the other brother's horse in the face.

Soon convinced that Django can identify all three of the Brittle brothers, the quarry whom Schultz ultimately seeks, he perfunctorily purchases Django and asks one of the other five slaves to hold his gun while he unshackles his new property. Free at last, Django casts off his cloak and, momentarily, exerts revenge against his former enslaver before meekly capitulating to his new owner's demands. Appropriately clad in the deceased brother's clothes, Django compliantly mounts the dead man's horse, no thought of Broomhilda in his head, eager to accompany his new master anywhere.

More compassionate than Django, who throughout the film shows himself incapable of empathizing with any slave's plight but Broomhilda's or his own, Schultz, who flinched at the bloody ankles and keloid scars on Django's torso, considers the predicament of the four still chained together slaves. Prior to resuming his journey, Schultz elucidates their two choices. Either unshackle themselves with the key he tosses their way, lift the horse off of the living Speck, and carry him to the hospital 37 miles away, or use the gun Schultz gave them, bury the horse along with the two now deceased slave traders, and follow the North star to a more enlightened place.

While Schultz fades into the forest, confident his newly acquired property will follow, Django circles back and watches as his fellow slaves mimic his earlier casting off of the accoutrements of slavery and exercise Schultz's second choice. In Tarentino's schizophrenic trivialization of slavery on the eve of the Civil War, the third, most obvious choice, kill Schultz, then flee north never dawns on any of them.

Much too long on plot and short on story, the remaining two and a half hours of *Django Unchained* is equally disingenuous. Despite Tarentino's misdirection—his homage to Sergio Corbucci's aesthetic of revenge and violence proclaimed in the article he wrote, "Quentin Tarantino Tackles Old Dixie by Way of the Old West (by Way of Italy)," published on 9/27/12 in *The New York Times*, and the cameo appearance of Frances Nero, the original Django—the plot, the story, and the visuals of *Django Unchained* correspond uncannily to those of Sergio Leone's *For a Few Dollars More* (1967).

In Leone's classic Spaghetti Western, two incongruous bounty hunters—one,

old, sporting formal attire, the other, young, dressed bizarrely like some Argentinian gaucho espied in a photo—make a pact, recognizing that their individual success depends on joining together. One wants to secure his fortune; the other wants to revenge a wrong perpetrated on a member of his family. The drinking over the deal, the shooting of the sheriff, the unusual gun, the bounty killing of the three brothers, the enjoyment in watching people fight to the death, the protégé out-mastering the mentor, the over-complication of the task at hand, the swelling body count, the misplaced humor, the moral ambiguity of the protagonists, the long shot of a long shot of a long shot of a man on horseback reappear in Tarentino's *Django Unchained*, without Leone's aesthetic sense.

Even Tarentino's finale, ripped from *The Birth of a Nation's*, sacrifices originality for mimicry and authenticity for cliché. While both films end following a bloodbath in which the reunited lovers prance about on horseback, Griffith's white protagonists' ride into the sunset and live happily thereafter. Since the Civil War has yet to come, Tarentino's black protagonists canter toward re-enslavement or death in their anachronistic pursuit of the fabulous narrative Griffith envisioned for his white heroines and heroes.

The two films share more than just their endings however.

At its core, *The Birth of a Nation* is a revenge film bent on inciting white angst against blacks to exact payback for the South's having lost the War Between the States. Griffith justifies the emergence of the Ku Klux Klan by attributing the sins committed by the former slaveholders to the recently emancipated slaves: rape, miscegenation, irresolute dissipation, kangaroo juries, disenfranchisement, stuffing the ballot box to steal elections, congressional antics resulting in stalemate or unconstitutional law, and the overwhelming desire to crush an already emasculated race under the heel of the empowered. In depicting such atrocities and containing them within his own frame of reference—substituting whites in blackface for the most demeaning and substantial black roles—Griffith controls the discourse and defuses the retribution exacted if the racial situation had been reversed. Still considered a masterpiece by some critics, *The Birth of a Nation* gave rise to the new Ku Klux Klan as well as to the stereotypes of blacks endlessly recycled through "various guises" as Donald Bogle suggests in *Toms, Coons, Mulattoes, Mammies, and Bucks* in Hollywood films to this day.

Contemporary critics love Quentin Tarentino and his reverse racism, too. Without ever mentioning that Tarentino made their job easier by distributing copies of *Django Unchained*'s screenplay well in advance of its premiere, the most egregious of them sound eerily familiar, flaunting oxymoronic double speak, excerpted perhaps from Tarentino's promotional material.

Joel Morgenstern in *The Wall Street Journal* finds "Mr. Tarentino perched improbably but securely on the top of a production that's wildly extravagant, ferociously violent, ludicrously lurid and outrageously entertaining, yet also, remarkably, very much about the pernicious lunacy of racism and yes, slavery's singular horrors." A. O. Scott writing for *The New York Times* calls *Django Unchained*, "digressive, jokey, giddily brutal and ferociously profane. But it is also a troubling and important movie about slavery and racism." Seriously. A film marketed initially with a 400-page comic book of the entire screenplay and three action figures representing

Django, the revengeful slave; Stephen, the despicable uncle Tom; and Calvin, the Mandingo fighting owner of Candyland?

Opting for the "n-word" in their own reviews, almost all casually dismiss Tarentino's excessive use of the word "nigger"—citing its historical authenticity. Given that the word "nigger" did not become pejorative until the 20th century, such reviewers beg the question, revealing their ignorance of history and their propensity to believe everything they see in the movies.

The Academy of Motion Picture Arts and Sciences were equally enamored, honoring Tarentino's derivative kitchen sink distorting of fact and fiction with an Oscar for Best Original Screenplay and Christophe Waltz's reprisal of the Nazi character he played in *Inglourious Basterds* (2009) with Best Supporting Actor. Jamie Foxx, who claimed that Tarentino taught him how to be a slave; Kerry Washington, who felt the love story was the whole point; and Samuel L. Jackson, who believed he took the Uncle Tom and turned it on its head in a powerful way, never even made the Academy's cut.

As one commentator expressed in a TIME.com article entitled "*Django Unchained*: Tarentino Frees the Slaves,"

> the Oscar-winning Foxx is Waltz's sidekick. . . . Tarentino doesn't expend much effort in tracing Django's arc from slave to gunman to the righteous husband set on revenging the crimes against his wife. Washington has even less to work with: a pretty pawn in a stream-set dream sequence. The love story that could be at the movie's center gets the most perfunctory treatment.

Ah, but that's Hollywood.

In a less self-aggrandizing, self-censoring, self-promoting, self-referential, self-rewarding, and self-serving peculiar institution like Hollywood, a film about slavery's unspeakable horrors might center on the slaves themselves. In a less peculiar institution, Hollywood might "have courage enough to shake off its fears and taboos and to depict the Negro in films as a normal human being and an integral part of the life of America and the world," as Walter White urged its moguls to do in 1942. And, in a less peculiar institution, black actors who wish to practice their craft might demand more than the two options Hattie McDaniel claimed open to her when she protested White's intrusion and declared, "I'd rather play a maid than be a maid." There must be a third choice.

Django Unchained: A Historical Analysis | Art T. Burton

In some ways, *Django Unchained* reminded me of Mario Van Peebles' film, *Posse.*
Django takes place forty years earlier than *Posse,* which takes place during the Spanish
American War time period. *Django* takes place during the last years of slavery. Both
films have their genesis in the black exploitation films and the "spaghetti" westerns
of the 1970s. *Django* had a much bigger budget than *Posse,* and the acting was better.
In *Django,* depictions of slavery remind one of the film, *Mandingo* of the '70s. Chattel
slavery was much worse, physically and psychologically, than it was depicted in *Django.*
Much of the dialogue in *Django* is played up for laughs and comedy.

There was nothing comedic about chattel slavery in the United States or
anywhere else in the western hemisphere. To use slavery as a backdrop for a neo-
western is problematic due to the Post Traumatic Slave Retentions that still affect
black and white people in the United States. The film is a historical mess, bounty
hunters are a Hollywood invention, and basically what happened in the film did not
happen in real life. We can re-invent history for laughs and entertainment but first we
need to know the real history.

If we look at African slavery in the United States and tie it to a western frontier
example where Africans resisted slavery, as in the movie *Django Unchained,* it would
have to be the Seminole Indian War. Despite its name, the Seminole Indian War
was the largest African slave revolt in United States history. Prior to the formation
of the United States there was no Seminole tribe that existed. Many of the Indian
tribes, including the Choctaw, Creek, and Shawnee fled into Florida, where there
were already tribes such as the Miccasukee, Timuca and others. Florida was a Spanish
colony originally and they welcomed runaway African slaves. The Africans built a
free community, the first in North America, called Fort Mose' near St. Augustine,
Florida. Later runaway African slaves built a community in the Florida panhandle
called Fort Negro, which was later destroyed by the U.S. Army, led by Andrew
Jackson. Thus began the conflict known as the Seminole War. All the Indians in
Florida were called Seminole. The Spanish had a word, "Cimarrone," which was
used for the English word, "Maroon." Maroon was a term given to fugitive African
slaves. "Cimarrone" was corrupted by the Africans, Indians and English to the term,
"Seminole." Therefore, the Africans from inception were a key component of the
Seminole nation in Florida.

The United States fought the Seminoles, Africans and Indian, throughout the early nineteenth century up until 1847. The entire major strategists, interpreters, warriors for the Seminole nation were African or African/Indians. Osceola, the great Seminole warrior, was found to be of African heritage in the late twentieth century. The major interpreter for the Seminoles with the U.S. government was the African, "Abraham." The greatest African leader of the Seminoles was Gopher John, John Coballo, or as he was most often called, "John Horse." All the Seminole Indians and Africans were sent west to the Indian Territory (Oklahoma) after they signed a treaty with the U.S. government. The Indians said the Africans were their slaves to protect them from being taken away and being placed in bondage.

Around 1850, in the Indian Territory, John Horse and a Seminole Indian leader, named Wild Cat, took a group of Africans and Indians to Mexico. They formed Seminole communities in Mexico and assisted the Mexican government in fighting hostile Indians in that country. The Mexicans called the Africans and Indians, "Mascogos." Most likely this was done because they spoke the Muscogee Indian language. After the Civil War, the U.S. government heard what a great job the African/Indian Seminoles had done in Mexico and sent an emissary to Mexico to try to get some to come to the U.S. to fight hostile Indians in west Texas. The Seminole Indians refused but a group of African Seminoles agreed to come back to the U.S. They were stationed at Fort Clark in Texas and served from 1870 to 1913. Three of the men won the Medal of Honor for valor in the Indian Wars. The official designation for the unit was the Seminole Negro Indian Scouts. John Horse stayed in Mexico and never returned to the U.S.

There was a larger group of African Seminoles that stayed in the Indian Territory in the Seminole Nation. Some of these men fought with the First Regiment of the Indian Native Home Guard in the Indian Territory during the Civil War. After the war there were many heroic African Seminoles who became members of the Seminole Nation police which was known as the Seminole Lighthorse Police. Men that distinguished themselves during this period known as the "Wild West" era were Thomas Bruner, John Dennis, Tom Payne, Cumsey Bruner, Caesar Payne, and Dennis Cyrus. Both, Caesar Payne and Dennis Cyrus also served as deputy U.S. marshals. Cyrus served as a Seminole Lighthorse policeman for twenty-five years. The real truth can be more exciting and informative than the fictional stories. Today the Seminole Nation recognizes two African American bands within their tribe, the "Dosar Barkar" and "Caesar Bruner" groups.

In the Indian Territory in the late nineteenth century, it was known that the most dangerous criminals were the Seminole Africans and Indians. At the same time, the most feared Indian policemen in the Indian Territory were the Seminole Lighthorse police. They were known to shoot first and ask questions later. There were never more than thirteen Seminole policemen at any one time, unless the Principal Chief asked for special policemen. The most famous deputy U.S. marshal who traveled into the Seminole Nation to catch felons was the famous black lawman Bass Reeves. This intrepid lawman was a former fugitive slave, who beginning in 1875, worked for thirty-two years as a deputy U.S. marshal in the Indian Territory. Reeves became a legend in his own time; arresting thousands of desperados, and is quite possibly the greatest frontier hero in United States history.

Tarantino Enchained | Stanley Crouch

Leading from behind, sliding downhill, abusing all the talent previously shown in directing, in writing, in coaxing the best from actors—this is a serious charge. Yet that is what Quentin Tarantino has done in *Django Unchained.* The recent Oscar is simply further proof of Hollywood's cult of superficial cool. With *Django,* Tarantino has slipped down behind himself into a shallow and bloodstained hip-hop turn that his own best work has well refuted. Often refuted. Tarantino wrote and directed the finest Blaxploitation film ever made, 1997's *Jackie Brown.* This film was an inventive and even courageous victory. Choosing not to sucker-punch the black audience through bad taste, or even to exploit it, the director/writer created something revolutionary: a well-made black action movie set in the criminal world.

We must understand what Blaxploitation was to fully comprehend Tarantino's earlier success before the recent and resounding failure. Blaxploitation was a short-lived, highly superficial but commercially successful genre of the middle 1970s. The trend was well documented in Isaac Julien's sobering and somewhat depressing documentary, *BaadAsssss Cinema.* As Julien's documentary shows, the genre was actually something like a mayfly assigned to save Hollywood with large profits. Junk in trunk, Blaxploitation introduced to the Dream Machine the salient fact of a black audience, and how easily it could be appealed to, with almost no effort at all. Just put chocolate on top, white down below—kicked, stomped, or shot down, if necessary. Writers, directors, and actors seemed to fall out of the trees. It became lucratively evident that every group has a taste for a Sylvester Stallone—wham, bam, thank you, ma'am. Once the sinking ship was safely afloat, things got back to segregated business as usual.

No genius need apply in order to explain that Blaxploitation began the backward road to pro-pimp, pro-street gangster chants, unmercifully exposed with due diligence in Byron Hurt's almost astounding *Hip Hop: Beyond Beats and Rhymes.* Both documentaries are essential to a viewer who wants to understand how far removed from so-called rebellion *Django Unchained* actually is. Though true art never moves forward or backward, trends do.

In *Jackie Brown,* Tarantino ignored the single-minded and simplistic rules of Blaxploitation and he made a very important decision. He switched Elmore Leonard's middle-aged but still attractive blonde, Jackie Burke, into the embodiment of pop

black femininity, Pam Grier, the buxom queen of bargain-basement black movies. Then Tarantino went about sending his film in the direction of *The Asphalt Jungle* and *The Killing*, introducing the force of quality and a very rarely expressed subtlety of character development into the crime tale, especially the black cartoon version. This was very different from the way that Blaxploitation began and maintained itself. Tarantino's dip into that popularized heart of darkness, however, was not a nostalgic reading of a flimsy trend that appealed to the black American version of sustained adolescence. Down the tubes went the stale garishness, nudity, violence, and the absurd plots in which these knock-off films focused on sleazy, pretentious cartoon rage, presenting themselves as a version of "militant" politics. There was little blood in the young filmmaker's Blaxploitation script, but lots of well-drawn personalities.

Until *Django Unchained*, none of Tarantino's narratives showed predictable black versions of hollow men and women, characters that always responded to life with guns, explosives, martial arts, and bloody special effects. The most enduring and easily misused American feeling is the sense that power must always be literally fought in order to make room for authentic vitality. Of course in the adolescent world of male childishness, there was always a rumble in the cinematic jungle; it showed its giant face in James Bond beating down a number of black criminals, and in the indie world, Nicholas Cage begins *Wild at Heart* by becoming so enraged that he beats the brains out of a black hit man with a switchblade, staining the stone floor of a movie theater's lobby. Revenge is the teenage mindset. In Blaxploitation, this was given an ethnic spin, usually explosive. Black people——male and female——not only fought the white man, but were victorious every time.

Tarantino turned in another direction and built a cinematic world focused on a human agenda of rich complexity. He was much like Robert Altman, Sam Peckinpah, and Martin Scorsese in that regard, yet he brought a personal originality with blistering, comic, and resoundingly inventive character studies. In *Jackie Brown*, his character faces up to contemporary urban problems far better than loudmouth black professional protestors like the New Black Panthers, who profit from complaint and draw their styles from impotent saber rattlers.

Ethnic insights do not always weather storms, however, particularly if one, black or not, is too committed to common cloudbursts: they can slowly evolve into an aesthetic version of sleeping sickness. Tarantino surprises us again because his *Django Unchained* is one of the worst versions of Blaxploitation ever seen. It yields to convention in the most impotent ways. From controversy to commercial success, the troubles began with its star, Jamie Foxx, a third-rate actor whose shortcomings seem infinite. What was written for him was an insipid tale that Foxx, predictably cocksure, inhabits woodenly, missing the strike zone of an actual performance. The star, representative of pop culture at its most obvious, uses only about a half-dozen facial expressions, none mysterious or suggesting unmentioned depths. Foxx is given such a contrived and impossible task that he is forced to be a superhero to do even a bit of it. Obsessed by his wife whom he intends to rescue from slavery, Django does what he must do because they have such a touching and impassioned cup of thick home-brewed affection, though the two barely speak to each other on-screen, only dream or stare longingly, equal in dialogue to a pair of black sheep in a pasture.

Slavery, the film implies, was a sharp blade. It cut all the fat from romance and the lean meat left has only a deliciousness exclusive to Django and his Broomhilda, neither sharing the taste of it with the audience. And that is how it goes, their love running silent and never close to deep. Overlong scenes never bring off a masterpiece of formal creativity equal to the long basement scene of *Inglourious Basterds*, which, by the way, already stands with any compelling extended scene, tightened up with surprise, pace, humor, menace, and suspense. There Tarantino took up Altman's anger at short scenes and swift cuts inspired by television commercials, where so many new directors get their start. Tarantino did not talk about it but he proved the durable aesthetic value of a cinematic section almost twenty minutes long. Things are very different in *Django*.

Foxx's performance reveals him to be an amateur next to the masterful Samuel L. Jackson, who brought off a nuanced performance as the hired killer in *Pulp Fiction*, or the illegal gun dealer in *Jackie Brown*, an arms hustler who uses Black Nationalist rhetoric on his intended victims, talking of the white man trying to set "black against black." Jackson delivers some of Tarantino's most truly insightful writing. Though Jackson gives an exceptional performance as a house slave in *Django*, a man who is quite intelligent and given to jokingly running everything on the plantation, brutal or not, his character is never matched or counterpointed. The film has no comparably complicated black character, good or bad (or somewhere in between, like most people). It appears that more than one Negro character on a large plantation with plenty of slaves is too much for a thin postcard covered with dirty notes.

Tarantino's career began with films that used ethnic diversity in a natural way, and he also made stinging fun of racism. In *Pulp Fiction*, he went to town with the idea that lynching could have hypnotic and confused homoerotic underpinnings, which could explain why these gory rituals so often built up to a peak of savage intensity when castrating the black man, as if exorcising a sexual demon by removing the testicles. Tarantino had taken the shock of violent racism to a new place in cinema. Examples of his thinking across ethnic lines arrive in casual allusions to Apaches in the basement's parlor game played by the Nazis, which thematically connects to the nickname of Brad Pitt's character, Aldo the Apache. The terrorist American officer intends to brutally horrify troops and Gestapo officers, alluding, through scalping, to the cutting off of Nazi ears in Sam Fuller's *The Big Red One*. Only Tarantino would have the terrifying American officer played by Pitt bring up the Negro as a folk hero by asking whether the next exciting thing done by the German officer who has captured Pitt will be "Eliza on the ice," a reference to the once well-known character in the stage version of Uncle Tom's Cabin—perhaps the source of the clichéd sacrificial dark buddy of the melodramatic white hero who appears in far too many Hollywood action films.

The characters are conceived and performed with such charm, sophistication, humor, and personal mystery that they are much more frightening than the Halloween monsters of domestic war movies. Tarantino's Nazis force us to see how enjoyable it is to be part of the chosen Aryan few. They carry themselves as if blessed by the invincibility of cosmic mercy—unlike those who are desperate, resourcefully undignified vermin; those who must be removed to better the world and keep the

floors clean to a point of slippery glossiness. These elements allow the film, for all of the willed combinations that move outside of reality or history, to do something marvelous: ascend to a place right next to historically close encounters, such as Conspiracy and Downfall. This was due to its human insight.

Tarantino's gifts as a writer were revealed early in his penetrating sense of the human labyrinth that transcends good and evil and confuses too many Americans. He confounded the audience's preference for cartoon obviousness so inventively that it led to an international career of great commercial success. (Spike Lee has convinced himself this is about race instead of superior writing ability.) Then there is the younger director's syncopated sense of narrative form in which the unexpected rhythm of purposefully disordered sequences appears, goes beyond befuddlement, and helps create worshipful international cults worldwide. That gift for the unexpected is only blunted if the filmmaker sees both the subject and its intended audience far, far too simply, deluding himself into believing that he understands it all much too quickly.

Tarantino does not address the shades of gray in the context of his largely parallel Southern characters in *Django,* those who benefit from slavery and make the most of the power it delivers. He claims to have itched to make a film set during slavery, needing substantial time and research and to do a great deal of reading on the subject. It came to no avail, not with any of the luminous ideas and images we think we should expect from him. In this film, we are given no sense of the tethered superiority felt by the so-called white trash required to do the most dangerous work. There was a simple reason: injury and mutilation of slaves cost the masters much more than any terrible accident had by poor whites; the lower rung of a superior species was always available and inexpensive.

Sexual pleasure for the white men is alluded to but never seen; nor do we find slave women who knew how to parley two heads on a pillow until they arrived at some kind of privilege. In Tarantino's oddly simplified and inaccurate world, women are there more as set decoration or props, not living characters. All of the complicated life in the context of slavery has been well documented through personal testimony and astute observation, so ignorance is no excuse. There is too much artistic work from Faulkner, Ellison, and recent writers, not to mention the clearinghouse on the subject of slavery that academics have brought to American campuses of higher education, a pyramid reaching from a large base of mediocre data to a slim peak full of stoic and indispensable information.

Tarantino seems not to be meeting the most famous clichés with a strong sense of touchingly complex and confounding humanity that may have been pushed down but was hardly destroyed. Ralph Ellison and I once agreed that a grand irony of American culture is how something meant to deceive and hide another action can do its assignment but also turn against the obvious in the process. The context blooms with alternate energy, sometimes becoming a moving, even captivating, aesthetic force that cannot be shot down.

Some of the finest spirituals entertained and distracted the slave owners while runaways prepared to steal away from the plantation. John Ford varied this fundamental motif from American culture when the singing Indian woman in *Stagecoach* distracts and deceives the endangered passengers while their horses

are stolen. What could be heard during slavery is the lyrical grandeur the black community spreads though "Deep River," the great spiritual sung in *The Sun Shines Bright*. The recently freed slaves and their Negro preacher bring an unexcelled purity commonly found in the most gifted of the poor, the educated and uneducated, and the unrelenting buffoons known to all ethnic groups. Ford's continuing dismissal of social prejudice comes forward in this tale about a Southern town being held back from self-righteous homicidal anarchy. An older judge stands up to the mob; he is neither infected by the invisible blood poison of bigotry nor willing to sacrifice a young, innocent black man to yowling townspeople demanding a gurgling death and ready to tear down the jail to see it, though one of them is later discovered as the culprit, the actual rapist and killer of a girl.

Given his pride for being a so-called nerd who learned film by working in a video store and by reading so much criticism, Tarantino's claim of hating Ford for both riding as a Klansman in *The Birth of a Nation* and killing off dehumanized Indians "like zombies" in his westerns, sounds like a self-righteous and fraudulent billboard of advertised condescension. It reminds me of William Knowland, who in 1964 ran with Barry Goldwater, attempting to score a debate point as he reminded Hubert Humphrey that Lyndon Johnson had been a voter for segregation in 1948. Humphrey smacked him down with a lightning response: "That's what I like about Lyndon Johnson: he learns."

The self-made bad boy seems not to have made much of Ford's eventual rejection of his own aesthetic shortcomings and his decision to avoid reducing any group (white, red, or black) to a simplistic reading. He absorbed the lesson of William Faulkner, who in 1942 threw down the gauntlet in American fiction with *Go Down, Moses*, introducing an unmatched and layered complexity to race relations that has yet to be excelled. All normalized national shortcomings were howled at in Ford's 1948 *Fort Apache*, which lifts the worm-filled can of internal bigotry until it is seen in Henry Fonda's character, the Eastern man transferred to the Southwest, Lt. Colonel Owen Thursday. A supreme embodiment of alienated leadership, melancholy, class prejudice, bravery, defensive belittling, outrage at governmental corruption—but an even greater outrage at an underestimated Indian chief having the nerve to defy him, the military representative of the United States Government, which he will not tolerate. Thursday leads his men to their doom. Cementing the fate of his command, he dismisses all seasoned admonitions and flesh-and-blood advice, demurring that no "breech clouted savage" had learned the tragic art of battle "under Alexander the Great, or Bonaparte, at the least." Fonda's character is a fictionalized Custer, going down foolishly and being celebrated for his arrogance and glory hunting by every school boy for dying with his boots on.

In *Sergeant Rutledge*, bigoted assumptions compel the father of a murdered and raped girl to fire on a Negro before asking any questions. He is there, as is her naked body, so he must be guilty. The highly respected black cavalryman is pursued, brought to justice, and prosecuted by a man quite willing to rely on the sort of stereotypes that would have guaranteed victory in the terms of *The Birth of a Nation*. Things are so logically turned around by the facts, however, that Rutledge is acquitted at the film's end. The guilty man confesses on the witness stand and it has become

apparent that a stereotypic conclusion can be fatal, a tragedy.

One of Ford's intentions was to tear the bark off many different kinds of bigotry, while arguing for the importance of diverse agreement, as he did through modern situations in *The Last Hurrah*, where he lampooned Nixon's Checkers speech and warns the audience through the speaker's success about the dangerous combination of the soppy love of pets and the tendency to be impressed by a gadget made attractive through electronic media. This astute level of understanding remains in vehicles up to and including his last western, in 1964, *Cheyenne Autumn*.

Those who don't look and pay too much attention to the tomfoolery of a young braggart might miss Tarantino's debt to the past master. Since Ford also shows a horse dancing at the end of *The Sun Shines Bright*, you might assume that *Django*'s conclusion is part of a muddled allusion to the work of his predecessor—if not an attempt to get away clean with a theft of no consequence. In *Django*, Tarantino attempts to top himself by using the tale of Siegfried and Brunhilde, flipping over Ford's meaning to say what would work perfectly for a contrived hip-hop hero. The townspeople of *The Sun Shines Bright* finish the 1953 film carrying a banner reading, "He saved us from ourselves." Django saves the whites and the faithful slaves from themselves. The rebel angel, downy white feathers replaced by black coiffed naps, marches down the ice-cream-cold popsicle stick, destroys the Valhalla of the big house, and mass-murders "all ye faithful" with good old Dy-no-mite Jimmy Walker would approve.

For a creator who has produced such complex female characters, perhaps the worst sin of *Django* is not its replacing drama with endless bloodletting, and romance with sensation, but the abuse of Kerry Washington's talent. The filmmaker becomes an insider and expert on black culture in a very stilted way, nearly competing with Spike Lee for the barbershop crown so perfectly parodied by Eddie Murphy in *Coming to America*. Blackface sensibility makes almost any white man into a minstrel among the sables, imitating the kind of Negro many black women have been disgusted by because he will sell out to sexism rather than defend his African queens in the only way a real man would. Perhaps naively expecting the compromised bad boy to participate with outstanding originality in what could be seen in Kasi Lemmons's *Eve's Bayou*, or Denzell Washington's *The Great Debaters*, we got what we did not at all expect.

The Dream Machine's indifference to female talent remains, with or without an ethnic twist. *Eve's Bayou* introduced Jurnee Smollett in one of the most remarkable beginnings since Elizabeth Taylor in 1944's *National Velvet*. She has since grown up to languish on the same heap with Angela Bassett and all of the black actresses who are victims of talent-blindness (this is a snow storm that always manages to freeze the careers of gifted performers, past and present, like Kim Stanley or Laura Dern). From the stunning *Nothing but a Man* to right now, enough well-written parts for black, brown, beige, and bone-colored women have been produced every so often for one to be startled by the shallowness of all the women in *Django*, black or white, but definitely the thinly conceived, inarticulate darkie girls.

Our most successful "postmodern" filmmaker was not up to the real revolution possible for black Americans. Some see the real deal and come on with it: total

humanity, equal to all. The real change all over the world is the female demand for equality, not the submission to corn pone ideology, greasy junk food drowned in ketchup, as if fake blood will make it better for the duped customer. Humanity straight, no chaser, will always do the job. As with fans of the most corroding hip-hop, Tarantino has been taken in. He does not write strong silent types, male and female, and in the case of the prized slave woman, only a weak and silent type. There is another way to look at the problem and to do something revolutionary.

Tarantino is trapped by ideology. Just attempting to fashion a programmatic purpose can bring down the best of us. Low-hanging fruit poisons the person too anxious to pick and polish it. Talking about what he intended in *Django,* Tarantino sounds as doomed as LeRoi Jones did at the bottom of his "hate whitey" period, or as Spike Lee when he was referring to himself as "a black nationalist with a camera." He makes himself into one of the white child extras in Bing Crosby's *The Birth of the Blues,* rising from behind cotton bales and astonishing darkies overcome by his hot clarinet improvising. A perfect update would be the NAACP's Image Awards; or Trick Daddy's video, "I'm A Thug," with white kids who are thrilled to be there and to watch this hip-hop slumgullion with gold teeth and braids eat take-out fried chicken at an expensive hotel restaurant in Los Angeles, scandalizing the white folks at every turn. Of course, these are not far-out ideas at all. While telling Howard Stern about the new film and his successful career, Tarantino pulled the covers off. Last December, the filmmaker described going to a party with Jamie Foxx and getting into a polluted one-night stand with an aggressive, unattractive woman because, of course, he wanted Foxx and his friends to see him as a cool guy who could get down with an unknown woman immediately. Down is what he got. Quentin Tarantino can run around with or hang out among whomever he wants. A writer gets material or inspiration from everywhere, but it is shocking to hear a major voice in Hollywood say something this delusional: "I've always wanted to explore slavery, but I guess the reason that actually made me put pen to paper was to give black American males a western hero——give them a cool folkloric hero that could actually be empowering and pay back blood for blood."

The depth of the long, soulful game played by Martin Luther King and his cohorts succeeded, all the while rejected by a lucrative version of Blaxploitation in the saber-rattling desert of giant faces, but simple minds do not know it. Minstrelsy came back, as James Brown said, talking loud but saying nothing. In short, Mr. Tarantino, you see there is nothing about skin tones and its pleasures or troubles to be learned from The Big Black Human Being in the middle of the room, not from Foxx and his friends. You already proved yourself with *Jackie Brown.* There it is.

Tarantino's Plantation | Justin Desmangles

"Of the three arms of psychological warfare—radio, news and movies—the latter, from my point of view, has by far the greatest potentialities as it combines the impact of sight and sound. . . . [Film] is an industry that stands ready to produce the most potent instrument of war possessed by any nation in the world."
—Nelson A. Rockefeller to John Hay Whitney, May 1, 1942

"There are those people who, having enjoyed the profits and privileges of racialism for most of a lifetime, now that racialism is under fire and in retreat, profess a lofty scorn for it and are terribly pained when you so much as refer to it in any shape or form. Their means have changed, not their ends, which are the same as they always were, to exploit racialism for their own comfort and convenience. They are a dying race and they will not be missed. They are a source of discomfort to their children and embarrassment to their grandchildren."
—C.L.R. James, *Beyond A Boundary*, 1963

White fantasies of black flesh have fueled American commerce now for centuries. The phantoms are still very much with us, forming the axis around which not only business but politics and art revolve. The very weights and measures once used to buy and sell slaves are now employed to calculate the value of culture. The humiliation of blacks has always been a key element in American popular entertainment, dating from before the declaration of the Indepedence. Lynchings were often a family affair, attended by children as well as elders, with the rites often carrying on into the wee hours. Souvenirs of body parts &c. Historically, artists have proved a far more venal group in America than even politicians. None find their profession as close to that of prostitution as that of actors and actresses. In fact, it can be said, and has been quite often, that Hollywood is one big whorehouse. If this is true, then the role of director is not unlike that of procurer. He or she pimps the product, with all the wiles of a Madison Avenue magician, tricking the customer as to its value.

Quentin Tarantino has always been very sensitive to the sadism of his audiences, the masochism, too (Hence the constant and drearily inevitable use of the word nigger). As a prodigious scholar of film history, he is well aware of the beguiling tricks and ploys, both technically and socially, that can be used to produce effects

often unknown to the casual viewer, yet desired by that viewer nonetheless. It's hard to imagine that a film like *Django Unchained* would have been made if Barack Obama was not president of the United States, but the psychological disruptions in the nation's self image, brought on by the image of a black man as president, created such a need among Hollywood's most coveted audience. That audience being, of course, those who wish to experience their own passions, resentments and desires, vicariously through the medium of Stanislavskian show-biz, and willing to pay almost any price to do so, over and over again.

Today's Hollywood films do not get made unless they can be sold, and quickly. The first questions any studio executive asks are, How do we sell this? What is the marketing plan? Where is our audience? This fact is largely the reasoning behind the glut of remakes, sequels, serials, and comicbooks-as-movies (see Pauline Kael's classic essay, The Numbers.) In this case Tarantino had the juice, he was bankable, and his film had the added plus of not being entirely original, but rather a protracted series of quotes glossing well known genres (the hallmark of all Tarantino's work, by the way). In fact, it could be argued that *Django Unchained* is the least original of all his films, as well as being the least cinematic, as it borrowed largely from techniques common to the made-for-t.v.-movie. It is well known by now that Tarantino's "research" included hours of watching *Roots*. Some of the more vacuous clichés employed, by a director who should know better, are the slow motion reverse shots used to underline a tired joke throughout the movie. A "nigger on a horse" we are reminded again and again, is such an uncommon sight in the South, that it is cause for all to stare up at one, dumbfounded, mouth hanging dumbly open. Slow motion is also used time and again to frame close-ups of slave faces, whose speech is always inchoate, in an effort to linger on their emotions of wonder and disbelief. This kind of primitive fetishism extends itself to even odder moments throughout the film, such as when Django asks his new master, the bounty hunter, to tell him a story of German mythology. (This tale telling underpins the cookie-cutter, one dimensional, so called love story that is roux to this gumbo). Tarantino directs his actor to essentially simulate glee-eyed childishness, enraptured by the tale. Only slightly worse is the sequence where Django is allowed to choose his clothes for the first time (?) in life. Not surprisingly, an outfit resembling that of a cartoon pimp is chosen. Something one might have expected to see in an early Snoop Dogg music video. More corny slow-motion reverse shots ensue. He is supposed to be a valet.

Growing up in America, one hears often of freedom but very little about slavery. This habitual utterance of the word freedom is all but compulsory. Freedom this, freedom that, it's a free country, free speech, land of the free, &c. &c. But of course all this freedom business is based on slavery, not only as an economic structure, but as a theological proposition and cultural subterfuge. Slavery. The subject itself is not considered in any way shape or form polite conversation. Many are made visibly uncomfortable just by its suggestion. Witness the freakish sideshows created by Republicans testing it out on the front burners of 2012. The election, and more recent re-election, of the nation's first black president has pushed this usually violently suppressed issue to the fore, but for the most part in ways that are ill informed and misshapen, such as the concepts of post-race and post-black, or

worse, virulent and diseased by racism, such as the ideological merchandise of Lee Daniel's Precious, and most recently *Django Unchained.*

Defenders of *Django Unchained* have stood upon some rather flimsy if not all together ignorant ground. One point often hoisted upon us in favor of the film is that Django himself is a hero who avenges slavery itself by killing whites. This absurd and feebleminded assertion is easily dismissed by even the most superficial reading of the film itself. First of all, Django never at any point in the film makes common cause with any slave whatsoever. He usually shows nothing but ambivalence, if not outright contempt, toward them. In fact, his new identity as actor-of-violence-against-whites is formed in the crucible of his new master, the bounty hunter, who buys his freedom for himself, his use. A more accurate reading of the film might suggest that this scenario, indeed the entire film, is actually the dream of the bounty hunter, dead or dying of the wounds inflicted at the end of the story. That is to say more accurately, a dream in the mind of Tarantino, and his all too accurate cultural reading of the white imagination's need of a fantasy black male avenger. However, historically, with a number of important exceptions, acts of violent revenge against the oppressive forces of white supremacy have more often than not been carried out by dark skinned people against ourselves (see Frantz Fanon, *The Wretched of the Earth,* the early novels of Chester Himes, also Richard Wright). To remove the onus of historical accuracy off itself, the white imagination, at work in art, has very often conjured a black male aggressor, usually sexualized, as a means of forgetting the past and not taking responsibility for the future. Tarantino's work has always been deeply rooted in this tradition, a tradition which dates back centuries, from the very beginning. This is the same tradition that has left many of our young people in prisons, out of college, police who perpetuate violence with impunity, disproportionate sentencing in court, and a popular culture that celebrates criminality.

To celebrate *Django Unchained* as an authentic example of black heroism is deeply problematic, to say the least. I would suggest, again, that the character has no real grounding in Afro-American culture, but rather the white historical imagination's projections of it. Moreover, what kind of message are we sending ourselves and each other to laud such cultural product? We are reminded again and again throughout the film that Django is the exceptional one, one-in-a-million, a talented ten percenter, if you like, who is simply not like the others. Well, are we, the films black audience not in fact the defacto others that Tarantino is talking about through the mouths of his actors? Of course, the answer is yes. It plays out as a good nigger, bad nigger, house nigger, field nigger, type of cultural currency exchange in which our value is determined, yet again, formed and deformed, by the standards of commerce. A slave trade.

So what about the other slaves in the film? Abject and mute, for the most part servile. In fact, time and again, Tarantino directs his slave actors to simply watch the hero, mouth agape, eyes bugged out, docile and slow if moving at all, much like they, too, are simply watching the film go by. As the script tells it, even in moments when they are ostensibly free, they continue to sit or stoop in their cages.

At the ceremonies of a mutual admiration society for the self-congratulatory, better known as The Oscars, Tarantino was rewarded for his efforts with a Best

Original Screenplay statuette. Small wonder, considering the bulk of this vacuous cliché addled nonsense was drawn almost entirely from cinema history. Hollywood loves nothing better than an index of its own self worth in which to genuflect. Tarantino, it is well known, or should be by now, is a prodigous scholar of the history of filmmaking, and his best work often resembles the techniques employed by artists who work in collage, cobbling together an original picture from sources both canonical and occasionally obscure. In the case of *Django Unchained* however, the sources from which Taratino would cut and paste were already anemic, dead, or dying. The Western, as a genre, has always been an important part of the national un-remembering of our bloody past. I say un-remembering, because it is in fact the product of a sinister level of conscious engagement, entirely unlike actual forgetting, in which the past is merely lost, like books left in a fire. In terms of disabusing the Indian, The Western, as an institution, has served the purpose of un-remembering paramount to that of Thanksgiving, or even President's Day. Now, with *Django Unchained*, the form is being revived and ressusitated, put to use as a means to un-remember slavery. Despite its extended roster of historical inaccuracies, the film is being used to teach not cinema, but African-American Studies curriculum at Harvard University. This, too, represents a form of structural violence being used against the whole of black people in America, to sanction and condone such plainly inaccurate depictions of our past as legitimate and worthy of serious study (see Houston Baker, *Betrayal: How Black Intellectuals Have Abandoned the Ideals of the Civil Rights Era*).

A Love Story?

The deep spiritual affinity and love that has come to represent the best in our traditions, that has sustained the weight of our burdens and helped us move forward as a people, ever forward to the goals of determining our own destiny, are entirely absent from this film. I would say to those who have maintained that there is a love story at the center of this film, to get real, examine just where that love story is from, and be a bit more truthful about whether Hollywood has ever been interested in depicting love between black folk with any gentleness and care.

Never A Dull Movie: *Django* Explained | Jack Foley

It is not bad. Let them play.
Let the guns bark and the bombing-plane
Speak his prodigious blasphemies...
Never weep, let them play,
Old violence is not too old to beget new values.

　　　　　　　—Robinson Jeffers, "The Bloody Sire"

"When people ask me if I went to film school I tell them, 'No. I went to films.'"

　　　　　　　—Quentin Tarantino

I saw Quentin Tarantino's *Django Unchained* at about the same time that I saw *Bernie* (2011), a delightful "black comedy" directed by Richard Linklater and starring Jack Black, Shirley MacLaine, and Matthew McConaughey. In *Bernie*, a very sweet, loved-by-everyone, slightly effeminate man (Black) takes up with an older, rich woman (MacLaine). She is attracted to him initially but eventually settles into her usual pattern, which is to be nasty, possessive, authoritarian; she is noted for being that way with everyone, including her close relatives. Finally, almost without meaning to, Bernie murders her, shooting her four times in the back. He is eventually found out—D.A. Matthew McConaughey is hot on his trail—but convicting him is a problem. The entire town hated her and loved him, especially since he used the money he got from her to support the church, the school, to help people in need, etc. Bernie is an immensely active, loved, and appreciated citizen of this small Texas town; he is the great town benefactor. How can the town for which he has done so much convict him of murder? The film is done as a kind of documentary and based on a true story; we see the actual Bernie at the end of the film. The question the film raises is: How does one react to a murder? The murdered woman, people feel, "deserved to die": she was awful to Bernie, awful to everyone. But who exactly makes that call? Who can determine which people "deserve to die"? The film balances us among various feelings.

Such delicacy is nowhere present in *Django Unchained*. Django (Jamie Foxx) murders all sorts of people and every one of them "deserves to die": there are no

innocent victims; the people murdered are all very bad characters. (That is the point made by Django's friend and liberator, Dr. Schultz—Christoph Waltz—when *he* kills people; these are murderers, horrible people who "deserve to die.") No ambivalence for either him (he murders plantation owner Leonardo DiCaprio more or less in cold blood) or for *Django Unchained*'s director/screenwriter, Quentin Tarantino.

Quentin Tarantino has said that he made *Django Unchained* in order to give black people (black males, surely) some sort of Western hero to look up to. He is modeling the central character on various movie cowboys—including the Djangos from the various Django films made in the 1960s and later. At the end of *Django Unchained*, Tarantino has the hero's horse do a little trick dance—just the sort of thing that Roy Rogers used to do with his horse, Trigger. The name of Tarantino's hero (which means "I awake" in Romany) is a reference to various "spaghetti westerns." In the first of these—*Django*, 1966, directed by Sergio Corbucci and starring Franco Nero—the hero's fingers are broken, but he finds a way to shoot his gun anyway: hence the name, Django. The great Romany guitarist Django Reinhardt's fingers were injured in a terrible fire but, like the hero of *Django*, he found a way to play his guitar—*his* "instrument"—anyway.

But the main point is that all those Djangos are white. This Django—courtesy of a white director—is black. I'm reminded of a pattern that used to occur in ethnic communities. There was, everyone knew, a "real" Fred Astaire. But in the Jewish community, for example, there was also a Fred Astaire *figure*: not the real thing exactly but "The Yiddish Fred Astaire." Something like that seems to be occurring here: this film doesn't give us the "real" Django (who is white) but "The African-American Django." Don't black people already have heroes—heroes not generated from spaghetti westerns but from actual black communities? Malcolm X, for example, or even Shaft. Cf. Chester Himes' novels. Is Django more of a "hero" than Coffin Ed Johnson and Gravedigger Jones? Aren't films sometimes made about them?

We are encouraged to find it disgusting when the Samuel L. Jackson character—an obsequious, menacing Uncle Tom: Jackson is brilliant—practically erupts in tears at the death of his master. But we should note that it is only through the agency of a white man that the one-in-ten-thousand Django achieves his freedom and that one of his few moments of tenderness is towards the now dead body of his German benefactor. Dr. Schultz has managed to free not only Django but Django's wife: Django tenderly touches Schultz's head and blows him a kiss of gratitude. Did Tarantino expect the black community to feel the same way towards him because of his film?

Apart from the relationship between blacks and whites, the great issue of this film—of any Tarantino film—is violence. "Yeah, well, it's a movie," Tarantino has stated. "It's a fantasy. It's a fantasy—it's not real life. It's a fantasy. You go and you watch. You know, you watch a kung-fu movie and one guy takes on 100 people in a restaurant. That's fun!" And again: "I'm a big fan of action and violence in cinema... That's why Thomas Edison created the motion picture camera—because violence is so good. It affects audiences in a big way. You know you're watching a movie." Arnold Schwarzenegger, who also has a new, violent movie, *The Last Stand*, recently made a similar statement, insisting that Hollywood violence is essentially fantasy—

"entertainment"—and has little connection to the violence that occurred in, say, Newton, Connecticut: "It is such a horrific tragedy, but we have to separate out what is in the movies—which is pure entertainment—and what is out there in reality...It is a very complex issue."

The "complexity" of the issue of violence (and the notion of movies as "pure entertainment") is clarified by a brilliant article by Rebecca Solnit, "Hate Crimes in America (and Elsewhere)." Solnit's article discusses an incident in which a woman refuses a stranger's advances and is then attacked with a knife:

> The man...framed the situation as one in which his chosen victim had no rights and liberties, while he had the right to control and punish her. This should remind us that violence is first of all authoritarian. It begins with this premise: I have the right to control you.

> Murder is the extreme version of that authoritarianism, where the murderer asserts he has the right to decide whether you live or die, the ultimate means of controlling someone. This may be true even if you are "obedient," because the desire to control comes out of a rage that obedience can't assuage. Whatever fears, whatever sense of vulnerability may underlie such behavior, it also comes out of entitlement, the entitlement to inflict suffering and even death on other people. It breeds misery in the perpetrator and the victims.

Violence, Solnit insists, is a control issue, an issue of authoritarianism, of entitlement—and, contrary to the assertion of Robinson Jeffers' poem, it never begets "new values" but repeats itself endlessly. It arises because a person is not doing what you want that person to be doing. In a now notorious interview with Krishnan Guru-Murthy, Tarantino responded to the interviewer's question about violence in his films by becoming, as the media put it, "rattled"—though "furious" might be a better word. Refusing to respond to Krishnan Guru-Murthy's question, he told the interviewer, who is, incidentally, a person of color, "I'm not your slave and you're not my master...I'm shutting your butt down." Aren't issues from Tarantino's film—his piece of "pure entertainment," his "fantasy"—finding their way into "real life" here? Guru-Murthy was doing something Tarantino didn't want him to do—something Tarantino didn't like. How did Tarantino respond to that? Did he quietly explain to Guru-Murthy how tired he was of hearing questions about violence—and that if anyone wished to know his answer, it could be found all over the internet? He did say something like that—but he also went much further. He insisted on belittling Guru-Murthy and his news show: "This," said Tarantino disparagingly, "is a *commercial* for my movie." And, in a totally "authoritarian" move, he says he is "shutting [Guru-Murthy's] butt down." Didn't Tarantino *expect* that Guru-Murthy would ask him about violence? Couldn't he have warned him in advance that he wouldn't discuss that question?

How does Django respond to someone who is doing something *he* doesn't like? He shoots him—which gets rid of that person. Doesn't such behavior teach us that the proper way to respond to something we don't like is not to try to change it or to "educate" it: the proper way to respond is to *annihilate* it. Tarantino doesn't threaten to shoot Guru-Murthy, but "shutting his butt down"—shutting him up, making him *stop*—accomplishes something of the same thing. The issue here is control and entitlement in exactly the sense that Rebecca Solnit describes it. Tarantino is asserting himself here as the master, not as the slave: he is treating Guru-Murthy as his subordinate. Of course, Tarantino doesn't go anything like as far as his hero does—as Solnit herself suggests, there are important questions of degree—but the point is that, in Tarantino's response to a television interviewer just as in his movie, *violence, which is here entirely verbal violence, is the attempt to take control of a situation which the perpetrator fears is getting out of his control. Violence is the attempt to assert his will over another's.*

Tarantino has remarked, "Violent films don't turn children into violent people. They may turn them into violent film-makers, but that's another matter altogether." In this statement, does the adjective "violent" modify "film"—"violent film"—or does it modify "film-makers"—"violent film-makers"? Tarantino clearly intends the former meaning—he means people who make violent films—but the latter meaning remains a syntactical possibility. There are definitely "control-freak" film directors—violent film-makers, film-makers who channel their violence, their desire for control, into the film itself. Alfred Hitchcock is among them, as is Douglas Sirk, Rock Hudson's director: "Rock Hudson," Sirk remarked, "that beautiful body of his was like putty in my hands." Control—and authoritarianism—can be, and sometimes is, one of the pleasures of being a film director.

But beyond this, there is something of the master-slave relationship in the very situation of watching a film. We respond to a film we love by saying that it was *captivating, enthralling.* A thrall is a slave. Like Martin Scorsese, Quentin Tarantino is a film-fan film director, and in a way, *Django Unchained* is about nothing more than Tarantino's lifelong love affair with film itself. It is a film that is constantly telling us how wonderful and magical film is. And it is often successful in creating wonder and magic. But the wonder and magic come at a certain price.

As we sit in the audience, we willingly give up some of our freedom: we allow the film to dominate us, to fill us with its reality rather than our own. In this sense, *Django Unchained* is very often brilliant film-making—film-making of a very high, often beautiful order. (Think Leni Riefenstahl.) Tarantino can make masterful images that stay lodged in the mind. There are sudden, breathtaking shifts, stunning close-ups, magical cuts to quicken the pulses of any cinephile. Somewhere, at the heart of this film, is the sense of a child gazing with wonder at the marvelous images that dance before him on the lighted screen. That Oedipal patterns should manifest as well is no surprise. Tarantino's film throws us—and him—back into childhood and its issues. Django is taking authority away from the people who have had it— male figures, "fathers"—and claiming it for himself, establishing himself as the new authority, the new "father," with a beautiful, totally admiring if slightly vacuous wife-mother-bride at his side. (Like Django, "Broomhilda"—Kerry Washington; the character is named for the broom-wielding comic-strip witch as well as for Wagner's

Brünnhilde—is riding a horse and toting a rifle when we last see her.)

But at the heart of the film, too, is an adult who has never learned any way other than childish petulance to deal with problems whose solution requires considerably more than that. "Violence," remarked Oliver Stone after the release of *Natural Born Killers*, "I'm against violence. *But did you expect me to make a dull movie?*" That's exactly the sort of thing Quentin Tarantino seems to think as well. Tarantino deliberately wishes to mask the deep connections between what we see on the screen and the intimate, problematical behavior in which we sometimes engage. He won't admit that films—one of the greatest educational instruments ever invented—are anything other than "entertainment." In fact, however, films "screen history," as Gore Vidal once remarked, and their version of the past is always in danger of *becoming* the past. Films not only entertain us: they create us, too. "I went to films."

Django Unchained and The Black Man Sitting Behind Me at the Movie Theatre | Joyce A. Joyce

The diverse and wide-ranging responses to Quentin Tarantino's *Django Unchained* and the reactions to the movie by the man, sitting behind me and my husband at the movie theater, bring to mind a folk comment, collected in Langston Hughes and Arna Bontemps's *Book of Negro Folklore*. In the section subtitled "The 'Problem,'" the following "wise" advice has the title "Respect for Law":

> In a little southern town, a mob was fixing to lynch a man when a very dignified old judge appeared.
> "Don't," he pleaded, "put a blot on this fair community by hasty action. The thing to do," he insisted, "is to give the man a fair trial and then lynch him." (504)

In the few pages to follow, I would like to give Tarantino and the Black man, sitting behind me—guffawing *every* time a character used the word *Nigger*—a fair trial, though their trials emerge from different circumstances that converge. Because a number of intellectuals, writers, and teachers who are my friends and/or mentors; because a number of quite notable well-known filmmakers; and because a sizable number of those I encounter daily who have seen the movie and who have *not* seen the movie find the movie quite problematic historically, intellectually, or creatively, I have purposely not consulted any reviews of the movie, blogs about the movie, or interviews from those field of folk who are not in the movie (after having my assistant collect this information on a zip drive still in my briefcase). I limit my discussion here to my own reactions, having listened to what Tarantino and his cast have to say about their intentions and why they accepted their roles. Perhaps, as much controversy exists in response to *Django Unchained* as it did to Richard Wright's *Native Son*, which frightened too many Black readers and angered an even larger number of Whites.

Two Geico commercials now constantly bring my mind back to *Django Unchained*. One of these commercials has a Black man sitting on a couch without air conditioning, using a fan to cool his quite sweating body and to keep his huge lobster chilled. The other features Dikembe Mutombo, Congolese-American, most known as one of the most successful basketball shot blockers, running around in a store, such as K-Mart or Walmart, knocking packages out of shoppers' hands, saying,

"Not in my house." These are merely two of a number of Geico commercials whose aim is to convince viewers/consumers that they would be much happier than they are if they had Geico insurance. Though both these commercials are ludicrous, the difference between them is that we recognize the first as impossible or improbable and the second as quite realistic. Mutombo is actually a real-life, retired basketball player, running around on a commercial television set, belittling his talents, and he is a Black male.

Since I do not live in a post-racial world, I do not want to see Mutombo behaving as if he is in a minstrel show. I want him to be a hero, like Django. Most movie-goers are quite familiar with Quentin Tarantino's stylistic signatures and long list of movies. With *Django Unchained*, Tarantino says that he wanted to present a spaghetti western, set in the most horrific period of America's past (YouTube Press Conference, December 23, 2012). In response to what some see as excessive violence (one of his signatures), he says that two brands of violence emerge in his movie, one in which he had to address the true brutality of antebellum Mississippi and the cathartic violence from which he wanted the audience to need Django to have his retribution (YouTube Press Conference, December 18, 2012). It is provocative that he says he cut back on some of the violence because he realized he was sticking a twenty-first-century audience into antebellum Mississippi.

A primary characteristic of a spaghetti western is that of the anti-hero. Thus it is fitting that the audience has mixed feelings about Django, the anti-hero. In the spaghetti western, the anti-hero, for the most part, challenges mainstream society and, therefore, remains outside of it. Obviously, Django has no choice except to operate outside of mainstream society, made up inclusively of slaveholders. The desire to find his wife, Broomhilda, fuels his heroic actions. In an interview, published on YouTube on December 23, 2012, Jamie Foxx says that *Django* is not a film about powerlessness; the hero is an agent of his own power. He indicated in a previous YouTube interview (December 19, 2012) that producer Reginald Hudlin said that he wanted to see a Black Spartacus take up arms and save his woman. In Hudlin's idea, the love story, violence, and the hero converge.

Django indeed embodies the violence that characterizes the anti-hero and the western genre as well. We see Django's potential to fight back in the first scene in which he appears when he speaks up to acknowledge himself to Dr. King Schultz and when he puts his foot into the wound of the man trapped under the horse. Once he learns how to shoot, his quest to find his love is emboldened. Not only is Django's violence typical of spaghetti westerns, it is also a signature of every Tarantino production I have seen, and I have seen many. Violent scenes abound: the whippings, the pivotal scene with the dogs' tearing the Mandingo fighter to pieces, the bloody shoot-out, which Schultz precipitates when he shoots Calvin Candie, and the blood that covers the walls in the final scene in which Candie's sister, Lara Lee Candie-Fitzwilly, flies backwards after Django shoots her. These scenes complement Candie's evil act and explanation when he cuts off the back, lower part of the skull of Ben, the slave who took care of his daddy and of him. Explaining that the three temples in the piece of skull he cut off represents creativity for Newton and Galileo and servility for the Black slave "unburdened by genius," Candie also suggests that it

is this unburdened servility that prevents slaves from killing Whites.

Like Nat Turner and Gabriel Prosser, Django emerges as the most rebellious of slaves. Blassingame informs us "Every effort was made to keep the slaves in awe of the power of whiteness, and ignorant of their own potential power (233). One of the delights of the movie is the use of music that illuminates the glory of the anti-hero, a common feature of the spaghetti western. Most memorable is Richie Havens's singing "Freedom" (which he sang at Woodstock) as Django takes off his jacket when he surrenders after the shoot-out when Schultz is killed. I smile along with the slave who initially hated Django when he thought Django was truly a slave owner, but subtly smiles when Django emerges from the smoke of dynamite, collects the remaining dynamite, grabs a rifle, and rides his horse back to Candieland.

Like the smiling slave left in the wagon, I was happy to see Candieland explode and to see Django join his wife, smiling on her horse. A glance at Norse and German mythologies reveals that Schultz greatly simplifies his story of Siegfried and Brnhilda as much as Tarantino altered the spelling of Brnhilda's name. The story Schultz tells more specifically parallels Django's journey to rescue his wife, Broomhilda. While none of the women, including Broomhilda, have sustained camera shots in the movie, we do get a glimpse of the role of women in the antebellum South. We see field slaves, such as Batina (who is a bit too much like Prissy in *Gone with the Wind*) prostitutes, such as Candie's Black mistress, the Black house mistress whose buttock Stephen slaps (suggesting that he has had sex with her), and, of course, Candie's sister, Lara. Clearly, she and her brother are far too affectionate with close body kisses on the jaw, suggestive eye contact during these scenes, and Candie's placing his hands on her bare shoulders. After Candie's death, we learn that Lara is as vicious as her brother. Despite the common exposure of the Black female body during slavery, Broomhilda does indeed emerge as a strong figure, determined to escape slavery and her dress (when Candie demands that she be taken out of the hot box, bathed, and dressed) is appropriate to her demeanor. Lara Candie's dress, on the other hand, suggests a woman with no flare, who would have a difficult time appealing to men, and her make-up makes her less attractive than her slave servants. I have this stereotypical notion that Black women do not faint, yet I realistically understand that Broomhilda thought she was totally alone—as she tells Shultz—and that her husband was very possibly dead, given his fighting spirit. I still think the *Broom* in her name invites ire.

I applaud Tarantino for being politically conscious in critiquing what he rightly refers to as "America's horrific past" in his press conference with all the major cast members. And though he is correct when he says that the use of the word *Nigger* is true to the characters and time period and though I agree that he should not as he says "clean up" the language, we still have the man sitting behind me, who if he is guffawing in a public theater every time he hears the word *Nigger*, chances are quite good that he has not read about Nat Turner and Gabriel Prosser; he is not an anti-hero or a hero; he might not have a problem with Dikembe Mutombo's running around in a store blocking food shots for Geico commercials. For me, the man sitting behind me becomes a metaphor for Stephen. His laughter suggests that *Nigger* is a word he uses and that he is quite uncomfortable with the word. He has

not read Claude Brown's essay "The Language of Soul," published in 1968, where Brown proposes, "Perhaps the most soulful word in the world is "Nigger" (232). Brown also critiques *Nigger* in a way that gets us closer to my problem with the man in the theater. Brown writes, "Despite its very definite fundamental meaning (the Negro man), and disregarding the deprecatory connotation of the term, "nigger" has a multiplicity of nuances when used by soul people. . . (232). The problem here then is that the man behind me is not using the word himself; he is responding to its use by White characters and slaves in the film, and his laughter enhanced when Stephen—described by Samuel Jackson, who played the role—as one of the most despicable characters in movie history (YouTube Press Conference, December 23, 2012). So laughter in response to this movie depends on one's perspective.

Humor, nevertheless, surfaces glaringly as a dominant characteristic of the movie. Though I have heard comments condemning the scene with slave holder Bennett (Don Johnson) and the ludicrous problems with the KKK hoods that blocked his comrades' vision, I find the scene as delightfully funny as Stonecipther's personality and that of the other poor Whites who are ignorant, bestial, and who live in squalor on Candie's filthy rich plantation. In most cases in the film, humor emerges as a critique of the frivolity and depth of the evil that characterizes the antebellum South. Like Mutombo's running around the store, slavery is still too reflected in American psyches and cultures for some of us to appreciate the movie's truly amusing scenes.

I also fear that the man behind me does not know that the Mandingo fighters, portrayed in the movie, are a Hollywood fabrication of African-American history. If he consults classic texts, such as John Blassingame's *The Slave Community: Plantation Life in the Antebellum South*, John Hope Franklin's *From Slavery to Freedom: A History of Negro Americans*, Eugene Genovese's *Roll Jordan Roll: The World the Slaves Made*, Kenneth Stampp's *The Peculiar Institution: Slavery in the Ante-Bellum South*, he, as I did, will find no references to Mandingo fighters. He will find much information, detailing the pride, resourcefulness, and beauty of the Mandinka, who were the source of a novel titled *Mandingo*, published in 1957 and written by Kyle Onstott, a dog breeder and judge, who studied the Mandinko and who wrote the book to make money. The 1975 film *Mandingo* is based on this book. Tarantino cleaned up (excluded) the offensive sex exploits at the core of the novel and the 1975 film, which I have indeed seen. Just as he gives himself roles in his films, it is intriguing that he places a huge white statue of two Mandingo men fighting directly behind Candie's seat in his dining room, suggesting the depth of evil that describes Candie's attitude toward his possessions/ property. I do not have enough space here to address Candie's obsession with power and the significance of the interchange between him and Shultz—two White men— when Candie attempts to force Shultz to shake his hand. This exchange resulted in both their deaths.

Therefore, if Tarantino is going to hobble, walk, or stand with those multicultural intellectuals who still choose (and it is a choice) to remain always mindful of how the legacy of slavery has shaped contemporary cultures, he has to consider that some of his viewers do not read books about slavery; they learn exclusively through television and movies, and his works bestow him with, perhaps, an unwanted responsibility. I

respect the comments he made in the interview with Jamaal Finkley when he said that he believes in what he is doing wholeheartedly (YouTube, "Quentin Tarantino on Violence). But believing in what he is doing does not mean that he should ignore that slavery and contemporary racism has (not have) left us all quite raw, wounded, vulnerable, and emotional. Like Stephen in the movie, the man, sitting behind me, piqued my patience, made me angry; his institutionalization made me sad, provoking my thoughts to turn around and scream, "Wake up," as Fishburn does at the end of *School Daze.* I did not.

Unlike the judge in the folk comment, collected in Hughes and Bontemps's *Book of Negro Folklore*, I would lynch neither Tarantino nor the man in the seat behind me; they both in different ways force me to explore how much I need to re-align my own spine, to echo Toni Cade Bambara in *The Salt Eaters.*

Works Cited

Blassingame, John W. *The Slave Community: Plantation Life in the Antebellum South.* New York: Oxford UP, 1949. Print.

Bontemps, Arna, and Langston, Hughes, eds. *Book of Negro Folklore.* New York: Dodd, Mead & Company, 1958. Print.

Brown, Claude. "The Language of Soul." *Mother Wit and the Laughing Barrel: Readings in Interpretation of Afro-American Folklore.* Ed. Alan Dundes. Oxford: U of Mississippi P, 1973. 232-37. Print.

"*Django Unchained* Press Conference." *YouTube.* YouTube, 18 Dec. 2012. Web. 28 Feb. 2013.

"*Django Unchained* Press Conference." *YouTube.* YouTube, 23 Dec. 2012. Web. 28 Feb. 2013.

Onstott, Kyle. http://www.goodreads.com/author/show/119365.Kyle_Onstott.

"Quentin Tarantino on Violence, the 'N" Word, and *Django Unchained* /Tinsel Talk." *YouTube.* YouTube, 18 Dec. 2012. Web. 28 Feb. 2013.

Last Tango with Django (or as They Say in the Hood: Django May be Unchained—But Your Ass Ain't) | Tony Medina

Did you exchange?
A walk on part in a war
For a lead role in a cage?
—Pink Floyd

Quentin Tarantino is a ploy to get us to appreciate Tyler Perry more. This generation's William Styron, his contribution to Black culture: getting a whole lot of Black people to come out of the woodwork to jump Spike Lee, who had the temerity—the sheer balsamic vinegar—to say, when asked his opinion of Tarantino's *Django Unchained*, he wouldn't pay to see it because "American slavery was not a Sergio Leone spaghetti western. It was a holocaust. My ancestors are slaves. Stolen from Africa. I will honor them." Lee, who knows Tarantino's work intimately—so much so, many of the Black actors he introduced to Hollywood through his films have been steadily pilfered by Tarantino for his string of racially-insulting, plastic arts agitprop—was right.

Watching *Django Unchained* is like going to the zoo to see the gorillas and having them throw shit at you. How Black folks are treated and depicted in this flick (I use this term because this is what one does with boogers) is horrifying and sickening. It's an egregious orgiastic trigger-happy reverse Affirmative Action revenge flick where the word nigger is used as many times as bullets. (Tarantino's N-word obsession would make even Abe Lincoln flip his lid! He used the epithet so often he practically gargled with it.) Nothing new for Tarantino who thinks Spike Lee is stealing his material and who believes his N-word usage is not a down-by-law white boy free pass, but a birthright because his mother was among the 50,000 women bonked by Wilt Chamberlain back in the '70s, a decade he's staked out in his psyche, along with all the Blaxploitation pimp peddling in neo-liberal revenge porn. A typical Tarantino screenplay:

NiggerNiggerNiggerNiggerShootNiggerNiggerNiggerShootNiggerNiggerShootNiggerShootNiggerShootShootShootNiggerShootNiggerNiggerNiggerShootShootNiggerShootNiggerNiggerShootShootShootNiggerNiggerNiggerShootNiggerNiggerNiggerNiggerShootNiggerNiggerNiggerShootNiggerNiggerShootNiggerShootNiggerShootShootShootNiggerShootNiggerNiggerNiggerShootShootNiggerShootNiggerNiggerShootShootShoot-

NiggerNiggerNiggerShootNiggerNiggerNiggerNiggerShootNiggerNiggerNiggerShootNiggerNiggerShootNiggerShootNiggerShootShootShootNiggerShootNiggerNiggerNiggerShootShootNiggerShootNiggerNiggerShootShootShootNiggerNiggerNiggerShootNiggerNiggerNiggerNiggerShootNiggerNiggerNiggerShootNiggerNiggerShootNiggerShootNiggerShootShootShootNiggerShootNiggerNiggerNiggerShootShootNiggerShootNiggerNiggerShootShootShootNiggerNiggerNiggerShootNiggerNiggerNiggerNiggerShootNiggerNiggerNiggerShootNiggerNiggerShootNiggerShootNiggerShootShootShootNiggerShootNiggerNiggerNiggerShootShootNiggerShootNiggerNiggerShootShootShootNiggerNiggerNiggerShootNiggerNiggerNiggerNiggerShootNiggerNiggerNiggerShootNiggerNiggerShootNiggerShootNiggerShootShootShootNiggerShootNiggerNiggerNiggerShootShootNiggerShootNiggerNiggerShootShootShootNiggerNiggerNiggerShootNiggerNiggerNiggerNiggerShootNiggerNiggerNiggerShootNiggerNiggerShootNiggerShootNiggerShootShootShootNiggerShootNiggerNiggerNiggerShootShootNiggerShootNiggerNiggerShootShootShootNiggerNiggerNiggerShootNiggerShootNiggerNiggerShootShootShootNigger.

Basically, *Django Unchained* in a nutshell. With the exception of slaves roaming around a bucolic plantation as if at the Brooklyn Botanical Garden or the sprawling lawn of Hugh Hefner's Playboy Mansion, just a-lazin' and a-grazin' in the noonday sun, interrupted by the occasional back lashing or shove into a hot box.

In *Django Unchained,* Tarantino's so lazy his Black characters might as well be hand puppets on a wall. He has Kerry Washington play an enslaved house Negro who was taught to speak German by her mistress, yet she's reduced to lawn furniture with an occasional pained facial expression when whipped by her deranged, incestuous slave master. You have scene after scene of stand-around slaves: they stand around while their captors are killed; others stare blankly as another is being devoured by dogs; house slaves innocuously serve the white cronies of their slave master whose trade is fireside human cockfights in his parlor using Mandingo slaves; and again the same slaves captured by Django in the flick's opening remain cleaved to a mute immobility as Django kills his (and their) slave catchers. *Django Unchained* does for Black folks what D.W. Griffith's *Birth of a Nation* did for white folks. It distorts reality and perverts history while simultaneously giving a false sense of superiority—and ironically, inferiority—while subsequently turning slavery into an incoherent cartoon that ignores its most important aspect: Black folks and their humanity. But, hey, "that's Tarantino," many Black folks (and whites folks) alike have said. That's what should be expected from one of his flicks. And besides, the Black man gets to kill a lot of white people.

The most mainstream American critics have said that *Django Unchained* was incoherent, messy, indulgent and in bad need of editing, yet Tarantino's current apotheosis continues to be cemented by mainstream media and Hollywood as his slave solecism was still nominated for a Golden Globe and Oscar in the Best Picture category. Rarely did anyone point out the sheer dehumanization of Black life and the annihilation of the Black body. One broke-down Mandingo champion fighting slave who refuses to battle another in a death match for the perverse pleasure of the effete, affected slave master (played convincingly by Leonardo DiCaprio) is ripped apart by a pack of wild, trained dogs. Of course, there's no cut-away from the gory scene. In fact, you get the sense that Tarantino was giggling and jacking off from behind the

camera while shooting this scene.

When the depiction of slavery and Black misery is in the hands of Tarantino, the privileged white outsider who assumes Black passage, it becomes a more complex profanation, much like the problem of critics viewing Samuel Jackson's hating house Negro character as a racist. His loathsomeness is a problem of class. His self-hating is a problem of enslavement and a byproduct of the racism embedded in the system of capitalism. It's clear that Tarantino negates Black humanity while pimping the illusion that he is radicalizing American film and, by extension, American history, as he believes he had in his Holocaust revenge flick, *Inglorious Basterds*.

But Spike Lee peeped his game. He had previously criticized Tarantino's mono-maniacal milieu. He knew what *Django* was about and what genre Tarantino was employing in exploiting slavery. His work is not subversive, as many would have you think. It is, in fact, the antithesis, and does more damage than it purports to negate in its depiction of Blackness/the Black experience via a slave revenge trope.

What is disturbing is the uncritical acceptance of such Hollywood dreck without any analytical eye or outcry, save for a few dissenters. Black folks have reacted emo-tionally out of a need for some psychic sense of revenge for the atrocities of slavery and Jim Crow and so on, living vicariously through Tarantino's *Django*; while others see the flick merely as a violent action-western stab at satire that happens to be set in the antebellum South. Yet the titular Django (who some believe comes across as an equal and sometimes better than those who enslave and torment him and his captive wife Broomhilda he wants to liberate from slavery and sexual brutality) really exists at the behest of his German bounty hunter liberator (Schultz, played by Christoph Waltz) and his misguided nigger-trigger-happy auteur.

When the film *Beloved* came out, Oprah, who could sell dog shit to a dog, couldn't get white folks—her core audience—to see the film. It seemed that white folks didn't want to see a film about slavery. At the time, Samuel L. Jackson sniped that no one went to see it because the movie "sucked." Jackson's remark was insulting and puz-zling, because how did he (or anyone) know if the film "sucked"—according to Jack-son—if they had not gone to see it? What's interesting beside the fact that Oprah had one of her first epic fails unable to get her core audience to the box office, even though she promoted it notoriously on her show, was that many white Americans flat-out refused to see a film based on a literary novel depicting aspects of American slavery (starring their darling Oprah), yet they would go out in droves to see a graphic novel cartoonish version of slavery that is pure fantasy and, as Spike Lee warned, dressed as a spaghetti western Clint Eastwood-Charles Bronson-Rambo revenge wet dream meets Kunta Kinte as Shaft. The film, of course, plays on one's emotions in a literal black-and-white good-vs-evil simplistic trope. And who, pray tell, happens to be a main supporting actor in it, playing the vilest of Negroes? None other than Samuel L. Jackson, film critic and thespian who has worked with Tarantino so much, and was so convincing as the over-the-top, cunning, masked Uncle Tom, his next role for QT might as well be *Uncle Ben Uncooked*. No need comparing the film quality of *Beloved* and *Django Unchained*, both directed by white men, though one is more literate and less demoralizing. But it's peculiar that one film can get people (black and white alike) to run to the theaters and the other would "repel ghosts," to borrow from a

title of a Jean-Michel Basquiat painting.

Beloved's lack of box office success had nothing to do with marketing, for Oprah pushed it like crack on her show repeatedly. Usually, that makes someone rich. But in this instance it didn't. *Beloved's* lack of box office success has more to do with people not wanting to confront America's vile history of slavery unless in an incoherent, self-indulgent schlock version as Taratino's (with his incessant nigger-trigger), where Hollywood rewards his pimping Black folks to assuage warped notions of white superiority. Tarantino's take on slavery, ironically, is chicken soup for the white supremacist soul (and ego). To reduce any criticism of the flick as hateration (a la Lee, who's been thrown under the bus by Black folks and replaced by Tarantino as an honorary Black filmmaker and revolutionist, according to Christoph Waltz in his Oscar acceptance speech) undermines the very legacy that Lee was safeguarding in his boycott of the flick. But apparently in Hollywood (and among American movie-goers) gore trumps guilt.

Tarantino, who has made arrogant assumptions regarding the so-called historical inaccuracies of the film *Roots,* has absurdly positioned himself as an authority on the authenticity of films on slavery. His Django brand of subtle and blatant racism disguised as redemptive entertainment has entered into academic curricula, sanctioned by gatekeepers such as Henry Louis Gates and talk show personality Touré. This has been widely accepted by many in the Black community and some in the so-called Black intelligentsia. His execrable, dreadful Django brand has been turned into slave action figures, and entered the American lexicon as a verb, adjective and a means of signifying to white folks how Black folks really feel deep down inside behind the mask Paul Laurence Dunbar immortalized.

Who goes to a Tarantino film for any sort of revelation or redemption? Even when pointing out *Django Unchained's* simple-minded pimposity and sophomoric schlock and shock-shit, Tarantino's apologists believe he is a well-meaning neo-liberal, yet they ignore his rehashing of stale stereotypes that exploit and humiliate Black people, Black pain, Black culture, and Black misery with his gratuitous racial tititlating gory orgy of violence and dehumanizing sensibility. For many of the Black characters in *Django Unchained* are chained to Hollywood's enslavement and perceptions of Black lives denied their own narratives. They are merely props to push Tarantino's continuous racial wet dream satyriasis disguised as entertainment disguised as benevolent redemption. Perhaps Tarantino should fucks with his own culture and stop fetishizing Black misery with his own white pathology. He can get up with Steven Spielberg and bring out Lincoln Unrestrained—with the N-word slung around at such rapidity critics would mistake Lincoln for having Tourette's or a strange form of bronchial anger.

His Oscar and Golden Globe for original screenplay for *Django Unchained; The Onion* calling Quvenzhané Wallis the C-word; and the Black actors (suffering from what Michelle Wallace refers to as "invisibility blues") of a film that was supposed to be about so-called Black heroism during the antebellum slave period in American history—ignored and snubbed as in the movie posters— all amounts to a nightmare of an endless movie called *Afterbirth of a Nation.* The *Django Unchained* slave action figures stand a greater chance of getting an award than the Black actors who suppos-

edly starred in the flick.

It is brutal reminder that capitalism, which has its stock and trade in chattel slavery and the system of white supremacy, continues to not only be a nightmarish mofo—but as the success and popularity of *Django Unchained* attests—remains a den of cultural and psychological gentrification and iniquity.

Hollywood is notorious for its Pavlovian teasing of Black people wanting to see themselves reflected on the silver screen. What is disturbing about *Django Unchained* is not the helplessness of the enslaved or its fantastic historical flights of fancy and insult to one's intelligence, but Black people's lack of humanity in the hands of a boorish and clumsy puppet master like Tarantino. Black people are reduced to mere hand puppets on a wall. They exist in Tarantino's trademark formula: Poke fun at white folks while degrading Black folks. The Klan depicted as the Keystone Kops and a Black bounty hunter who shoots up a lot of white slavers does not equate to being riddled by the N-word over a hundred times in two-and-a-half hours; or so-called Mandingo slaves forced to beat each other to death in the parlor of the perverse slave master while house slaves serve mint juleps and grin and nod. We've seen this shtick in many of Tarantino's films. The gratuitous use of the N-word in *Reservoir Dogs;* in *Pulp Fiction* where Jimmy Dimmick, played by Tarantino himself, refers to his garage as "dead nigger storage"; in *Jackie Brown* where the N-bomb is dropped 38 times; the depiction of Black folks as goons and buffoons; and the vile undermining of Black manhood (Ving Rhames anally raped in *Pulp Fiction*—a throwback to William Styron's fictional portrayal of Black abolitionist Nat Turner as a homosexual?) But he seems to get a pass from the mass. It's as if a desperate thirstiness has rendered folks speechless.

You starve a people long enough then feed them shit, they'll eat it up like it's a steak. Then throw a steak in front of them and they'll say, "What the fuck is this shit?"

We need to discern between steak and shit—and when the shit hits the fan. And, as they say in the hood, *Django* is the shit!

The Big Payback:
Black Love, Vengeance, and *Django Unchained* | Jill Nelson

Until the release of *Django Unchained* on Christmas day, 2012, Hollywood's depiction of American slavery was dominated by 1939's *Gone With the Wind* Margaret Mitchell's fictional, nostalgic rendering of the demise of the antebellum South. Mitchell's portrayal of the Civil War, Confederacy, slave owners and slaves dominates American popular cultural conceptions of the period. Her portrait of docile, dependent darkies like Mammy, Miss Prissy, and Uncle Peter have entered popular consciousness as legitimate representations of enslaved identities and realities.

Nearly 75 years after the premiere of *Gone With the Wind* Hollywood presents writer-director Quentin Tarantino's *Django Unchained,* the story of Dr. King Schultz, (Christopher Waltz) a German bounty hunter who purchases and frees former slave Django Freeman, (Jamie Foxx) trains him as a bounty hunter, and then helps him to find and free his German speaking wife, Broomhilda von Schaft (Kerry Washington). *Django Unchained* incorporates multiple film genres: the western and the spaghetti western; the films of the 1970's known as blaxploitation characterized by violent black resistance to oppressive authority; graphic novels; and a comic book sensibility and relationship to violence that are Tarantino signatures.

Django Unchained is based upon two themes, the love story of a black man determined to reunite with his black wife and a collective revenge fantasy—largely absent in Hollywood and not sympathetically rendered—that instead of forgiveness and another round of long suffering, former slaves take liberty and give Massa' death.

Sankofa, filmmaker Haile Gerima's brilliant 1993 film, stands as the definitive film about American slavery. The film makes real the stench of abused black bodies, their terror and rage, the heat and thousand cuts of the fields. To watch this film is to viscerally experience the violence and degradation of bondage and mourn the loss of family and homeland. *Sankofa* horrifies and simultaneously humanizes, challenges and insists that we survive and resist in the face of the unspeakable. It is the story of not only what was lost, but what was saved. About the preservation and recreation of language, community, ritual and love within and in spite of a system committed to and dependent upon slave's dehumanization. Un-manicured and uncompromising, it is simultaneously a horror and a love story rife with complex, developed characters and stunning visuals. The price black filmmaker Gerima paid to make *Sankofa?* Ten years to raise the under $1million budget and the film was shot in six weeks. To

retain control, Gerima hired Kay Shaw Communications to create an independent distribution and promotion strategy. That the film succeeded outside Hollywood's framework is due to their innovation.

Nearly twenty years later, Tarantino's *Django Unchained* offers Hollywood's contemporary take on slavery. While Tarantino is not Gerima, he is light years away from being Margaret Mitchell or David O. Selznick, as is his film, in which a rebellious freed slave's love for his rebellious, still enslaved black wife is the central story line. Jamie Foxx as Django is a black super hero exacting payback from legions of very, very bad white people, all in pursuit of his brown-eyed, brown skinned girl. Hard to resist, especially in a cultural moment when the only black woman with her own show on television—again, Kerry Washington in ABC's Scandal—is relegated to being the sex toy of the weak white president, and the most powerful black woman in Hollywood is Tyler Perry in drag. It's folly to expect validation or the whole truth from Hollywood, and rare to be entertained and not insulted. *Django's* brew of black love, revenge, and skewering of Hollywood's conventional renderings of slaves and slave masters, all wrapped up in a western shoot 'em up, was irresistible. And funny. Django's spelling his name for a white man and adding, "The D's silent"; the scene where a group of wannabe night riders complain and bicker about their inability to see through their ill-fitting hoods; the obsequious, shrewd and in control HNIC slave Stephen, played by Samuel L. Jackson, summoning his master Monsieur Candie (Leonardo DiCaprio) to his own study so he can tell him like it is as he relaxes in Massa's clothes and leather chair, fire crackling and brandy snifter in hand. Humor unmasks the stupidity and buffoonery beneath the bigotry of white hoods and privilege. When was the last time you exited a feature film about black people feeling good? Not righteous, long suffering and stoic, but that James Brown kinda' good, as in, "Sometimes I feel so nice, good God/I jump back, I wanna kiss myself."

As for efforts to create an issue around the frequent use of the word nigger/niggah/nigga, getouttahere. It's not as if slaves were called Negro, Black, African American, or Sir, and attempts to restrict the use of nigger/niggah/nigga to niggers/niggahs/niggas are futile. I'm more bothered by the word's contemporary prevalence as a term of endearment/verbal filler for the inarticulate in 2013 than hearing it in a movie set in the late 1850's. The anti *Django Unchained* chorus is reminiscent of the response to Alice Walker's 1982 novel "The Color Purple" and the 1985 film directed by Steven Spielberg. More than a few forums were held at which (mostly) Black men proudly announced they hadn't read the book/seen the movie but could state unequivocally that both demonized them. Thirty years later, a few days before *Django Unchained* opened, director Spike Lee announced on VIBETV, "I can't speak on it 'cause I'm not gonna see it. All I'm going to say is that it's disrespectful to my ancestors. That's just me...I'm not speaking on behalf of anybody else." Lee later tweeted, "American Slavery Was Not A Sergio Leone Spaghetti Western. It Was A Holocaust. My Ancestors Are Slaves. Stolen From Africa. I Will Honor Them."

Lee's comments, picked up by countless media outlets, served to alert a huge potential audience to the movie's pending release. His remarks were disturbing and censorious, particularly from an artist whose best work is unorthodox, provocative and incendiary—think of *Bamboozled, She's Gotta Have It, Do The Right Thing*—and has

been similarly attacked. Lee's comments amounted to a landslide of free, off the arts pages publicity. *Django Unchained* grossed more than $30 million it's opening weekend.

I was surprised that Tarantino won an Oscar for Best Original Screenplay for *Django Unchained*. In almost three hours Tarantino failed to develop complex relationships, including the central one between Django and Broomhilda. Faced with the challenge of creating black characters of depth, with the exception of Samuel L. Jackson's Stephen, Tarantino wasn't up to, or perhaps interested in, the task. The white characters didn't fare much better. Depth and detail aren't Tarantino's strong suit. Broad strokes, parody, provocation and violence are.

Django Unchained is a simple story strong enough to accommodate a hodgepodge of Tarantino's impressions, conceits, ideas, visions and sometimes brilliance and produce a movie that was entertaining, exciting, provocative and, perhaps oddly given Tarantino's fascination with past movie genres, new. No doubt the participation of Reginald Hudlin, a seasoned writer, producer, former President of Entertainment at BET, and longtime friend of Tarantino's as one of the film's producers added to the film's edginess and authenticity.

The significance and seductive appeal of *Django Unchained* lies not in it's perfection, but it's arrival—not unlike Barack Hussein Obama when he announced his candidacy for President of the United States in Springfield, Illinois on February 10, 2007—at a perfect moment. Weeks after the film opened the second term of America's first black president began amid renewed effort by the New Confederates in Congress and their Tea Party storm troopers to take the country backward, Obama's electoral mandate be damned. As a nation, we have yet to resolve the issue of race, and we are in a moment when the civil war, our nation's defining battle, is resurgent. Is it possible to think about *Django Unchained* and not reflect on contemporary political and personal realities? Whether it is the overwhelming desire for freedom; or black women's yearning to be a black man's beloved reflected in Django's journey or in the eyes of the President of the United States when he gazes upon his wife; or the visceral desire for some straight up payback. Who can think about the Obama family living in the big White House built by slaves and not contrast it to the film's final image of Django and Broomhilda riding off into the night, free and together again, after blowing up Massa's big white house? Quentin Tarantino has made a highly entertaining film that speaks to the zeitgeist of the moment. *Django Unchained* has invigorated conversations about race, love, history, slavery, and white supremacy—past, present and future—conversations too often dismissed as anathema in the fantastical farce-land some call post-racial America.

Damsel in Distress:
Django Unchained as Revenge Fantasy | Halifu Osumare

Premiering on Christmas Day 2012 and the eve of the 150th Anniversary of the Emancipation Proclamation, Quentin Tarantino's *Django Unchained* is a revenge fantasy—a fairytale of a superhero like Spiderman, Superman, and before them the Lone Ranger, only this time the superhero is a black man. In an interview with TV-One's then CEO, Wonya Luca, Tarantino revealed part of his motivation, "I think it's about time we had a black hero who saves a black woman." We have, in fact, grown up with white superheroes that rescued their damsels in distress, so why can't we have our virile black hero who rescues the black woman? Since black females in Hollywood films have been historically depicted as the take-charge, hands-on-the-hip, tell-it-like-it-is Mammies of the pre-Civil Rights era or street-wise Sisters of the 70s blaxploitation era, being a woman in need of saving by the take-no-prisoners virile black male is a welcome change. Even most black feminists wish for this in secret. Leading cultural and social critic and scholar bell hooks nails it when she says:

> Even though black women work, they fantasize about not working.
> Or they dream of being able to stop working for a time if there
> is a man to watch their back. And they want him to be the knight
> in shining armor ready to defend their honor. No matter that this
> is the stuff of romantic fantasy, the stuff that gender equality was
> supposed to do away with.[1]

Even if this is a wanting "our cake and eating it too" fantasy, if men can fantasize about being the superhero, why can't we fantasize about being saved by him, *occasionally*? But it took a white man to give us that hero.

As homage to spaghetti westerns, *Django Unchained* easily lends itself to that hyperbolic, testosterone-laden genre that glorifies violence, blood and gore—a perfect template for the American slavery horror. With the help of a German bounty hunter, Dr. King Schultz played by Christopher Waltz, who won the Best Supporting Actor Oscar for his portrayal, a freed slave, Django, very convincingly portrayed by Jamie Foxx, sets out to rescue his wife, Bromhilda or Hildy (Kerry Washington), from a brutal Mississippi plantation owner, Candie, played adeptly by Leonardo DiCaprio. This is the scenario through which Tarantino's revenge fantasy

gets played out.

Given Tarantino's previous films that are infamous for equally being steeped in blood, revenge, and an aestheticization of violence—*Pulp Fiction, Reservoir Dogs, Jackie Brown, Kill Bill 1 & 2, Inglorious Bastards*—at least this time he is utilizing his aesthetic penchant in the service of history, or more accurately, as African American history historian Jelani Cobb notes, "a riff on the mythology we've mistaken for history." The myth is that black people, both men and women, were somehow passive participants in their enslavement, like so many of the slave characters depicted in the film. As much as the woman in me adored the scene when Django walks into the shed, where Hildy is lying down waiting for her "fate" with the white slavemaster Candie, to take her away from the plantation that he is about to blow up, I know that the basis of this concept of the lone savior is situated in the rugged individualism trope of American mythology. This mythology masks the collective black group struggle for freedom, for which so many fought, women as well as men. Cobb rightly analyzes that this "alternate history is found not in the story of vengeful ex-slave but in the idea that he could be the only one."[2]

The "noble undertaking"—saving the black woman—appeals to so many sisters anyway because, as bell hooks assess,

> Everything we commonly hear about romantic partnerships between black women and men is negative. We hear that black men are dogs and black women bitches and ho's. We hear that the divorce rates are so much higher than those of other groups. We hear about the lying and the cheating and the lowdown violence. We hear about the mistrust and the hatred.[3]

In Tarantino's film, we get a heroic black man, albeit fantasized, who is willing to stand up to the system that was developed to use us for chattel while denying our humanity. Django, as a character, demonstrates the fearlessness and valor that real love between a black man and a woman can generate, and we need to see that dramatized. We need to see, as hooks notes, "the work of [black] love."

Yet, could a black male director create such a story and get awarded for it? Is white privilege at work in Tarantino's accolades for Best Original Screenplay, when black directors like Spike Lee create scripts with pointedly black themes and are not given the same serious consideration? As Cobb assesses, "Quentin Tarantino is the only filmmaker who could pack theatres with multiracial audiences eager to see a black hero murder a dizzying array of white slaveholders and overseers. (And, in all fairness, it's not likely that a black director would've gotten a budget to even attempt such a thing.)"[4] White privilege becomes the normative hegemonic environment that gives white men the power to even heal black wounds, as they deconstruct their own history of domination.

The rugged individualism at the heart of white patriarchy is the very stuff of United States "manifest destiny" to so-call *tame* the West. As westward movement became the mandate creating the near genocide of native peoples (a subject not even touch on in the film), slavery became the holocaust that created the North-South

divide that nearly destroyed the nation. Can Tarantino's gratuitous violence even begin to match the reality of the carnage of American history, when we take a long hard look at it? Yet, it was collective resistance (such as black freedmen joining the Union army after the Emancipation Proclamation) that helped destroy the South's stranglehold on black lives, not superheroes.

The beautiful, smart, and politically active Kerry Washington portrayed a Hildy that managed the necessary vulnerability, while maintaining the requisite strength to keep the faith that her man would return. It is this female counterpoint that gave Django his hyperbolic heroism. Scene after scene, Washington beautifully portrays the susceptible strength of nature itself that kept her man dreaming of their reunion. Here too Tarantino demonstrates the "reality" of fantasy when in one scene she rises from a soft, tranquil river dressed in all yellow, like Oshun the Yoruba goddess of love. Unconsciously, Tarantino invokes another parallel mythology with African undertones through the meaning of Hildy's character.

At the film's conclusion, as the reunited Django and Hildy ride off triumphantly (on separate horses), and the infamous plantation Big House, Candyland, explodes behind them, we are left to imagine how they will establish the functional, caring black family, even in racist America, which is another mythology and perhaps sequel.

Endnotes

1. bell hooks, *We Real Cool: Black Men and Masculinity.* New York: Routledge, 2004, 119.

2. Jelani Cobb, "Tarantino Unchained," *The New Yorker*, January 2, 2013. Online, 4. http://www.newyorker.com/online/blogs/culture/2013/01/how-accurate-is-quentin-tarantinos-portrayal-of-slavery-in-django-unchained.html. Accessed January 28, 2013.

3. hooks, *We Real Cool*, 115.

4. Cobb, "Tarantino Unchained," 3.

Why I Needed to See a Black Woman
Spit in a Pot! | Heather D. Russell

*"Lingering beneath the notion of the black matriarch is an unspoken indictment of our female forbears for having actively assented to slavery. The notorious cliché, 'the emasculating female' has its roots in the fallacious inference that in playing a central part in the slave 'family' the black woman related to the slaveholding class as **collaborator**"*
—Angela Davis, Introduction to *The Black Scholar* (Dec 1971)

After the Pulitzer-prize winning publication of William Stryon's *Confessions of Nat Turner* (1967), and despite the beautifully articulated righteous indignation that ensued in the aftermath in and out of print, none of us should now be surprised when complexities and nuances of black history are elided, bastardized, or even worse, simplified, once black subjects are appropriated in the offices of liberal white popular production and consumption. I knew I would hate *The Help* (2011) and I did. It was abundantly clear to me from the promotional bits that the film, falsely marketed as a radical revision of "the black woman as Mammy" archetype, would inevitably reproduce persistent racialized and gendered conventions; Melissa Harris-Perry and Valerie Boyd have already weighed in more eloquently that I can on this point, but needless to say, the film met my expectations fully. With Spielberg's *Lincoln* (2012), I was perhaps less viscerally annoyed at first, than with *The Help;* I anticipated the familiar U.S. historiographical plot: great liberal white hope (John Quincy Adams in *Amistad* anyone?) saves eternally needful and grateful African/s by arguing eloquently for (*Native Son's* Mr. Max without the irony!) black freedom; amidst relentlessly racist protestations from "bad white men," truth and justice prevail, democracy is salvaged, and freedom and liberty for all, assured.

In the historical imaginary presented, Spielberg's *Lincoln* freed enslaved Africans sans the moral suasion of Frederick Douglass, William Wells Brown, William Lloyd Garrison, Lydia Maria Child, et al. This is classic Spielberg. BUT the ending scene, in which fiery anti-slavery orator, Thaddeus Stevens *climbs into bed with his (unnamed in the film) housekeeper*, Lydia Hamilton Smith, all but rendered me apoplectic, despite my knowledge of their long-standing relationship. In the movie theatre, there were audible "ahs" at this filmic instance. Forty years after black feminist intervention (like that of Angela Davis), the myth of our collusion with white men during slavery, albeit in this case a "good white man," remains potently persistent—the ethico-moral

imperative of the 13th amendment conscripted to sex.

The aforementioned withstanding sufficed it to say I was less than optimistic about Quentin Tarantino's *Django Unchained* (2012). Having heard Spike Lee's admonition to boycott the movie, issued reportedly without seeing the film, and, after my newly enrolled Tarantino enthusiast students in *19th Century Narratives of Enslavement and Resistance* were impatiently awaiting my "intellectual" sanction, I thought it disingenuous to wax poetic on its failings *without having actually watched the film*. I have never seen *Pulp Fiction* in its entirety, nor *Kill Bill 1, 2, or 3* (is there even a 3?). I spent much of *Django Unchained* acclimating to the sensory assault of blood, guts, and violence, apparently hallmarks of Tarantino's oeuvre. The battle royal scene was for me, the voyeuristically gripping proverbial turning of the tale. In short shrift, the abjection of enslavement relentlessly assailed my every sensibility. There was no let up. And, among the mostly white audience surrounding me, a strange admixture of disbelief, tension, guilt, and nervous laughter, was palpable. *This is how 19th century audiences must have reacted*, I thought, *to Mary Prince's resistant soundings* insistently uttered amidst unimaginable brutality, seared wounds smarting in the salt marshes of Turks and Caicos, and the "flesh ragged and raw with licks. Lick-Lick." Mary Prince's however, is no pulp fiction; neither escapist fantasy nor neo-noir. "To be free," writes Prince in her 1831 narrative, "is very sweet." "All slaves want to be free. The man that says slaves be happy in slavery—that they don't want to be free—that man is either ignorant or a lying person."

At the close of the film when Miss Lara Lee gets obliterated by Django, I turned in disbelief to my fellow moviegoer and said, "oh no he didn't...he actually went there." Images of Mississippi's Carolyn Bryant and Rosewood's Fannie Taylor flashed across my mind, so too did white female slaveholders, who in 1815, according to Hilary Beckles, constituted 50 percent of the slaveholding class in Bridgetown, Barbados. Complicity at last acknowledged, I cheered along with fellow movie-goers inescapably transported in ways they probably could not imagine into a momentary phantasmagoria of blood and fire, vengeance, retribution, and divine justice. In the end, however, as the brilliantly titled recent novel by Trinidadian author Earl Lovelace reminds us: *Is Just a Movie*. "*Beware,*" warns the African prophet in John Edgar Wideman's novel *The Cattle Killing*, "do not fall asleep in your enemy's dream."

I am drawn sharply back in postmortem conversation to the persistence of the myth of black women as collusive collaborators with white men. *Ok*, I said, *it was surprisingly bold in many ways, but not one black woman spat in the soup, or threw poison in the food, or purposely forgot their role, or helped get the kerosene to light Candyland on fire!!!*

In the entire 165-minute-long film, save Broomhilda von Schaft, whose naked, scarred, and restrained body, emerging from the holding pit and eerily reminiscent of Douglass' voyeuristically narrated and sadistically displayed (Deborah McDowell and Frances Smith Foster's argument) "Aunt Hester," not one of the enslaved black women portrayed is represented as resisting her condition. To the contrary. Beautifully attired, heavily made-up, and sophisticated black women baring ample bosoms lay sultrily atop their white slaveholding lovers. Or, safely ensconced in the lavish kitchens and dining halls of their masters and mistresses, dressed impeccably in the starched black and white of gentile servility, black women pour lovely pots of

tea and serve perfectly made crumpets and scones with jam. Almost two hundred years after emancipation, Mammy and Jezebel remain firmly intact.

Now, one could argue that in this revenge fantasy, the incumbencies of honing minor characterological development is necessarily subordinated to the Django-Broomhilda love-plot. And, I might be satisfied with that explanation were it not for the following scene:

Django and Dr. King Schultz, have crafted the escape plot to free Broomhilda. Django will disguise himself as a slaver in the market for Mandingo fighters. Together, Django and Schultz, each on horses, ride astride the sadistically brilliant Calvin Candie, onward to "Candyland." The Mandingo fighters coffled and enchained, shuffle alongside. During the journey, however, one of the enslaved black men venomously glares at Django. He need not speak one word, for every viewer knows that given the chance, the enslaved black man would in a filmic instance, unhesitatingly drive an ice-pick down Django's throat.

This moment of embodied, unmistakable, subversion, albeit misdirected, tacitly aligns the enslaved black man with the hero Django in a history of physical resistance to slavery. *There is no single corollary moment in the entire film,* in which enslaved black women are presented as anything other than either passive or active collaborators with the slaveholding society. Black women are barred once again from participation in what Claudia Tate has described as the "black heroic liberational discourse" which shapes our historical imaginations regarding slavery.

In the end, however, Quentin Tarantino was not writing and/or producing history. Is just a movie after all. He was, in the vein of his forbears like William Styron, simply "meditating on history." Still, such meditations are not without their consequences. The grand fictions of slavery continue to belie the uncompleted, unfinished and uncompensated project of liberty for formerly enslaved Africans throughout the Americas. Ours has been, as Lovelace has written "a half-way freedom" to be sure.

From *The Help*, to *Lincoln*, to *Django Unchained*, the image of the assenting, passive, counterrevolutionary black woman, endlessly repeats. Despite the myriad historically documented and publicized instances of black women's active participation in daily acts of resistance to enslavement, ranging from passing messages; guiding fugitive enslaved Africans to freedom; inducing abortions and preventing pregnancies, to numerous other acts of "gynecological resistance;" poisoning masters and mistresses, and, of course, engaging in armed revolt, black women's historical role in black resistance to enslavement continues to be elided, derided, and subordinated to their male counterparts. Why this perpetual need to render her complicit? And while I am in no way suggesting that figuring black women's historical resistance is some kind of panacea for radical social change. For my daughter's sake, I needed to see just one black woman in *Django Unchained,* spit in a pot.

Racial Profiling in Black Hollywood: Black Images and Cultural Transformation | Kathryn Waddell Takara

Quentin Tarantino, director/producer, has been lauded and criticized for his latest Hollywood movie, *Django Unchained,* a brutal action, revenge "spaghetti" western with a black man (ex-slave) and white bounty hunter (German) as co-heroes. This adult film noir features anti-heroes Django (Jamie Foxx) and Christolph Waltz (Dr. King Shultz) as a black ex-slave and white German bounty hunter and trickster who reveal reversals of traditional roles, distorted images, and unexpected behavior and attitudes of a black and white men working and riding side by side during the ante-bellum period in the South, a time of division, separation, fear, brutality, and injustice. The director imaginatively exposes the shadow side of slavery, the cruel customs, brutal conflicts, and often fatal consequences of commerce in human flesh. One is forced to see the emotional commonalities of human frailties through surprise reversals in roles, unusual and unexpected bonds and communication links, and basic human strivings for love, freedom, and money in rarely explored conditions in the South and Southwest.

Tarantino himself embodies a paradox of being a white director writing and directing a story about the sensitive subject of slavery and freedom, with black and white costars and an unconventional twist: black and white renegades bucking an often romanticized cruel institution that is at the foundation of a shameful part of American history. The aim is to create an attractive and empowered black hero who defies the ugly tradition and customs of white superiority commonly found in American, European (German, French), and African American history, literature, and the ever powerful social media. Indeed, Tarantino's reinterpretation of history, developed from a white man's imagination, points to a season of promise, bold reconstruction, and creativity in films in the 21st century. However, it should be noted that even Tarantino seems to repeat the voyeurism of black suffering as much as he critiques it.

Tarantino is an unconventional film maker with a notable reputation, power, contacts, access to and possession of money, and a relatively long history of working with talented black actors which has helped to make this film a moneymaker. One cannot help but wonder if a black producer would have treated and represented the script better? Perhaps, but at this time, most black film makers lack the abundance of resources: money, contacts, access to powerful people in the industry, and an

uninterrupted track record of successful blockbusters.

Most blacks in the industry recognize the limited roles available to black actors and that blank men in the movie industry confront many turbulent and often negative images in available scripts. Sharing this awareness, Tarantino accepted the challenge in producing *Django Unchained* to fight the shackled stereotypes. He knows that black men do not have the same privileges, power, and access to resources; they enjoy fewer rights and roles than white men and women actors. Rather black men in Hollywood have been historically vilified and represented by many negative images and stereotypes: being violent, residents of bleak communities, poor, undereducated and dysfunctional, victims, and perpetuators of criminal activity.

Tarantino tackles the problems of black images and exclusion in Hollywood of black roles and actors. He understands the powerlessness of a group trapped in a system based on money, property, contacts, and other common slanderous depictions of blacks perpetuated in the exclusive Hollywood film industry. Black males especially have roles as intruders, outsiders, not belonging to the elite power circles, to ordinary family life, to respectable jobs, nor to outstanding and brilliant careers. They are not portrayed as role models and mentors, super intelligent and creative geniuses, but rather as shallow, often one-dimensional characters who follow rather than lead, face uncertain futures, and fail to realize a "happy ending" due to some innate tragic flaw. With few exceptions, they lack the usual qualities of a hero, a good leader or someone worthy of emulation. Tarantino is aware of the acute lack of psychological and character development in most black roles. When dependent on white producers and money, blacks are still often portrayed as entertainers, athletes, comedians, law enforcement agents or tragic victims. Tarantino uses big name actors and actresses, and gives underrepresented people a chance to play non-traditional roles. His strategy for his actors is: Get in character, play a role.

In *Django Unchained*, Tarantino challenges these traditional media images of powerless black men; he pushes the envelope to the edge of acceptable, and intentionally offends white segregationists and racists, some black historians, social activists, peace makers, and people who feel guilty or vulnerable in their relations and experiences with Blacks, especially those of the middle and upper classes. Tarantino's morality is through the back door. For example, in *Django Unchained,* he uses inversion to portray the complicated dynamics of the institution of slavery, shows parallel worlds with inverted roles. He triangulates history, politics, and emotions. Dealing with American history, he satirizes the glorification of the wild West with its violence and guns, lawlessness, corrupt officials, and power brokers.

Tarantino is morally ambitious: he exposes, exaggerates, and critiques the old savage system of slavery, ups the level of superfluous violence and mayhem to endless fountains of blood, to make a lasting impression of a cruel institution. He mocks and belittles the Ku Klux Klan, using the irregular and tiny eye slits in their white robes to demonstrate how they can't see, don't know what they are doing nor where they are going except to spread racial terror and violence. He is a melodramatic director and takes events to their extremes, using outrageous and flagrant violence against vulnerable people and animals from the beginning to the end of the film, causing as many blacks as whites to suffer.

Through Django's (Jamie Foxx) actions, he evokes indirect questions: When is the right time to take up guns to resist injustice? What is legal? What is a forbidden zone? Is Tarantino a visionary director who aims to change the world as we know it? Is he a new kind of extremist promoting violence and revenge? One of his aims is cultural transformation. He wants to change the views of Euro Americans and others on slavery by presenting it upside down and inside out. Perhaps he even aims to awaken a national conscience and consciousness

In *Django Unchained,* Tarantino challenges the dark, suppressed places in people and history, for example, the false sense of white security or the belief in white superiority. He moves us past our own definitions and self-righteousness and exposes the historical hypocrisy of democracy by focusing on slavery and a way of life that demeans and ruthlessly controls black people. He is ever provocative, a "Maestro of Memories," but whose memories and how accurate can he be? He is an outsider himself who tries to understand and project another group's collective experience, memory and understanding.

To this end, Tarantino exposes and attacks historical white privilege: confronts the American myth where many whites see themselves as cultured and civilized, worthy of dominance and control, superior intellectually, creatively, and culturally to other groups. He reveals the historical system of slavery: problems of race, greed, power, and the subordinate power and role of women.

Sins in Slavery

Through the Django character, Tarantino portrays slavery as a deep pit of hell, full of insecurity, violence, and the unknown, and he uses his characters to visually shock, stir up and rattle white fears and collective guilt. He vividly presents and represents on screen another perspective on American slavery and race relations. The setting is in the antebellum old South and old West, and confrontational events take place in Texas, Tennessee, and Mississippi. The perverse, sadistic, egocentric slave owner and proprietor Candi (Di Caprio) at Candyland Plantation, witnessed through the eyes of Django and Christolf Waltz, exemplifies Tarantino's distain for and judgment of racists and power mongers.

Tarantino has a plethora of themes in this movie: violence, love, freedom, servitude, guilt, revenge, and abuse of authority that are played out by brave and tough characters who defy tradition in his reconstructed history. The voluntary black-white partnership between Django and Waltz fills the scenes with crime, guns, power-plays, and unconventional relationships with the law, exposing the corrupt customs and conditions of slavery. He reveals false images and stereotypes of blacks, whites, and morality within and outside of the law.

We follow and witness the hero Django (Jamie Foxx) and the growth of a recently freed slave and his new sense of identity. He becomes a strong man, who takes power using a gun, violence, and his sharp acumen to change his world. He is tall, handsome, and becomes a skilled marksman who travels freely, rides his own horse, carries a gun, learns to shoot, read, write, and figure things out. He is the classic bad "nigger" outlaw who earns respect of those around him and the audience in the

movie, but the question arises: is he anything more than an assassin? Admittedly he shows grit and earns the respect and fear of whites as he shoots them down, but is he justified in carrying out his revenge fantasy in the name of love?

Tarantino offers solutions here and there to the dark world that he portrays in *Django Unchained*. Unlike most Hollywood movies featuring a black hero, themes of revenge, love, and reconciliation are often avoided. The improvement of race relations is seen in the partnering of Django, the black freedman, and Waltz, the white bounty hunter. Love offers hope. Django is in love and has been forcibly separated from his wife. He is determined to find and reclaim her, and thus he has unfinished business. Values get slippery, rise and fall, as Django will do anything for his beloved wife, even mistreating other black slaves and killing whites or whoever stands in the way. Revenge offers him restitution, a sense of self-determination, control, and hope for a new world as well.

The lack of religion, so common in most movies about the African American experience, is noticeable. Contrary to many movies featuring blacks, in *Django Unchained*, there is no visible Black spirituality, no church and redemption. Tarantino attacks the hypocrisy of religion in a scene where a white minister and slaver holds the Bible and reads scriptures while performing heinous acts of violence against blacks. The recurring unfamiliar violent scenes are somewhat softened by interludes of black music ever in the background.

Tarantino's portrayals of slavery and violence are graphic and disturbing. There is the lack of necessary items for basic survival. Then there is the lack of necessary items for basic survival: decent food and shelter, few appropriate clothes for freezing weather, the lack of medical care for infections and other illnesses, often caused by harsh, inhumane conditions, the tight chains that create wounds, and the psychological injuries caused by inevitable rape, sexual abuse, cruel words that insult and degrade like "nigger," and forced infidelity. Sadistic slave owners make slaves beg to stop the harsh and irrational punishment: time spent in hot houses, whippings, scarring, and other tortuous acts. Fear of death by abuse, refusal to be further demeaned, false accusations, and absent loved ones cause many slaves to run away. However, they face terrible reprisals meted out to fugitives if and when they are caught or return.

Tarantino's disturbing images begin with the horror of slavery, tortured men in chains, chaotic violence, dense with incidents that reveal the abject powerlessness of the blacks. He bends history's tapestry and the indelible stereotypes of slavery. He wages war against the white conspiracy of black images, myths, and stereotypes: the happy slave, the benevolent fatherly slave master, the docile slaves, *ad nauseum*.

He reveals various white attitudes toward blacks through the slavers: hate, distain, fear, guilt, demonization, and the erasure or marginalization of black history in popular discourse. He exposes and exaggerates the darker feelings and insidious plans of whites to control blacks. By so doing, he shows varying degrees and levels of consciousness and conscience, even as he denounces heresy, the stereotypes of slavery, and the deception that the American values of hard work leads to success for all people. The sham that freedom is a right and marriage is sacred is embodied in Django's difficult search for Broomhilde (Terry Washington), his wife.

Loving Language

Tarantino's love for language is noteworthy. He uses it as a tool and indicator throughout the movie. Waltz and Candie are especially grandiloquent. Their "beautiful" words and lengthy dialogues to indicate politeness and manners, culture and civilization, an illusion of upper class and well bred people. The dialogue illustrates how language can bind or separate, depending on usage and psychology. It can deceive and camouflage intentions, especially when used in the right situation with the right tone and perhaps accompanied by few sincere or insincere smiles. For example, Django's wife, Broomhilde learned German from her slave mistress, and she intrigues Waltz who arranges a secret meeting with her and Django after seeing her privately in his guest suite on the plantation. One can assume that language can determine how many degrees of separation exist between Django and Waltz, Django and other slaves, Waltz and other whites. For example, harsh raw language is used to indicate extreme evil and final revenge while the use of the French language gives a false elegance to the effete plantation owner.

Liabilities Of Slavery

Django represents and exposes the liabilities of slavery. Slavery is "The Measured Life," a culture of excess, inequality, violence, deprivation, a kind of holocaust that indicates and justifies taking up arms and resistance. Tarantino attempts to create a violent backlash against slavery and its romantization as he seeks to manipulate public opinion and change the current course of history. Using the conditions surrounding Django and other slaves, Tarantino depicts the hideous traumas of slavery: no freedom, self-determination, protection under the law (corrupt), no social justice, and the inescapable violence as seen in the scenes with the slave catchers, overseers, dogs (blood hounds), whips, and torturous lawlessness. He shows with close-ups the numbing effects of excessive violence—manacles, scars, blood, faces distorted with anguish and pain.

The politics of color are revealed in the house slaves' very existence as obvious miscegenation results in mixed (bi-racial) generations, privileges, and vulnerability. Sex and power force black women to become sex slaves as seen at Candyland.

The plantation owners represent the economics of the institution and the country as slavery is free labor and the products of slavery produce their livelihood. Meanwhile, representatives in politics who are landowners make laws to keep blacks down and keep slavery intact.

Tarantino intercedes in the popular slave discourse and exposes the demons of slavery: racism, power, the vulgar foulness of the institution, how blacks are used as pawns who are dehumanized, vilified, denigrated, insulted, relegated to a status of subhuman chattel, and denied human rights. He attacks White abuses and irrational emotions: rape, brutality, and fear. He believes that victims of slavery deserve to have their suffering seen and understood. He uses the Candyland Plantation to illustrate his points: Candyland Plantation is a model of comfortable affluence, offering an illusion of culture and civilization. Like all plantations, it was built on the backs of

slaves, servants, and free labor. At Candyland, we witness how slavery dehumanizes both slaves and master, exemplified by forced fights, non-consensual sex, and delusions.

Slavery is a clear disruption to racial solidarity with the forced division between house and field slaves, freedmen and indentured servants. Unity of aim, community, and family is subverted by cultural assumptions that whites are superior to blacks, are good Christians, civilized leaders, and responsible patriarchs. Tarantino questions the moral authority of his characters.

Tarantino has a sense of humor and comic relief in the scene of the KKK, but as a black woman who grew up in the Jim Crow South and witnessed the Klan marching through my town, I did not find this scene humorous. The Klan in Alabama inspired fear and intimidation in African Americans and outsiders. We knew that the Klan was inclusive of certain members of the White Citizens Council who were the powerful, educated, and distinguished white leaders of our community.

When it comes to freedom, Tarantino seems to feel that the country has come to such a terrible place that he sees the need to break the laws to insure that people can experience life, liberty, and the pursuit of happiness. Again Django becomes the symbol for Black freedom as Tarantino forays into the pretensions and assumptions of many whites. He seems to be interested in freedom and empowerment that comes with consciousness, and not in the conscience of Waltz and Django. He wants to awaken the conscience of whites.

Characters: Choosing Images

Tarantino chooses his characters and the actors that play them with an eye to portray as realistically as possible his revisionist history and non-conventional script. Django is the irritating free black, the "nigger" on a horse, the "nigger" with a gun who exposes the fake "civilization" of whites as seen at Candyland. In spite of the trappings of elegant surroundings, formal dining, expensive clothes, classical music (piano and harp), liqueurs, a library full of leather gold bound (unread) books, and the ultimate white cake baked by black hands, Django can see that the plantation is a den of iniquity where his beloved Broomhilde is at risk and must be found. Django is the smart "nigger" who hoodwinks his white captors after Waltz is killed, and returns to Candiland to rescue his wife, burn down the plantation, and kill a host of the owner's henchmen, employees, and supporters.

Although Django is clever, a quick learner, and an astute observer who can hoodwink most blacks and whites with his different disguises, he becomes violent when the plantation owner kills his partner Waltz and will not relinquish Broomhilde even if paid for, due to the betrayal of their close relationship by the odious house slave and Uncle Tom, Stephen (brilliantly played by Samuel Jackson).

Throughout the film, psychology is used to dehumanize and/or empower the characters. Tarantino uses harsh language to degrade others (the word "nigger"). He uses the psychology of laws and black codes to degrade, demoralize, and even criminalize blacks. The institution of marriage between blacks was considered illegal and not recognized by whites, but without marriage, living together was considered

a sin, and thus another psychological burden. A psychological irony is that the plantation owner was called "Big Daddy" by black women slaves, and in reality, he was probably their real father.

Stephen, the head house "nigger," always sides with his owner and is a betrayer of other slaves whom he thinks threaten his well-being and favored status or that of his master. He uses his deferential and obsequious behavior and groveling as psychological tools to express his loyalty and devotion to his master. He closely watches and monitors BroomHilde after he discerns curious connections between her and Django and figures out her plot to join her husband. Stephen then reveals the conspiracy to his master, blackmails Django to turn himself in and confess his plan or he will give up or kill Broomhilde.

Tarantino exposes the consequences of the psychological use of scientific racism which infers that Africans, due to brain size, are the most submissive of all creation and need to be obedient and guided in order to justify slavery, the mistreatment of blacks by whites, and to create fear and mistrust in the minds of whites. Punishment for disobedience or rebellion of Blacks varies if they don't obey, but in the case of Django, when his plan to take Broomhilde away is discovered, he is again "sold down the river" to the brutal Le Quick Dickey mining company where slaves are worked to death. Fortunately he escapes.

Django's revenge is that it "Hurts so Good" The radicalization of Django is seen as the growth of a free man, his emerging identity, ideas, and developing world view. He is an outlaw who earns the respect of all who encounter him including the movie audience. He is what is respectfully called a "bad nigger," but is he anything more than an assassin? Throughout the film, he shows grit and earns the respect and fear of whites even as he shoots them down. Django is fearless, and his freedom is expressed through his actions. He stands out to all who see him, thus he is outstanding, even when or because he seeks revenge and commits crimes to earn money to buy his Broomhilde out of slavery. He vents his rage and unhappiness at the absence of his wife. He commits intentional acts with an eye to his goal of reuniting with his wife. Django came out of a place where his sense of self survived because of his great love beyond his history of subordination and fickle fate.

Is Django a super hero or an anti-hero? He is a free black who takes the role of a cowboy who kills. He lives outside the often corrupt and prejudiced law, rides his own horse even up to a saloon with his own sidearm in the company of a white man (Waltz), has a drink, and passes himself off variously as a bounty hunter, slave trader, or valet. Throughout all of his experiences as a free man, he remains alert, witty and smart. He rejects his earlier life as a slave with no self-determination. When he is forced into freedom by Waltz, he chooses to ride with and help him to find and identify the Brittle brothers, who are ruthless killers. Django lives outside the racial box: he is black, free, intelligent, and a quick learner; he is proud, fearless, and committed to his values and principles, a hero willing to die for love and freedom. He walks and rides with confidence and pride, and he is secretly admired by other slaves when he stands up to whites and takes calculated risks.

But how and why does Django have his freedom? He is rescued from his chains by Christolph Waltz, a white bondsman with his own agenda. By outwitting and

killing the slave traders who are transporting Django in a coffle of slaves, Waltz gives Django his freedom, a horse, $75, and later lessons to shoot, read, think, speak, and dress like whites in exchange for his help.

Waltz is a successful bounty hunter for white criminals who is sometimes disguised as a dentist; he is also a latent capitalist with no religion, an eccentric German who becomes a mentor for Django and provides the spark for freedom and self love, and an opportunity to travel and explore new horizons. He teams up with Django for monetary reasons. Waltz is clever, egotistical, manipulative, and full of ruses. He shamelessly dupes others, is a charlatan and a liar. He is ever deceptive yet pleasant and congenial when he wants to be, and he changes his role and demeanor when it is advantageous to a situation. Money is his prime motivation, and he kills and collects the bounty for those who are wanted by the law dead or alive. He kills because it is easier than capturing his victims, and perhaps because he lacks morality.

Waltz goads Django to take action, become an agent of change, and an actor in his own drama (finding and recovering his wife). He forges a bond and an agreement with Django: you help me identify and capture certain renegades and criminals, and I will help you reunite with your wife. He convinces Django, who is willing to walk through hell fire for love, that with enough money he can buy his wife's freedom. He persuades then teaches Django to shoot and kill whites, an unimaginable breach of southern etiquette and black behavior, and then sell the corpses to earn enough money to free his wife. Waltz kills for money, travels across the country hunting those who dared to cross him in the past, abusive slaveholders, and violent men. He exchanges flesh for cash, not unlike slavery. Is he morally good or bad and immoral? In appearance Waltz is dapper, speaks faultless English, and seems to have absolutely no compassion for his victims. He is a progressive liberal, but also a scoundrel and opportunist, yet he maintains a certain romantic appeal.

How many degrees of separation are there between Django and the bondsman, Django and the other slaves? Both men are rebellious hooligans and subversives, who reject the system of slavery. They make an agreement to help each other: Django helps Waltz as bounty hunter to locate people and Waltz helps Django to find, buy, or otherwise free his wife.

Both men's values rise and fall according to the level of security and insecurity that surround them. Django learns from Waltz. He develops free will. Tarantino depicts the growth of a free black man, his personal sense of identity, emerging new ideas. Django embodies the birth of a leader who for some is a role model, with power to change his world, to think and figure things out, consider situations and bide his time until the time is right. This strong black man is an outlaw who nonetheless earns the respect of his audience as a "bad nigger," but is he anything more than an assassin? He shows admirable courage and grit and earns the fear of whites even as he shoots them down.

Tarantino adds to the mix other black characters: various house slaves. He parodies their existence as they dress up in attractive western clothes, serve their master, act out the master's fantasies, and often betray other slaves. It is almost comedic how some behave: puppets and imitators (black skin, white masks) with little apparent sense of self, knowledge of their origins, families, or the larger black

community of slaves.

For example Stephen (Samuel Jackson), the master imitator in the film uses the tools of humbleness and self-depreciation to survive in the big house with a few coveted material benefits: to live and eat in the master's house, dress well, avoid hard labor and punishment of the field hands, and have the ear and confidence of his boss. He spies on and reports the activities of other slaves to his master and thereby exposes his warped and corrupt character.

Another character is Broomhilde, Django's mulatto slave wife, who speaks German and English and embodies intelligence, beauty, values, courage, endurance, and long suffering. She is another principle resister to the whims and fantasies of the master and remains true to her love and husband, even as she receives various punishments for refusing to be compliant and cooperative.

There are also scenes of the field slaves who represent the conditions Django endured before he was freed: regularly beaten and punished, often severely for any infraction or resistance, real or imagined. They are portrayed as mostly obedient and submissive.

The plantation owner, Candie (Di Caprio), pretends to be civilized and charismatic. He is a loquacious villain who indulges in fancy language and long monologues. He tries to impress others with his extensive library, knowledge of the French language, fancy clothes and dinners, servants, large plantation, and many slaves. In reality, he is a vicious, cruel, self-absorbed, and lonely man with what seems to be an unusual (incestuous?) close relationship with his adoring sister, and a threatening control over his role-playing slaves. He is a symbol for oppression, identity theft, corruption, white superiority, sadism, self-deception, and lying both to himself and others. Tarantino uses irony when Waltz picks up a favorite book of Candie in his library, written by Alexander Dumas, a literary giant and hero and cleverly informs him that Dumas was a famous Black writer in France, shattering Candie's belief in the inferiority of all blacks.

What is the strategy of Tarantino and how does he work with a plot? He uses themes like freedom, revenge, and love in its many forms as a vehicle to move the story forward and simultaneously present new images of blacks in Hollywood. In various situations, he demonstrates how Whites want to maintain dominance over blacks and the lengths they will go to protect their power and privilege. They trade money for human flesh (slaves) and use selected roles and titles that reinforce their status as leaders, power brokers, and respectable members of their communities.

Vicious Violence

Tarantino's selects his characters with different aims in mind. He seeks to humanize and empower blacks in at least one man who is Django. However, his treatment of violence exhibited and executed by his characters is different from the violence that black characters typically enact. He recognizes that violence intoxicates and liberates, but is also a root cause of negative stereotypes of blacks. He uncovers and reverses the tragic displays of fury and violence in black lives: black suffering and violence is the bear in the background that has its roots in slavery. Violence also

hides in the instinctive nature of man's will to survive.

In the movie, Tarantino exposes sadistic lurid whites who are heartless and chilling in their dehumanization of blacks, their blockages to freedom, their need to maintain absolute control. They sublimate their insecurities and fears of insurrections, retribution, and loss by both acting mean and aggressive. Django witnesses the sadistic slave owner Candie as he forces his "Mandingo" black slaves to fight each other until one of them dies, if they want to live, have a few privileges, and escape the rape (their women, children, and offspring), beatings, and inhumane conditions so prevalent in slavery. The slave owners know that the threat and pain of shackles, chains, cages, restraining contraptions modeled after instruments of torture from the Dark Ages, influences the behavior and choices of the slaves. Their aim is to control and use slaves, and, frustrated when they lose control, they desperately tighten restraints and restrictions, taking comfort in their ability to inflict great pain on those whom they consider insubordinate and inferior.

The violent images of Tarantino are seen in the cold, hard, too tight chains, various shackles and restraints of the slaves as well as in the many gun fights and massacres. Both Django and Waltz are basically moral men, but killers for love and livelihood, financial gain. In contrast, the slaveholders are violent, non-repentant and basically immoral men. Obviously Tarantino has no compassion for the slave traders, owners, overseers and other authority figures in the brutal system of oppression and exploitation. Violence toward slaves, animals, slave owners, lawmen with criminal pasts is a common form of terrorism of the period. For example, branding of the body and even the face, the use of vicious killer blood hounds, repetitive floggings, burning the eyes, forced marches, the separation of families, the lack of birth and death records, castration, and hanging upside down were all common forms of violence and punishment used by some cruel masters. Multiple scars that covered the backs of slaves were testimony of the painful suffering of men and women slaves and constant reminders of misbehavior or wrong attitudes. To avenge the victims, Tarantino seems heartless as he shows heads, torsos, and horses that explode like tomatoes or watermelons, endless splashes of blood when Django and Waltz go on killing sprees. American violence, ruthless cowboys, the slave owners, the gangster characters, and the powerful lawless men are and have been glorified on the screen and in American myths and legends. Tarantino satirizes these types through his characters and exposes the power of contemporary media to promote and glorify violence.

Meanwhile, throughout the film, Tarantino uses the backdrop of Nature to soften the violence and as an unconscious perennial witness of the violence and immorality of his characters. The seasons change, varying in different parts of the country, ever beautiful, peaceful or hostile to man, amidst human pain, suffering, corruption, and chaos. The scenes of winter storms and snow, mountains in fall, summer cotton fields, empty plains and the hope of springtime are a recurring objective presence and represent the stages and processes of life itself.

Finally, symbols and metaphors are most striking at the dramatic end of the film when Django rides a stolen white horse bareback showing his mastery over the large animal (the body) as well as his mind in a moment of pure, righteous, emotion

and triumph with his newly freed and recovered beloved Broomhilde. Together they watch the fiery destruction, caused by Django, of Candyland Plantation and the twenty plus white men and the house slave Stephen who perish within. Django single handedly and bravely was able to fight and conquer his enemies and rescue his wife because of the powerful passion of his love, his exceptional fighting skills, and his logical tactics (the mind).

Conclusion

It is not surprising that Tarantino has been attacked and marginalized by whites and blacks for his portrayals of different communities and characters. Still he is largely respected and rewarded for his courage and commitment to the destruction of stereotypes of black males, slavery, and his imaginative reconstruction of history.

Tarantino succeeds in portraying physical, moral and psychological journeys over various and diverse territories (inner and outer) using Django, a black man, as a vehicle for his insights and message.

Tarantino also successfully shows the emotional intelligence and ignorance of his various characters at different stages of their lives: Django and Waltz make meaningful and moral connections in spite of their disparate experiences in opposite worlds of black and white. They connect across color lines and differences, are tested, and remain true to their aims and beliefs in freedom and justice.

The message? Empowerment comes from righteous anger and revenge. True love and cooperation with others can lead to justice. The value of retaliation for a righteous cause and the courage to speak out and act, in this case inspired by the hope to see beloved Broomhilde, lead to a sense of success. For Tarantino, a strong sense of identity, a commitment to self-determination and freedom are necessary qualities needed to be an agent of change like Django.

America is not yet the land of the real and the possible but we share our common humanity and planet in spite of our many differences. The oppressed and their allies must not be passive and silent, but take action to co-create a better and more just world for all. Today, blacks are still often disenfranchised, have an average income of ½ of whites, suffer from disproportionate imprisonment due to poverty and profiling, unequal education and opportunities, a lack of social justice, and erosion of our civil liberties.

Tarantino exposes in *Django Unchained* his post modern rendition of slavery and reverse roles, the contemporary subtlelization of stereotypes. Nowadays, many Whites can easily hide behind self righteousness and Christianity (the moral good guys) since there is less separation between church and (state) government; there is a conservative Supreme Court and Congress and a backsliding of civil rights. As a growing disillusionment with our leaders increases, especially with a black President, many whites feel confusion, irrational fears, and threatened by a growing national collective minority. They suspect that their privileges and democracy itself as they know and interpret is at risk. Unfortunately, Blacks are still demonized and marginalized in the media and popular discourse, although better conditions surely exist for most of us on the whole.

My personal reaction to Django is mixed. I was unsettled and jarred by the violence. The heavy, dark humor and merriment was not funny. My enjoyment was compromised and overshadowed by the endless and often senseless violence which happened to my own family in Alabama. We have all seen this kind of excessive violence in the old cowboy and Indian movies sometimes called spaghetti westerns. I was also offended at the liberal use of the word "nigger" that recalls again my Jim Crow experiences in the South, even though as an historian, I recognize the common parlance of the word, then and now.

I wonder if Django is really worthy of being called a hero or is the movie another case of blaxploitation? Would I want my children to follow his path of violence? Does Django ever take responsibility for his violent actions and destruction, or does he just ride off into the sunset or moonrise with his beloved Broomhilde? Is this ending believable or are there consequences for his choices and actions? It seems to me that there are no "good" guys in the movie.

In conclusion, Tarantino's over the top voyeurism offers forgiveness for our spectatorship of black suffering, at the same time recognizing the complicity and complexity all around. Where do we go from here, beyond "criticize, condemn, and complain"?

America's Soul Unchained | Jerry W. Ward Jr.

Django Unchained is the most patriotic American film of 2012, because Quentin Tarantino plunged into the system of *Dante's Inferno* and brought up the bloody, violent and unchained soul of the myth of the United States of America. Steven Spielberg's *Lincoln* is pseudo-patriotic, a retreat from what American historians must admit is the messy truth about Abraham Lincoln. Tarantino, on the other hand, gives us all the rugged, slithering, macho motives that govern the dynamics of being American. He succeeds in making viewers frustrated, angry, and anxious to debate the merits of reducing Richard Wagner's *Götterdämmerung* to a soap opera and ending a fragmented black love story with Broomhilda and Django riding off into the bliss of fugitive darkness.

We have been trying, without much success, to have a conversation about what it means to be an American since the nineteenth-century publication of Alex de Tocqueville's *Democracy in America*. Although any revolution of consciousness occasioned by *Django Unchained* will not be televised, the grounds for a crucial conversation have been "immortalized" as a richly satiric cartoon, a cinematic allegory that divides spectators into pro-Django, anti-Django, and disingenuous neutral camps. Since mid-2012, the Django conversation has snowballed. Unfortunately, it will evaporate as soon as the next film of maximum outrage lights the screen. Nevertheless, Tarantino's genius deserves all the kudos and barbs, detractions and commendations we shall give it from here to infinity. Indeed, the National Rifle Association should give Tarantino a special award for the patriotic fervor of *Django Unchained* in reaffirming the Constitutional entitlement of Americans to bear arms and make havoc among themselves and people on an endangered planet. An Oscar will not suffice.

If there is credibility in Irving Howe's famous Hebraic judgment that "[t]he day *Native Son* appeared, American culture was changed forever" ["Black Boys and Native Sons." *Dissent*, 10 (Autumn 1963): 353-368], there is equal credibility in the claim that the day *Django Unchained* was first screened, American cinema culture was altered. While pure violence is a staple ingredient in our forms of mass entertainment, few films depict how Americans are permanently enslaved by love of violence. Like Richard Wright's novel, Quentin Tarantino's film broadcasts a message that the prudent among us will not ignore, a message that puts the agony of interpretation in

a harsh, politically incorrect spotlight.

Our interpretation of *Django Unchained* is largely determined by the angles, prejudices, and ideological bags we bring to the acts of viewing and talking. If the film is approached as an effort by a white director (although Tarantino is not exactly a "white" surname) to tell a black story, the viewing is shaped by assumed or specified expectations about how a black story of enslavement ought to be written and reconstructed or translated into film. If it is assumed that *Django Unchained* attempts to be a multiethnic representation of American history circa 1858-1859, our attention is drawn to the legitimacy of violence in the shaping of the United States from 1619 to 1776 to the present; the presence of the black story is a kind of inner light that illuminates the gross and vulgar surface of American democracy's saga. In this instance, the film fails to challenge the exhausted black/white binary conventions of America sufficiently, but it does begin to expose a fantasy of oppositional progress. It is neither good nor accurate history, nor was it meant to be. It is mainly an exposure of American entertainment as national pathology. That fantasy undermines or erases fact works against sympathetic reception of the film, but it does not prevent our understanding why violation of the human body and the worship of violence is an innate element in our historical being. Ultimately, *Django Unchained* is an anatomy of the imperfections of whiteness, the hypocrisy of Euro-American founding dreams, and America's violent soul.

Ishmael Reed, one of our most astute cultural critics, notes in his review "Black Audiences, White Stars and *Django Unchained* ["Speakeasy Blog," *The Wall Street Journal*, December 28, 2012] that the film is a representation of slavery for mainstream audiences. Reed concludes Tarantino is not a responsible white historian and "the business people who put this abomination together don't care what I think or about the opinions of the audience members who gave Tarantino a hard time during that recent q. and a." The q. and a. to which Reed refers is briefly described in Hillary Crosley's " 'Django Unchained': A Postracial Epic?," *The Root*, 25 December 2012.

Reed's conclusion directs attention to the agony of interpretation and the cultural politics that informed the making of Tarantino's film. In suggesting that neither Arna Bontemps's *Black Thunder* nor Margaret Walker's *Jubilee* would be a candidate for a film, Reed is silently telling us why his novels *Flight to Canada* and *Yellow-Back Radio Broke Down* would never fit into a Hollywood scheme of representation. It may be impossible to prove that Reed's novels or *Slaves* (1969) by John Oliver Killens inspired Tarantino in the way Sergio Corbucci's *Django* (1966) and *Mandingo* apparently did, but it is fascinating to speculate that Reed's defamiliarizing of historical time and space played some role in Tarantino's defamiliarizing of America's core values. Reed's narrative strategies are neatly matched by Tarantino's technical strategy of shooting the movie in anamorphic format on 35 mm film. Whether we like or dislike Tarantino, we do have to deal with his art. And we have to deal also with the stellar performances of Jamie Foxx, Kerry Washington, Leonardo DiCaprio, Christopher Waltz; Laura Cayouette's face will be etched in memory as the perfect image of what a Southern belle looked like in 1859 and Samuel Jackson's palpable discomfort in the role of Stephen, the HNIC, warrants several essays. Were the acting in the film not so good, the agony of interpretation would be less intense. It is downright

unsettling that even the minor actors do not disappoint us as cartoon figures. It is deeply troubling that what George Kent named "ceremonies of poise in a non-rational universe" can be had at a discount.

Much has been made of the fact that Tarantino retrofits the Italian spaghetti Western into an American noodle narrative of the South. Thus, he achieves, if we must use a culinary metaphor, a casserole of cinematic genres, a highly valued artistic abomination. In the world of filmmaking, an abomination may not be a failure, particularly if the aesthetic of *merde* and the mimesis of violence is at issue. The visual allusions in *Django Unchained* lead us to suspect that Tarantino is much influenced by the cinema of Sergei Eisenstein, Luis Bunuel, and Ingmar Bergman. It is obvious that he is indebted to the accidental or intended comic excesses of blaxploitation film and to the cinema of cruelty exploited in Peter Weiss's *Marat/Sade*. As future cultural studies of *Django Unchained* will demonstrate, Tarantino generously tips his hat to his ethnic and cinematic ancestry by transposing elements of Pier Paolo Pasolini's *Salo* (1975) into his film. Pasolini, it must be noted, has the dubious honor of having produced the most reprehensible abomination in the history of film. In addition, some of the cinematographic features of *Django Unchained* are as praiseworthy as those in Francis Ford Coppola's *Tetro* (2009).

Perhaps Tarantino's dwelling in the bowels of exaggeration by way of *Django Unchained* is just what Americans needed most to see. They need to look at themselves, at who they were as they publicly "mourned" for the children and adults murdered in Sandy Hook. They were not mourning for hate crimes, self-hatred, or the condition identified by Carolyn Fowler as "racially motivated random violence." They needed to see they were not mourning for the 506 victims of homicides in Chicago during 2012 or for the thousands of flesh and blood victims of rampant violence and abuse in America's cities and suburbs. Americans simply do not grieve for the *Zeitgeist* that is seducing our nation to consider social implosion as an option. *Django Unchained* was perfectly timed to provide 165 minutes of violent entertainment and to cast light on the nature of America's soul unchained. That soul, which we all possess, is incapable of authentic grief. It has "normalized" violence. Violence is salvation. Our souls have mastered the art of indifference, and we are post-humanly happy to have a tragic catharsis on the plantation of life and to walk hand in hand with blind fatalities and unqualified love for our country. We are patriotic. Quentin Tarantino is alarmingly intimate with the habits of the American soul, and he serves us slice after slice of synthetic white cake.

Marvin X Reviews *Django* | Marvin X

Django, finally, the black hero who kills white people! What a change from my childhood attendance at the movie house watching the white man kill Indians and we sometimes cheered at the death of Native Americans while infused with their blood. Whether infused with the white man's blood or not (and surely most North American Africans are, maybe only Gullah and/or Geeche Negroes can claim they are not) it was a pleasure seeing them die at the hands of Django. Yes, this Spaghetti Western, this neo-Roots, gave North American African film writers something to think about, even if they know it is highly unlikely we shall now expect to see more of this "resistance" genre in Hollywood. We've yet to see Danny Glover's long expected movie on the Haitian revolution, yet to see a film on Nat Turner's revolt or Denmark Vesey's or Gabriel Prosser's, although Arna Bontemps novel *Black Thunder* could provide the basis for a Prosser film.

And why has not Spike Lee given us his version of a resistance film rather than condemn this Western fantasy? I was taught in, one creative writing class at San Francisco State University led by the great novelist John Gardner, if you don't like something, use your creativity to write something better.

Being that I am in the Nigguh for Life Club, I am always fascinated by the endless and perennial debate over use of the term, whether nigger or nigguh, now made into a billion dollar word by rappers, reactionary record producers and hip hop culture globally. What fool would not want to use such a profitable term? And nearly all those who claim to abhor the term will, in a moment of passion, make use of it, for example, I hate you nigguh or I love you nigguh!

I have written about the psycholinguistic crisis of the North American African. As my comrade Amiri Baraka noted, what else do you think they called Africans entrapped in the American slave system, Sir? But imagine an African caught in the American slave system speaking German. Better yet, imagine those Africans caught in the Brazilian slave system who spoke several languages, including Portuguese, Arabic, Hausa, etc., while the slave master could not write his name! For me, the term devil ascribed to the Africans was quite amusing: we saw the depiction of pseudo science when the African skull was noted for areas of passivity. How ironic the Africans were described by the oppressor as devils but all the evil, i.e. kidnapping, rape of men, women and children, torture, terrorism and genocide came from the

European "good guys."

Django Unchained as a love story was positive. Seeing a North American African fighting to free his woman from the hands of the devil was inspiring since so many of our women these days suffer abandonment, abuse and neglect. So many must don the persona of the male and find their way by any means necessary. Of course, it would have been better to show a mass insurrection rather than this individual struggle for freedom. Of course, in the world of make-believe inhabited by Hollywood, the depiction of a mass uprising would have been way over the top with the possibility of subliminal suggestion. As Dr. Fritz Pointer said when Brother Mixon killed four police in Oakland, *Django* gave us a dose of obscene pride in seeing the whites die, just as we experienced obscene pride when the Los Angeles black policeman, Christopher Doaner, went postal after suffering alleged abuses in the LA police department. I remember being surrounded by LA police when I asked for directions to City Hall.

Long ago, H. Rap Brown (Imam Jamil Alamin) told us violence was as American as cherry pie. *Django* should remind us of America's roots (laws) that evolved from the violence of the slave system. All the present talk about guns must begin with the examination of America's roots. Most of the present laws were created to prevent the very acts of the type Django carried out. Not only did the slave system fear Africans with guns, but Africans on horses, not to mention Africans who could read and write, and, of course, three or more Africans standing together was a violation of the Black Codes.

But how can the world's number one gun merchant talk about clamping down on gun proliferation? Don't believe the hype. If anything new occurs, the gun merchants will simply increase the export of guns as the call for decrease heightens within America.

Just know America's fascination with gun violence is predicated on preventing the oppressed from rising up and overthrowing the oppressor. Django's personal mission is an example of what must ultimately occur on the mass level. As New York City Councilman Charles Barron once said, "Every Black man should slap a white man for his mental health!" Yes, for the mental health of the Black man and the white man! We've heard there can be no redemption of sin without the shedding of blood.

We believe in peace, non-violence, but we also believe in self defense, that oppression is worse than slaughter. It would be better that all of us North American Africans are murdered outright rather than endure this slow death on the killing floor.

James Baldwin said the murder of my child will not make your child safe. America is now witnessing her children being slaughtered in the suburbs just as poor ghetto children have been slaughtered for decades, and their ancestors the victims of genocide for centuries. Thank God, director Tarantino has given us a fantasy version of what must occur in the real world. His love story is what revolution is about: freeing the family! Yes, the American slave system was about the destruction of family, thus the task of the North American African is the reconstruction of family. We shall not progress as a people until we reconnect with our women and children,

rescue them from poverty, ignorance and disease; emotional, physical and verbal abuse. Ultimately, it is not about killing the white man, which we can never find enough weapons to do so, but it is all about us realizing our women and children are our most precious asset and we shall never make progress until we rescue them from the clutches of the devil. For sure, Django realized he could never be free until he saved his woman. For North American African men, this is food for deep thought!

Relinking Django | Al Young

"History is more or less bunk. It's tradition. We don't want tradition. We want to live in the present, and the only history that is worth a tinker's damn is the history that we make today."

—Henry Ford, *Chicago Tribune*, 1916

"There is an amazing mystical rapport between politicians and movie actors; they come from the same DNA. They're so much alike that I'm hard pressed to know which is the entertainment capital of the world: Hollywood or Washington, D.C."

—Jack Valenti, Former President of the MPAA, 2001

In our flickering, wham-bam techno-millennium, where can anyone draw the line between fiction and fact, travesty and truth, history and bunk? If the History Channel, the Discovery Channel and The Learning Channel no longer bother, why would Hollywood?

A canny, sassy, flamboyant maker of big-grossing pictures (*Pulp Fiction, Kill Bill, Jackie Brown, Inglorious Basterds*), Quentin Tarantino understands how shock, sensation, the unexpected, and the offbeat spike up and spice up any basic story. He knows, too, how basic storytelling overrides genre. And big-screen storytelling doesn't get any more basic than *Django Unchained*, his controversial, drop-dead 2012 hit. The basic plot of the Hollywood-invented shoot-'em-up gallops at a pace almost as lean, sweaty, and predictable as those sequenced stills of running horses captured between 1871-1885 in multiple camera stop-motion by Stanford's Eadweard James Muybridge, an alleged murderer.

Tarantino writes, produces, directs movies after the fashion and in the spirit of the earliest Hollywood box-office conquerors: Edwin S. Porter's *The Great Train Robbery* (1903), Mack Sennett's *Tillie's Punctured Romance* (1914), D.W. Griffith's *The Birth of a Nation* (1915), and Merian C. Cooper and Ernest Schoedsacks's *King Kong* (1933).

If the truculent *Django Unchained* trashes factual African American history, it also stampedes roughshod through U.S. settler and plantation history—and at a pace so reckless it might leave even disbelievers breathless. How clever of Tarantino to move the action and plot of a formulaic spaghetti western—sauced with blood and

plenty of meatballs—from the crude American frontier to the parlor-polished Big House of the antebellum South. The setting: 1863, two years before the end of the Civil War.

A shoot-'em-up for sure, Tarantino's yarn unwinds in a pattern that still gives diehard fans of classic spaghetti westerns the kind of fix that keeps them strung out. The pattern was set by Italian director Sergio Leone's *A Fistful of Dollars* (1964), *For a Few Dollars More* (1965), *The Good, the Bad and the Ugly* (1966), and *Once Upon a Time in the West* (1968). Italian composer Ennio Morricone scored the mood-setting music, crucial to stretching the high of those cut-rate productions. Sergio Leone's best-known and best-rated westerns made Clint Eastwood a star.

The authorized star of *Django Unchained* is Christoph Waltz, quite in spite of Jamie Foxx's big billing and glamorous presence in the movie's promotional trailers. Foxx plays Django, the story's hero, (the elaborately articulate Schultz Waltz might call him eponymous), one of seven Mississippi slaves just purchased by two professional, skuzzy-looking traders. The Speck Brothers are hauling their property by night across the Texas panhandle to deploy, so to speak, when the film opens. In a wintry, breath-clouded, ice-knifing scene, we watch Dr. disrupt by lantern light brothers Ace and Dicky Speck's wagon-pulled procession of barefoot, chain-linked human cargo.

Aiming his pistol point-blank, with no warning, Schultz calmly kills Ace Speck in cold blood. When Ace's shaken brother objects, Schultz takes aim again and shoots Dicky Speck in the face, astonishing the slaver and his shivering slaves. Once Schultz finds out which of the seven slaves has been hauled from the Carrucan Plantation, he bucks up. He seeks information about three fugitives on his wanted list: the Brittle Brothers.

It's a bushy-haired man with an "r" branded into one cheek who answers Schultz. The man's back is seared with scars. Schultz unchains Django and breaks off his leg iron. Django has told him he knows what the Brittle Brothers look like. He knows their names: John, Ellis and Little Raj (for Rodger). The cool and cunning bounty-collector has finally caught up with the man who will help hunt down his biggest-paying prey.

Django doesn't really know what to make of the drama suddenly unfolding around him. He misses Broomhilda (Kerry Washington), his fine German-speaking wife. Her silly name derives from the fifth century Visigothic ruler Brunhilda of Toledo, who fueled one of the most popular German legends. Later, in a cave, Schultz will retell the story of Brunhilda and Sigfried to Django. Three months ago, at Mississippi's Carrucan Plantation, the Brittle Brothers snatched Broomhilda and Django, split them up, and auctioned her off in Greenville. Django winds up with the Speck Brothers in Texas. Django seeks revenge.

In a flashback close-up that could've been shot yesterday in Baghdad's Abu Ghraib prison, we see Django, his face muzzled, his body held down by Rodger and Ellis Brittle while John Brittle brandishes the red-hot iron that will burn the "r" for *runaway* into the angry man's cheek. Broomhilda, too, we find out, has been likewise branded. We're talking chattel (as in cattle) slavery, a source of free labor—or, by any measure, the unpaid labor force that built America, the Americas, and much of what

we still call Western Civilization.

In this western movie, set in Dixie, certain facts stand out. When King Schultz and Django ride up on Fritz and Tony to the Bennett Manor in Gatlinburg, Tennessee, Spencer Bennett lets them know flat out what is what: "It's against the law for niggers to ride horses in this territory." When Schultz explains that Django is in fact his personal valet, a free Negro, who can ride what he pleases, Bennett barks right back: "Not on my property, around my niggers he can't."

Cotton ranks second as Bennett's money-maker; ponies come first. The majority of his slaves are young, servicing females known as ponies, and, yes, they are up for sale.

King Schultz tells Spencer Bennett: "I've been told by those who should know, the most exquisite African flesh in the state of Tennessee is bred right here on your land."

"Oh," says Spencer Bennett, "I got my share of coal blacks, horse faces, and gummy-mouth bitches out in the field. But the lion share of my lady niggers are real show ponies."

Schultz: "Well, that's what I'm looking for—a show pony for young Django. So the only question that remain is, do you have a nigger here worth five thousand dollars?"

In truth, Django misses Broomhilda; the thought of her haunts him. He sees his missing wife everywhere he turns. While Schultz longs to wrap up his search and sock away the cash he'll get for the arrest or capture, dead or alive, of the rest of the fugitives on his Southern wanted list, Django longs for Broomhilda. Having forced the dying Ace Speck to sell him Django, Dr. Schultz, who considers slavery immoral, now just happens to own this strapping young man who—under Schultz's tutelage of course—turns out to be a natural hunter and marksman.

Once they do run up on the Brittles, Schultz will need Django to identify them, so he makes a proposal. They'll pair up. The good doctor will give Django his freedom, plus $25 a pop for each of the three Brittle Brothers they track down. For good measure, he'll throw in a new suit and fancy cowboy hat. To Schultz's extraordinary offer, the agile, attentive Django says: "Kill white folks and they pay ya? What's not to like?"

Schultz and Django's dangerous, arduous five-month journey—part hunting mission, part killing spree—carries them by coach and on horseback (Schultz's horse Fritz; Django's horse Tony) across Texas and Tennessee to Mississippi and the infamous Candyland Plantation. Dandyish, sadistic plantation heir Calvin Candie (Leonardo DiCaprio), his widowed sister Lara Lee (Laura Cayouette). From their prolonged kisses and caresses, we can only gather that brother and sister love or, rather, might be loving on one another just a little too much.

And then we meet Stephen (Samuel L. Jackson), the almighty executive house Negro who, with Calvin, co-supervises their torturous plantation. So brutal and cruel is Candyland's reputation that slaves throughout the South shudder at the thought of being bought and deployed there. A magnificent piece of work, Samuel L. Jackson deserves special commendation for his superb depiction of Stephen the fathering uncle of all Uncle Toms. The bald, cotton-browed, eye-rolling Stephen, who looks as

if he's just stepped off the presentation panel of an Uncle Ben's Rice box, has served the Candie family for generations. We first see him in the big house, seated at a desk, rubber-stamping the backs of checks. Stephen, whom Tarantino might have named after Stephen Foster, composer of "Old Black Joe," knows in his ancient bones just how the system works. Color? Structure? What you mean? Plantation management and empire management require the same skills.

Slaveholder Calvin Candie—a man who pays and trains slave boxers to beat each other bloody for his jumpy amusement—believes in the quack pseudo-science of phrenology. Like 19th century eugenics whose tenets of white superiority crossed the Atlantic from the U.S. to take up life in Germany, phrenology held that the Negro brain is structured for servility. Old Black Stephen's brain and years have programmed him to stand ready to lay down his life right here, right now to protect his master and preserve the sacred institution of slavery, a system that has made his edgy life comfortable. From his and Calvin's viewpoints, what's there to not like?

When Django shows Schultz his reluctance to shoot to kill Smitty Bacall, a bank robber hiding out as a farmer, who's plowing a field with his twelve-year-old son, Schultz says: "Smitty Bacall wanted to rob stagecoaches, and he didn't mind killing people to do it. You want to save your wife by doing what I do? I kill people and sell their corpses for cash. His corpse is worth seven thousand dollar. Now quit your pussy-footing and shoot him."

A shoot-'em-up, indeed! What better sticker to slap on Tarantino's latest genre jaunt? Not only did he make the picture; he plays a key if awkwardly acted cameo role as a mine owner. Who can doubt his genius for calculating audience expectations for the films he keeps making? Genre-fed stories call for whopping servings of passion and blood; violence and sex. In *Django Unchained*, neither conjugal nor casual love-making turn up. The film roars and rushes to its cumless, fiery climax as the classic westerns have always done, as wall-to-wall gut-spilling carnage hogs the screen at Walmart level. At one point, so many blood-bubbling, blood-gurgling bodies get piled into the foreground that all you can do is shake your head and laugh. What is this?

Jamie Foxx, himself a sex symbol, never gets to express his tender or erotic side. Restricted to a passionate, closing kiss with his Kerry Washington, they have to leave it at that. Besides, in Hollywood and spaghetti westerns, violence embodies sex. Instead of Roy Rogers or Gary Cooper or Randolph Scott killing up whole busloads of people at a time, people who "deserve to die," with two six-guns, it's King Schultz and Django. Instead of John Wayne or Clint Eastwood getting the girl at the end, then trotting into the sunset, it's Django. Django and Broomhilda, the both of them consummately neutered.

Just as all art expresses and reflects its parent culture, so the spaghetti western embeds and celebrates American history and values. Cowboy or gangster? This was a question that sometimes came up when I first began to travel abroad in Spain and elsewhere, when they got it I was from the States.

That Tarantino's promiscuous use of violence in every film he makes is a given. He knows the market. What may not be immediately apparent is this: Quentin Tarantino's violence-packed storytelling owes plenty to American values.

I think of the young men and women seated at computer consoles in Florida, New Mexico, Arizona or Southern California, knocking back a Big Gulp or a Red Bull or a latté while, with the push of a key or with the click of a mouse, they discharge yet another missile. From far away, they watch missiles rain down upon villages in abstract Pakistan, Afghanistan or Mali, brown and black places they'll never see or visit. On video feedback screens they might even register images of splattered non-combat civilians running or falling or falling dead. How they really see them. They're following orders. "We're taking out people who deserve to die. The rest is collateral damage." They're doing their job.

PART TWO
COMMENTS ON HOLLYWOOD AND FILM

Nowhere to Run...Nowhere to Hide: Young Black Men Trapped in the Crossfire | Playthell G. Benjamin

"One of the most impressive things I have witnessed as a social worker in East Oakland is the bravery of African American men. Every day they face sudden death from criminals or the police." This comment was from Denise Kennedy, a young white woman who was completing her degree in social work. During a visit to the Fruitvale district of Oakland in the summer of 2013, I had a conversation with Denise, who lived and worked near the BART station where Oscar Grant was murdered. She spoke with the heightened sensibilities of an able poet, and felt deeply for young black working class men in East Oakland and their tragic circumstances. She also felt the shared frustration of being able to do little about it except bare honest witness to their plight. As I listened to her talk, I thought of how her comment echoed the Reverend Al Sharpton's observation: "Young black men have to dodge the bullets of the cops and the criminals!" Unfortunately, they are caught in a crossfire.

It was not lost on me that Rev. Sharpton's remarks were inspired by incidents across the country in New York City. One need only take a cursory look at the data in order to see that this is a nationwide phenomenon; it sometimes seems that the Gods are angry about this slice of America's demographic. Yet few media commentators, who dominate the discussion about the predicament of young black men, appear to comprehend the complex web of historical, economic, political and cultural forces which conspire to create their predicament; forces of such magnitude it takes on the character of classical tragedy.

What W.E.B. DuBois said about the ritual murder of black men early in the 20th century called "lynching" is also true about violence against black men today: "Not everywhere but anywhere, not all the time but anytime." Alas, since the murder of innocent African American males is a redundant phenomenon, one might well ask what makes the Fruitvale incident special. Well, they are all "special," in their way, but the victims didn't happen to live in the same town with a great literary warrior like Ishmael Reed who believes "writin' is fightin'" and employs his prose as a weapon in defense of the powerless.

I watched the rebellion in the streets of Oakland on television, after the jury gave the killer cop a slap on the wrist for wantonly murdering Oscar Grant as he was returning home from a night of revelry in San Francisco on New Year's Eve. Then after going out to see the movie about the horrific incident, I wanted to visit

the Fruitvale station, much like one who seeks enlightenment visits a sacred shrine to pay respect.

The movie, *Fruitvale Station*, was written and directed by Ryan Coogler, a young black man living in the Bay area and was about the same age as Grant. Coogler transformed Grant from a statistic, just another faceless victim, to a flesh and blood human being: a father, a son, a lover, a worker, a friend, a person who was part of a struggling community of black and brown people trying to eke out a living without running afoul of the law in the Darwinian struggle for bread amidst the economic wasteland of a post-industrial American city.

Oakland's Fruitvale District is dotted with the skeletal remains of factories, relics of America's industrial era when the label "Made In America" inspired awe in consumers and competitors around the world. These factories provided employment for an army of workers armed with nothing more than high school diplomas or less. These jobs attracted much of the black population to migrate to California from Louisiana and Texas in search of economic security and to escape the brutal racial caste system of the South.

That's how Bobby Seale and Huey Newton, who founded the Black Panther Party for Defense to fight police brutality in "Oaktown" nearly half a century ago, ended up in Oakland. However, instead of sticking to the struggle for a different and better approach to policing—a battle they might have won—they became Maoist "revolutionaries" and decided to overthrow the U.S. government by armed revolution.

Predictably, they were destroyed by the government that they publicly proclaimed their intention to overthrow on television. Alas, it proved a fool's errand and today I could find no trace of the Black Panther legacy in Oakland. Yet the police still murder innocent young black men in cold blood with near impunity, as the case of Oscar Grant demonstrates. And still the economic conditions in the city are far worse than they were then—especially for the working class.

Today, Oakland is a poster child for the post-industrial city; the booming factories have been transformed into artists' studios and living spaces, or parking lots for commercial trucks, while the giant cranes that line the Oakland waterfront bear silent witness to the grim reality of globalization, a phenomenon that is making the blue collar American worker obsolete and robbing unions of their bargaining power and their political clout. This situation has caught millions of American workers in the steel trap of structural unemployment and increasing political impotence.

American workers' jobs have disappeared, evaporated like icicles in a blacksmith's furnace. They are casualties of massive, unplanned technological changes in the structure of the American economy and the mammoth multi-national corporation's decision to export their manufacturing facilities overseas where they can pay their work force a fraction of what a unionized American industrial worker used to make. This has led to the twin evils of robotization and globalization, which is devastating the living standards of the U.S. working class. Afro-American intellectuals such as James Boggs and Dr. William J. Wilson have described the revolution in technology that transformed the manufacturing process, and its consequences for the working class in their books *The American Revolution: Pages from a Negro Workers Note Book*, and

When Work Disappears.

A bad situation is made worse because our public officials either do not understand what has happened to the American worker or they choose to live in denial, spinning urban fables about the return to a prosperous industrial economy. And the left, particularly the Marxist intellectuals, are equally perplexed. Chained to a theory of capitalism developed by a German political economist/philosopher whose critique of capitalism was developed during the first half of the 19th century as he witnessed the industrial revolution in England, and giant smokestacks were signs of progress, the Marxist "theoreticians" are clueless. The bromides they spout as cures to the protracted economic crisis in America today only add to the confusion.

Instead of explaining to unemployed workers that the only way President Barack Obama, or any President, can substantially alleviate mass unemployment is to make the government the employer of last resort—as Franklin D. Roosevelt did during the Great Depression of the 1930s, an event also triggered by the incompetence of Republicans at managing the economy—while the Republican/Tea Party controlled House of Representatives block every attempt on his part to initiate a massive jobs program rebuilding a crumbling American infrastructure, we are witnessing tragedy become farce, as the left blames President Obama for the lack of action—which is exactly the outcome the strategists on the right hoped for.

This makes the doctrinaire left—people like Dr. Anthony Monteiro, a longtime member of the Communist Party, Glenn Ford of the Black Agenda Report, Carl Dix of the Revolutionary Communist Party—objective allies of the Tea Party. It is irrelevant that they are coming from the far left, and the Tea Party is on the far right; in the end it is a distinction without difference. The consequence for the President's agenda is the same. And the American people, especially working class youths, will continue to suffer high unemployment.[1]

Yet while the pompous poseurs on the left spout theoretical abstractions, sinking ever deeper into hopelessly esoteric debates conducted in language that's incomprehensible to the workers they purport to speak for, unemployed black working class males are confronted with the reality that in America there are only two ways to get money: work for it in the legitimate economy or turn to the underground economy for survival—with all the dangerous pitfalls one must avoid. Since without money one cannot acquire the basic necessities of life, many young men are forced by their increasingly desperate circumstances to commit economic crimes merely to survive.

Some of them end up in the graveyard or, like Oscar Grant, are unsuccessful at criminal enterprise and wind up spending some time in jail. Hence although Grant had a prison record because of a conviction for selling pot—a wonderful euphoric weed the ancient Hindu sages called "the poor man's heaven," a common pleasure of millions of Americans—he was no thug. Grant was just an underemployed worker trying to make his way by selling the "joy weed" that the prophet Abraham extols in holy writ.

As those who really understand the real deal about agri-business in the Golden State well know, wisdom weed is the premier cash crop and it keeps quite a few people of all ages and races afloat in the Bay Area. The people I've met are honorable and

there can be no question that they have committed no crimes that begin to approach the atrocities of the tobacco industry, whose products, by some strange perversion of justice, remain legal and uncontrolled, and thus readily available despite the fact that it is more addictive than heroin or crack and science has demonstrated it causes deadly cancers!

The distinguished sculptor and college teacher Susannah Israel lives in the Fruitvale District and regularly shopped at the market where Grant worked. She remembers him as a friendly young man who was always helpful to shoppers and did his job with a smile and, like many thousands of Oakland residents of all colors and ethnicities, she was outraged when she heard he had been murdered by the BART cops. Especially since, as I was to later discover, most Oaklandites don't even regard BART security as "real cops." As the movie indicated and as the filmmaker tried to make true to life, Oscar was struggling to get his life together. He was taking college classes and had started a family with a Mexican-American lady.

The Fruitvale stop on the BART was walking distance from where I was staying in East Oakland, and after watching the movie, every time I passed that spot I thought of Oscar Grant.

In truth I had been reluctant to see the movie; I thought it was a thrice told tale that would vary but little in detail from all the others and it would just piss me off and make me want to pop a cap in a cop—something I had come very close to doing on two occasions in my life: once near the California Arizona border and once in Philadelphia, back in the day when I was a pistol packin' rebel. Since I have witnessed these kinds of incidents as a politically conscious observer for over half a century, one would think my emotions would be steeled to its recurrence. Not so.

Although the murder of innocent black men in America is an old story, one never gets used to it; each instance remains as shocking and painful as the first time. For me this is a long running tale. My first experience with community action against "police brutality" was in Philadelphia nearly a half century ago; I was barely 21. An Italian cop shot and killed a retarded black youth who had stolen some inexpensive item from a store. He was running away from the scene when the policeman shot and killed him. As news of the killing got around, the entire black community became outraged, and I got a preview of the mass urban rebellions that would break out all over America as city after city went up in flames later in that turbulent decade of struggle.

The North Philadelphia Equal Justice Committee called a demonstration against police brutality to be held right at the scene of the murder. Headed by Harold Allen and Sandy Smith, the North Philadelphia Equal Justice Committee was a front organization for the POC—Provisional Organizing Committee for a real Marxist Leninist Communist Party in the USA, an offshoot of the most radical leftist faction of the American Communist Party, quite a few of whom were black. Like all professional revolutionaries, they seized upon this incident of wanton police murder to mobilize the community for struggle and raise their political consciousness in the process.

I was invited to speak at the rally because I had become a well know voice in the black community by virtue of the lectures on black history I was presenting as

a weekly feature on "The Listening Post," the most popular radio talk show in the Afro-American Community of the Delaware Valley—Philadelphia, Camden New Jersey, Wilmington Delaware, etc. Hosted by Judge Joseph H. Rainey, this show was a trailblazer in progressive black talk radio, and was broadcast over WDAS AM, a commercial station. It was a regular stop for Malcolm X whenever he was appearing anywhere in the area, which was often.

I was also teaching a black history class in the basement of Mt. Zion Baptist Church, pastored by the activist preacher and protégée of Adam Clayton Powell, Rev. Leon Sullivan, aka "The Lion of Zion." It was in these classes that I met Max Stanford aka Dr. Muhammad Ahmed, and we formed RAM—Revolutionary Action Movement—in 1962. Both Sullivan's church and the RAM office were located in North Philly so we were quick to support the demonstration. I was speaking on the mic, firing the crowd up by reviewing the horrid historical record of white terror and murder directed against Afro-Americans by Euro-Americans, and the crowd continued to swell, with people hanging from windows and perched on roof tops.

The streets of North Philly are narrow, even a busy street like Columbia Avenue, where the rally was held, and the power of the people was palpable; one could feel it in the vibe running through the swelling crowd like an electrical current. Suddenly a contingent white policeman appeared. I pointed at them and shouted, "There they are! There are the killers!" When the cops attempted to break up the rally the crowd went crazy.

Even today, at 71 years old, I cannot remember a time when I did not feel a sense of danger on the streets of America, did not feel the need to be on guard, to operate in a flight or fight mode when walking about at night. When I was a teenager in Florida it was the rednecks who posed a danger, in Philadelphia it was the black gangs during my teen years and the white cops plus gun totin black criminals during adulthood. It was the price of the ticket we had to pay for living in the "Promised Land," the most modern affluent society in the world, a place of abundant opportunity and anything really is possible…if one can stay alive.

Staying alive, as the murder of Oscar Grant reminds us, is no easy matter for young black males, who suffer a higher casualty rate on the streets of America than soldiers fighting on the front lines in Iraq and Afghanistan! This point was brought home to me with shocking clarity when I saw a news report on CNN about violence on the streets of Philadelphia.

The broadcast was set in the operating room in the Trauma Center at the University of Pennsylvania, which is located on the edge of a large black community in West Philadelphia and is only about 20 blocks from the black community in South Philadelphia. The chief surgeon was an army colonel who had run operating rooms on the front lines in Iraq and Afghanistan. He told the reporters that there were some nights when he felt like he was back in the theaters of war because of the number and severity of the gunshot victims that wound up on his operating table.

The surgeon went on to say that his operating room was one of the major training facilities for surgeons heading off to the war zones in Iraq and Afghanistan. While all of this is shocking, the thing I found most disconcerting is that these

casualties were inflicted by black criminals not white policemen. This is no picayune matter because it contributes mightily to the use of deadly force by the police.

Unfortunately, most Afro-American commentators on white police violence would rather avoid this fact, as do white ideologues on the left, which prevents serious discussion of the relationship between violent black crime and white police brutality. It is virtually impossible to discuss this relationship without being accused of apologizing for the conduct of racist white policemen. Yet, unless one is willing to believe that white policemen leave their precincts itching to maim or kill a black male there has to be other explanations for white police murders of innocent black men, which they claim are accidents. And from all appearances some of them are. For one thing, if white policeman set out to murder black men as a matter of course, there would obviously be many more black males murdered by white policemen. Yet as things stand, black criminals far more often murder young black men.

This is not an attempt to blame the victim or deny the existence of white racists on the police forces of this nation, but simply to set the record straight. Despite the denial of police officials and fraternal organizations, some racist white cops no doubt welcome the opportunity to murder young black men. Perhaps more so now than during the period of slavery, which spans most of our history in this country.

During the slave era, strong young black men in the spring of life were not wantonly murdered by white overseers or the "pateroles" that patrolled the roads in search of runaways—both of whom came from the same class as today's white cops—that's because slaves were very valuable property that formed the basis of the wealth enjoyed by the planters who owned them. Hence, violence was used to intimidate and discipline slaves; if a po' cracker had murdered a prime field hand under the conditions that Oscar Grant was killed he would have been in big trouble.

This was, of course, not a question of recognition of the slave's humanity but instead would have been viewed in the same way one would view the casual slaughter of a prize horse. He would have been hung for cavalierly killing somebody's horse in California during the "Gold Rush" days. But today no one values strong, young, black males—unless they are athletes. And some white males even have a love/hate relationship with them, especially the sports-obsessed, macho, working-class white males of the sort that end up on the police forces in our inner cities. Many of them suffer something akin to what Sigmund Freud called "penis envy," which accounts for the practice of castrating black men in the south during the long era of lynching.

This was made clear in the testimony of the white woman in the O.J. Simpson case who told us of her surprise at the discovery that the lead detective on the case, Mark Furman, was a big fan of Oakland Raiders running back Marcus Allen, but he became enraged when one of her pretty white girlfriends said she had a crush on Allen. She went on to point out that Furman told her how he would pull over and harass unoffending black men he saw driving by with good looking white women in their cars.

This love/hate phenomenon among white men regarding black men is a persistent theme in American culture; it formed the major impetus for the rise of black face minstrelsy. It was the admiration and envy that white performers felt for the grace and elegance of Afro-American music and dance that made them want to

imitate it, but since it was the creation of "niggers" it could not be presented as "art," only as parody. Some scholars have labeled this the "attraction/rejection syndrome."

Thus the "coon show" was born, where white performers "blacked up" by smearing their faces with burnt cork, had huge painted lips and spouted outlandish dialogue. Astonishingly, this was the most popular form of mass entertainment in 19th century America. White male performers in black face were so pervasive when the song and dance team Williams and Walker (Bert Williams and George Walker) launched their career in San Francisco during 1893, they billed their act "Two Real Coons."

Although they refused to perform in blackface at George Walkers insistence while they played the all black TOBA, or "Chittlin Circuit," white performers in "blackface" had so thoroughly shaped the way Euro-Americans viewed Afro-Americans when black performing artists entered the white vaudeville stage— beginning with Bert Williams in the Ziegfeld Follies at the turn of the 20th century— they also had to "black up" with the burnt cork mask. And they were always cast as dancing, prancing, bumbling buffoons and comic domestics; such things as tender love scenes, or even romantic songs, were denied the black performer.

Not only were they bereft of all the manly virtues such as strength, courage, reliability, honesty, industry and sex appeal, but also they were even denied the flashes of wisdom that was characteristic of the European court jester. Freud's observation that whenever powerless men chose to speak truth to the powerful "they donned the fool's mask" was not true of them. The blackfaced Sambo figure was just an ineffectual fool, he had no saving graces, as Professor Joseph Boskin adroitly points out in his path breaking book, *Sambo: The Rise and Fall of an American Jester.*

The image of Afro-Americans fashioned in the Minstrel show was carried into the "talkies" i.e. moving pictures with sound, first by blacked up white performers like Al Jolson, then by authentic black performers like Stepin Fetchit. It was the motif of the first nationally broadcast radio show *Amos and Andy*, which was the most popular show on the radio in the mid-twentieth century and literally created network radio.

The radio shows were written and performed by two white guys, Freeman Gosden and Charles Corell, but when it was produced for television the show employed black performers who struggled as best they could to give depth and dignity to stereotyped caricatures of Afro-Americans created by whites. It proved a fool's errand, because the National Association for the Advancement of Colored People led a campaign that drove them off the air.

These distortions of Afro-American character and culture persist today among many whites, especially the uneducated population. And the neo-coon show antics of some very popular rappers also help to keep it alive. Even President Obama has been cast in the Sambo role; although he is as about as different from the stereotype as one can imagine, which underscores both the irrationality and the tenacity of this racist demeaning image of black men.

It is as if working class whites, who are as far removed from the real centers of power as the black working class, and who were the target audience for these shows and from whose ranks its creators were molded, have a psychological need to

diminish black beauty and intelligence in order to salvage some sense of self-worth. If it's difficult to be poor and black in America, there is relief to be found in the belief that one's failure is the result of racial discrimination; but if you are white and poor it is hard because then you are genuine failure, which is great a burden to bear.

For whites, their melanin depravation placed them higher in the American racial pigmentocracy in which pale skin is privileged over the black, brown and beige hues that Duke Ellington celebrated in music, Langston Hughes immortalized in verse and Gauguin reproduced in his paintings. And part of that process, which involves a lot of what Freud called psychological "Projection," is to accuse black men of their own transgressions. This explains how white men rationalized lynching black men for imaginary "rapes" of white women when in reality it was they who were raping black women.

This is the same class of phenomenon that Rabbi Richard L. Rubenstein noted in his book *After Auschwitz*. It characterized the mindset of many German anti-Semites who stigmatized the Jews as "Christ killers" and projected the guilt for their sins onto the Jews, then used it to justify genocide. This is what many poorly educated working class whites are doing today when they employ racist stereotypes to deny the legitimacy of the Presidency of Barack Obama, and applaud racist verbal arsonists in the mass media such as Bill O'Reilly that say things like people are "coming out of the crack houses" to sign up for Obamacare.

As odious as he is, O'Reilly is not the worst of the racist verbal arsonists in the mass electronic media. The most vicious defamer of Afro-Americans, non-white immigrants and even President Obama himself, is Rush Limbaugh—an embarrassingly ignorant porcine dope fiend—who spews out hysterical screeds to millions of dumb desperate scared white Americans daily. It does not require a lot of imagination to envision the effect this has on ignorant economically insecure whites who the Republican pollsters and strategist cynically describe as "low information voters." And Rush Limbaugh employs this media to whip his listeners into a racist frenzy much like Dr. Joseph Geobbels used it whip the German people into the anti-Jewish hysteria, which sparked the Nazi holocaust.[2]

During the black revolt of the 1960s, millions of working class whites north and south of the Mason-Dixon Line began to abandon the Democratic Party, fleeing like foxes from a forest fire, and migrate to the Republicans—a development that changed the nature of American politics and gave birth to the strange menagerie of bedfellows we see today. This exodus was spurred by the Democrat's role in passing the landmark civil rights legislation that destroyed the de jure racial caste system, statutes, which provided the legal justification for white privilege.

Pete Hamill is a New York City son of the Irish working class, a group that had benefitted mightily from the racial caste system in America. He wrote an arresting inside report that painted a penetrating portrait of that class as he observed them. His findings appeared in a *New York Magazine* article published in the April 14, 1969 edition, titled "The Revolt of the White Lower Middle Class." Although this article was written forty-four years ago, its prescience regarding the mood and direction of the white working class is manifest in the Tea Party Republicans today.

"They call my people the White Lower Middle Class these days." Hamill writes,

"It is an ugly, ice-cold phrase, the result, I suppose, of the missionary zeal of those sociologists who still think you can place human beings on charts. It most certainly does not sound like a description of people on the edge of open, sustained and possibly violent revolt. And yet, that is the case." Hamill goes on to explain, "the bureaucratic, sociological phrase is White Lower Middle Class. Nobody calls it the Working Class anymore."

Despite the fact that nobody wanted to call the working class by its proper name, a trend that continues today, Hamill insists:

> But basically, the people I'm speaking about *are* the working class...they stand somewhere in the economy between the poor... and the semi-professionals and professionals who **earn** their way with talents or skills acquired through education. The working class earns its living with its hands or its backs; they do not live in abject, swinish poverty, nor in safe, remote suburban comfort. And they can no longer make it in New York.

Although Hamill is speaking specifically about the situation of the white working class in New York City, the attitudes that he finds in white working class taverns in Brooklyn are echoed in the rants of Rush Limbaugh and other right wing media provocateurs, and the major themes can be heard in the rhetoric of the so-called "Republican Base." The passionate belief that they shouldn't have to pay taxes to help support programs for the poor is clearly reflected in the Republican attack on government food supplemental programs such as food stamps and free school lunch and breakfast programs for children, who will not otherwise get the nutrition that is critical to their physical and mental development. And ironically poor whites need it just as badly——as numerous television reports are showing as I write.

The callousness of the white working class is based on the belief that money is being taken from their paycheck to support people who don't want to work and expect to get everything for free. Hamill recounts a conversation he had with an ironworker, a very dangerous job, which dramatically illustrates his point:

> I'm going out of my mind," an ironworker friend named Eddie Cush told me a few weeks ago. "I average about $8,500 a year, pretty good money. I work my ass off. But I can't make it. I come home at the end of the week, I start paying the bills, I give my wife some money for food. And there's nothing left. Maybe, if I work overtime, I get $15 or $20 to spend on myself. But most of the time, there's nothin'. They take $65 a week out of my pay. I have to come up with $90 a month rent. But every time I turn around, one of the kids needs shoes or a dress or something for school. And then I pick up a paper and read about a million people on welfare in New York or spades rioting in some **college or** some fat welfare bitch demanding——you know, not askin', *demanding*——a credit card at Korvette's ... I *work* for a living and / can't **get a**

credit card at Korvette's . . . You know, you see that, and you want to go out and strangle someone.

Yet Pete Hamill tells us "Cush was not drunk, and he was not talking loudly, or viciously, or with any bombast; but the tone was similar to the tone you can hear in conversations in bars like Farrell's all over this town; the tone was quiet bitterness." And Hamill assures us that Cush's attitude is typical of what he found among other white workers.

> 'Look around,' another guy told me, in a place called Mister Kelly's on Eighth Avenue and 13th Street in Brooklyn. 'Look in the papers. Look on TV. What the hell does Lindsay care about me? He don't care whether my kid has shoes, whether my boy gets a new suit at Easter, whether I got any money in the bank. None of them politicians gives a good goddam. All they worry about is the niggers. And everything is for the niggers. The niggers get the schools. The niggers go to summer camp. The niggers get the new playgrounds. The niggers get nursery schools. And they get it all without workin'. I'm an ironworker, a connector; when I go to work in the mornin', I don't even know if I'm gonna make it back. My wife is scared to death, every mornin', all day. Up on the iron, if the wind blows hard or the steel gets icy or I make a wrong step, bango, forget it, I'm dead.'

This virulent hatred of black people and contempt for white liberal politicians on the part of the white working class was exposed in all of its fascist inclinations when George Wallace, the fire-breathing racist governor of Alabama, met with a group of working class white ethnics of the sort that sociologists Michael Novak describes in his 1972 tome, "The Rise of the Unmeltable Ethnics," whom he called PIGS: Poles, Italians, Greeks and Slavs. This is the Democratic demographic that first became the "Reagan Democrats" and metamorphosed into todays "Republican base." But at first they gravitated toward the American Independence Party, founded by Governor Wallace.

In his seminal text, *The Politics of Rage: George Wallace, the Origins of the New Conservatism, and the Transformation of American Politics,* Dan T. Carter, an award winning southern historian, recounts an incident that occurred on the campaign trail during Wallace's run for the presidency. After analyzing how Wallace enflamed the white racist audiences who came out to his rallies with reckless rhetoric, Dr. Carter writes:

> In the impassioned atmosphere of the 1968 campaign, however, it proved to be more difficult to predict the outcome of the intricate minuet of insult and response. While most followers were satisfied just to listen to Wallace talk about 'skinning heads' and 'popping skulls,' others wanted the real thing. Tom Turnipseed got a taste of that dark side when he stopped in a small working

class district outside Webster Massachusetts, in mid-September, to arrange a Wallace rally at a local Polish-American club. Their members, club officers told him after a few drinks at a local bar were 100% behind the Alabama governor. 'Now let's get serious a minute,' said the club president, "When George Wallace is elected President, he's going to round up all the niggers and shot them, isn't he?' 'Naw' replied Turnipseed, laughing, 'nothing like that. We're just worried about some outside agitators. We're not going to shoot anybody.' He looked around at the grim, determined faces. 'This guy got pissed' remembered Turnipseed, 'and he said, 'Well, I don't know if I'm for him or not. (p 362)

It is instructive to note that these guys felt this way before that overfed charlatan Newt Gingrich was running around like Porky Pig on crack raging against welfare recipients, calling Barack Obama "the food stamp President," and threatening to cut the program if he were elected President, despite the fact that so many people were on food stamps because the Republicans crashed the economy!

Even as I write, many Americans who depend upon food stamps to feed their children and senior citizens struggling to survive on meager Social Security payments, are horrified as they witness the spectacle of cold blooded House Republicans crafting a bill to drastically cut or eliminate much of the food supplement program; even though one of the congressmen writing the bill admits that his family once benefitted from food stamps. Newt, who holds a Ph.D. in history, knows his position is nonsense but he was playing to the untutored racist white mob, who acts on instinct rather than knowledge.

Furthermore Newt, and the other politicians on the rabid right have what Republican intellectuals, such as the powerful strategist Bob Fromm, have called the "Conservative Entertainment Complex" to warm up their audience. The intellectuals in the Republican establishment blamed the verbal arsonists in the CEC for Mitt losing the last presidential election to Barack Obama by forcing Mitt so far to the right. But if white workers held anti-black views such as Hamill and Dr. Carter recorded before the existence of powerful right-wing media organizations like WABC AM Radio and Fox News—home to Rush Limbaugh, Sean Hannity, Laura Ingram, Bill O'Reily, and other similar voices—pumping out carefully formulated disinformation 24/7, it is in the nature of things that these feelings are even more intense among that demographic now.

Thus it comes as no surprise that the average age in Rush Limbaugh's demographic is 67 years old; these are the people for whom the election of Barack Obama is an unmitigated disaster. For them it is as if the world has turned upside down and nature itself is out of whack. They have literally watched the world they grew up in disappear. When they came of age the idea of a black man in the White House—especially one with an African name, the progeny of an African man and a white American woman—was not even believable as science fiction; the idea exhausted the limits of the imagination.

Struggling whites who live in an information bubble where right-wing media

provide a stream of verbal arsonists enflaming their emotions as they listen to recitations of the alleged crimes of President Obama, who is tearing up the constitution, holding prayer services for the Muslim Brotherhood on the East Lawn—although there is no East Lawn—that Obama is a secret Muslim conspiring with Al Qaeda to destroy America, was born in Kenya therefore his presidency is illegal, are all too happy to believe it's true and are seething with anger toward the President, whom they regard as unfit to lead the United States, and that anger is directed to black men in general. No critic has written more perceptively, or with greater sophistication, about the dangerous role mass media is playing in promoting hatred of the President than Ishmael Reed; check out *Barack Obama and the Jim Crow Media.*

The rest of the nation were allowed a peek into insular working class white communities in the adventures of Archie Bunker, in "All in the Family," a popular television sit-com where the writers employed humor to expose and ridicule the rampant bigotry and ignorance of those uneducated working stiffs—Joe six pack or the more contemporary "Joe The Plumber" whom the filthy rich Senator John McCain befriended to try and gain "street cred" with this coarse, surly and paranoid crowd.

Some of these enraged racist whites from such communities end up on the police force in neighborhoods they regard as urban jungles filled with predatory black and brown males. Viewing the world from the racist perspective in which they were socialized, they are willing to resort to deadly force at the slightest provocation. A cursory glance at the cops who kill innocent unarmed black men reveals that more often than not they were born, raised, and continue to live in these white enclaves.

This is certainly the case with Johannes Sebastian Mehserle, the BART cop that killed Oscar Grant, taking the life of this 22-year-old young man before he had a chance to live. For instance Mehserle, a son of German immigrants, grew up in Napa County California. A look at the latest census data for Napa tells the story.

According to the 2010 United States Census, Napa County had a population of 136,484. The racial makeup of Napa County was 97,525 (71.5 percent) White, 2,668 (2.0 percent) African American, 1,058 (0.8 percent) Native American, 9,223 (6.8 percent) Asian, 372 (0.3 percent) Pacific Islander, 20,058 (14.7 percent) from other races, and 5,580 (4.1 percent) from two or more races. Hispanic or Latino of any race were 44,010 persons (32.2 percent). With an Afro-American population of 2 percent it is fair to assume that the killer cop had little interaction with black men before joining the BART security force. Thus he had little or no opportunity to meet and get to know accomplished black people as friends.

Alas, the segment of the Afro-American community these white cops most often interact with on the job is the criminal element. And this breeds hostility toward all young black males. Mehserle's hostility towards black men is verified by the fact that he had a series of complaints against him filed by Afro-Americans before he murdered Oscar Grant.

According to the census Napa has the most registered Republicans of any county in California, although 20 percent more residents register as Democrats than Republicans. Jerry Brown carried the county in his race for governor and Barack

Obama carried the area in his reelection bid. NAPA County is represented in Congress, the State Assembly and State Senate by Democrats. The last Republican to carry the county was George Bush in 1988. While many people think of NAPA County as affluent, the fact is that some towns in NAPA, such as Calistoga, have a lower median household income ($38, 454) than the notoriously poor and black town of Richmond California, which is $44,210, both of which however are below the national average which is over $50,000.

Hence some of these NAPA County neighborhoods fit within the description of the white working class neighborhoods festering with virulent racist hostilities described by Pete Hamill. "The working American lives in a grey area fringes of a central city or in a close-in or very far out cheaper suburban sub-division of a large metropolitan area."

One of Hamill's most important observations is that the majority of whites living in these working class enclaves viewed Afro-Americans as "Militants with Afros and shades, or crushed people on welfare threatening to burn down America or asking for help...or committing crimes." We can be sure if that was the image of Afro-Americans in 1969, when there was no hate media spewing out racist garbage stoking white resentment 24/7, equally negative images abound today. This is the crucible in which Johannes Mehserle was formed.

We know from many sources of the entrenched racism in California's police agencies, but we were provided an unvarnished inside view of how it affects police practices from Christopher Dorner, who became so enraged with the LA police department after he was driven out because of his complaints about the abuse of authority by his fellow officers, who routinely brutalized citizens in their custody, that he embarked on a clandestine mission to assassinate his fellow officers.

Dorner went on his killing spree during the heated discussion about the movie *Django Unchained*, which centers around the bloody rampage of an ex-slave on a mission to rescue his enslaved wife. He wreaked havoc on the enslavers and left a bloody trail of dead bodies on his victorious quest, and all who witnessed the carnage felt his victims got what they deserve. Hence Dorner quickly became a hero to many black, Hispanic and anti-police factions of all races; a twenty first century real life descendent of Django—it was life imitating art. And it was a joy for many people, who had witnessed all manner of police misconduct and corruption go unpunished, because they felt the racist white police were finally getting what they deserve.

They were delighted to see the police on the run, in fear of their lives and the lives of their loved ones, as they had been. In fact their attitude toward the police mirrors the Political Philosopher CLR James' attitude toward the rich in general: "The only time they can be trusted is when they are running for their lives!" It's just human nature for the oppressed to feel that way about their oppressors; this is what Dr. Franz Fanon meant when he said it was therapeutic to kill your oppressor. As a condition for discontinuing his killing spree, Dorner forced the LAPD to agree to a thorough investigation of his charges against the department. But when he was later killed in a gun battle they dropped the investigation and we have heard nary a word about it again.

What is clear is that we will have yet another murder of an innocent black man

by white cops in California, and elsewhere, because the heated racist rhetoric spewed by Rush Limbaugh and his partners in crime will continue to enflame the emotions of "angry white guys"—some of whom are on the police force. The source of this murderous anger, as we have shown in this essay, is deeply rooted in American history and culture; thus it is folly to think it will suddenly disappear.

What is to be Done?

The best way to prevent such police incidents going forward is for the leadership of the Afro-American community to adopt a strategy of building coalitions with other progressive forces interested in good policing to establish tough minded Citizen Review Boards with subpoena powers. We must also insist that every stop and frisk or arrest be recorded on video tape.[3] Although I have no reason to believe she took my advice, Judge Shira A. Scheindlin, who ruled on the legality of the policy concurred with my position in her 195 page decision. After pointing out that "Stop and Frisk" as practiced is a "'policy of indirect racial profiling' that resulted in the police stopping blacks and Hispanics who would not have been stopped if they were white." She declared "I also conclude that the city's highest officials have turned a blind eye to the evidence that officers are conducting stops in a racially discriminatory manner." She also charged the city with systematically violating the constitutional rights of Afro-American and Hispanic men under the 4th and 14th Amendments: Which forbids "unreasonable search and seizures" by the government and guarantees "equal protection" under the law.

Yet the judge stopped short of calling for an outright ban on the Stop and Frisk program. I believe this is because it is hard to argue against either the intent of the program—to save the lives of innocent citizens in areas with a high incidence of gun violence—or its effectiveness, because the statistics on firearm casualties including homicide have been dramatically reduced. However for the predominately black districts of New York City that's like saying *Spider Man* is better Looking than *Freddie Kruger*. In either case you are left with an ugly situation. Alas, while the numbers are down they remain horrific.

Hence the judge's approach to Stop and Frisk is to mend it not end it, and I think wisely so; since that was title of my essay on the issue. Instead Judge Scheindlin prescribed a series of remedies the NYPD must apply under court supervision. Prominent among them is the development of a pilot program in which the police in five selected precincts will wear cameras on their bodies when they interact with the public and record the entire encounter. She also appointed Peter L. Zimroth, a distinguished New York attorney and former prosecutor to monitor the NYPD's compliance with her orders. By virtue of the authority invested in the monitor the court was certain to play a major role in shaping the policing policies of the next Mayor also. In my view as an intelligent layman and concerned Citizen, with a personal interest in the outcome, I thought Judge Shindlin's decision was a model of Solomonic wisdom at work in the judiciary.

However in a startling turn of events, the justices on the bench at the United States Court of Appeals for the Second Circuit has removed Judge Sheindlin from

the case; stayed her orders for reform in the NYPD and transferred the case to another judge for adjudication. Hence the relief sought in the courts by black plaintiffs who had been victims of unconstitutional stop and searches by the NYPD is now hanging in limbo. And what was the alleged misconduct on the part of the Judge? According to the Court's ruling interviews given by the Judge to the Associated Press, the *New Yorker* and the *New York Law Journal* provided grounds on which "her impartially might reasonably be questioned."

However Jeffry Toobin, a lawyer and legal scholar who writes about legal matters for the *New Yorker*— one of the nation's most distinguished journals of opinion— whose own work was cited as a basis for the decision, had this to say of the decision in an October 31, 2013 *New Yorker* article titled, "The Preposterous Removal of Judge Schindlin."

> This is preposterous. The Second Circuit took this action on its own, without even a request from the city (the defendant in the case). Apparently, it took the view that there had been such an egregious violation of the rules of judicial conduct that the court had to act on its own—sua sponte, as the lawyers say. It also stayed Scheindlin's rulings aimed at reforming stop-and-frisk. Scheindlin did nothing wrong. She talked about her judicial career and her history on the bench in a way that illuminated the work that all judges do. In my experience, it's a common complaint from judges that the public doesn't understand their work, and doesn't care about what they do. Scheindlin's conduct in this case exemplified the independent tradition of the judiciary. She should be honored for it, not scolded.

Apparently it was the judge's assertions about the independence of the judiciary, and how she refused to privilege the prerogatives of government over the constitutional rights of ordinary citizens, to the chagrin of Prosecutors and politicians. For instance, in her interview with Toobin she declared:

> Too many judges, especially because so many of our judges come out of that office, become government judges. I don't think I'm the favorite of the U.S. Attorney's office for the Southern District. Because I'm independent. I believe in the Constitution. I believe in the Bill of Rights. These issues come up, and I take them quite seriously. I'm not afraid to rule against the government.

Gerald Horn, The John and Rebecca Moores Professor of History at the University of Houston, who is also a lawyer and former law professor that once practiced law in Second Circuit, believes "the Court yielded to the will of right wing politicians...I find the verdict shocking!" This decision strikes a special chord with Professor Horn, who quit the practice of law when he saw the Republican packing the federal courts with right wing jurist. "I was convinced the kind of land mark

decisions we had witnessed under the Warren Court would become increasingly rare," said Dr. Horn, "because of these were lifetime appointments. So I turned the study of history in the hope that I might make a more significant contribution to the advancement of justice there."

However, as Jeffrey Toobin notes, the decision of the Second circuit will soon prove a pyrrhic victory. "In a final irony," he writes, "the resolution of the case may not matter much anymore. Bill de Blasio will be mayor soon, and he has vowed repeatedly to change the N.Y.P.D.'s stop-and-frisk policy anyway. The appeals-court judges can take the case away from Scheindlin, but they can't take the mayoralty from de Blasio." There is a critical lesson in this to those who are engaged in the struggle against the abuse of the police powers of the state. When the courts fail to provide redress direct your efforts to the political process and change the government.

While Mayor Bloomberg continues to blindly defend his "Stop and Frisk," even vociferously opposing the use of cameras because he somehow believes it will hinder rather than help effective policing, Neill Franklin, a retired narcotics cop and former Commander of Training with the Maryland State Police, supports body cameras on police that record their interactions with the public. In an October 22, 2013 commentary published on the *New York Times* online opinion page, Room for Debate, he explains why police body cams are good for the police as well as the community:

> [W]e know that they—like most people—behave better when they believe they're being watched. While this is certainly a benefit for the communities in which they operate, it's also a benefit for the police officers themselves. A monitoring system could let us defend officers unjustly accused and punish those who are guilty. It could also reduce misconduct. Cameras are extremely useful in gathering and maintaining a record of evidence, providing a fuller picture of an interaction than a written report or even a patrol car's "dashcam" ever could. For this reason, they're also very good at protecting police from false accusations of misconduct.

Perhaps the difference in perspective between Mayor Bloomberg and Commander Niell Franklin is that Bloomberg is a billionaire white guy who is clueless about what transpires whenever there is an encounter between black men and white policemen on the streets, and that of Commander Franklin, who is an Afro-American male that spent 34 years in law enforcement.

I believe we should accept nothing less from the nation's police departments, some of whom have a history of cooperating with white racists going back to the 19th century. We should not only take issues of police corruption and abuse of power to court, we should also call for a federal investigation of every killing of an unarmed black man by white policeman. Attorney General Eric Holder is savvy on matters of racism and will investigate these complaints just as they did in the Oscar Grant murder.

However these solutions only address part of the problem of homicide among young black males, especially since the number of them who die as the result of

police shootings are almost statistically insignificant when compared to those who are killed by their peers in the protracted war on the streets. Whether we wish to admit it or not, and many Afro-American intellectuals who readily denounce the police do not, this nihilistic trend of internecine violence poses a far greater danger to our sons than racist white cops or armed white citizens. The numbers tell the story.

Peter Moskos, a professor in the department of law and police science at New York's John Jay College of Criminal Justice, and author of a book about policing in the inner-city, *Cop in the Hood*, provided the following statistics for 2011:

> Over 90 percent of New York City's 536 murder victims...were black or Hispanic. Just 48 victims were white or Asian. The rate of white homicide in the city (1.18 per 100,000) is incredibly low, even by international standards. The Hispanic rate of homicide in New York City (5.5) is barely above the overall national average (4.8). And yet the black homicide rate remains stubbornly high (17.2), 15 times higher than the white rate. Blacks are one-quarter of the city's population and two-thirds of murder victims. Black men age 15 to 29 represent less than 3 percent of the city's population but account for one-third of those murdered.

During the high point of lynching 1882-1915, a black American was lynched every two and a half days by white racist somewhere in the nation, albeit mostly in the southern states that had formed the confederacy. This was the period that outstanding Afro-American historian and Howard University professor Rayford Logan called "The Nadir" i.e. "lowest point," in his book, *The Betrayal of the Negro*. The full dimension of the tragic crisis of violence in the black community at the turn of the 21st century is that last year, the number of killings in Chicago alone exceeded the number for the entire nation during the Nadir.

None of these killings involved the police. In fact, according to the Stolen Lives Project, which zealously keeps a record of killings by law enforcement, 18 black and Hispanic men were killed by the police that same year. Furthermore there were 1500 shootings by criminals in black and Hispanic neighborhoods that failed to result in death. Hence there can be no question of where the greater danger to the lives of our sons reside.

I could hardly disagree more with those who claim that anti-black racism is the motive force driving Mayor Bloomberg's Stop and Frisk policy. But then I have an unfair advantage over the Mayor's critics: I grew up in the apartheid south under a Mayor who was a real racist, straight up, racial discrimination was open and legal, and city officials weren't squeamish about calling us "niggers." There was no shame in them cracker's game! That's how I know where of I speak when I say that racist Mayors don't expend city resources in a special effort to protect law abiding black citizens from black criminals. Racist Mayors say "As long as them niggers don't shoot no white folks let em kill each other." And they wash their hands of the matter.

I have always understood that by the numbers black criminals are more

dangerous to our young men than white cops. When my son was growing up here in Harlem during the 1980s and 90s, gangsta rap was everywhere on the radio, blaring from boom boxes on the streets, celebrating casual murder and crack cocaine was easier to get than prescription drugs, I always told my son that the policeman was his friend and if he found himself in danger on the streets seek out the nearest policeman. And I never allowed him to leave the house looking like a "thug." As a two sport athlete attending academically demanding schools, where teachers assigned homework every day, hanging out on street corners was never an option. It proved to be a wise plan, as he made it through boyhood in New York City unscathed.

When long time reporter Geraldo Rivera said he does not allow his sons to go out at night wearing hoodies, in the aftermath of the Trayvon Martin murder by the wanna-be cop George Zimmerman, and suggested that other black and Hispanic parents should follow his example, he was roundly denounced in a hail of invective. He was falsely accused of "blaming the victim," for Geraldo was doing nothing of the kind; he was just keeping it real.

As a reporter and columnist in the New York press, I have long known that the police had a profile of what gang members and likely criminal "perps" looked like. And the ubiquitous gangsta rap videos played a major role in developing those profiles because wanna-be thugs dressed like the rappers, just like real gangsters often dressed like the gangsters in the movies during the golden age of Hollywood mob flicks.

I remember that the *Village Voice* had an artist do an illustration for an article on the subject, based on the description given by policemen to the crack Afro-Trinidadian reporter on city politics, Peter Noel. When a dude came by to take my teenage daughter to the movies a few days later looking just like the drawing, I had a talk with him and told him to come back after he straightened his cap and learned how to dress properly to take a young lady on a date.

I explained that if he wanted to make a target of himself that was none of my business, but I didn't want my daughter to get caught in the crossfire. A tall handsome basketball player type, she thought he was "mad cool" but I thought he was a silly fool. And I had the power and responsibility of parenting, so I exercised my veto and zapped him. These are common sense steps that parents can take which could help save their sons and their daughters.

While astute political action and sound parenting can effectively address two of the dangers confronting our youths, random shootings by hysterical white racists poses another danger, albeit far less than the other two. The best remedy for this situation is for law abiding Afro-Americans to arm themselves, especially in gun crazy states like Florida, where guns can easily acquired legally. I have deep family roots in the Sunshine State; I grew up in that land of flowers where my soul found solace in my grandmother's gardens, after the death of my father in Philadelphia. In those days everybody kept guns and all of the men in my family were heavily armed. Uncle Irving was an avid gun collector.

This kept a lot of rednecks in check. And now, with the stand your ground laws black folks should arm themselves to the teeth, go to the gun range and learn how to handle your weapons...and when a redneck becomes aggressive and step to you

stand your ground and fire when you see the white of their asses, the red in their necks and the hatred in their eyes.

Endnotes

1. For an analysis of the views on the left see the essays under *"My Struggles on the Left"* at www.commentariesonthetimes.wordpress.com.

2. For a discussion of the evidence for this claim see "Is Rush Limbaugh and American Goebbels?" at www.commentariesonthetimes.wordpress.com.

3. I recommended this in a commentary on the NYPD's "Stop and Frisk" policy, titled "Mend it Don't End It" at www.commentariesonthetimes.wordpress.com.

How Hollywood Portrays Italian Americans | Lawrence DiStasi

When reviewing how Italian Americans have been cast and portrayed in the movies, two overriding images come to mind: the Italian as treacherous, and the Italian as dumb—or more precisely, as a case of arrested development. These two categories pervade Hollywood—and I include TV portrayals—even though on one level they are opposites: to be treacherous, one might think, would require someone at least minimally clever. From another angle, though, they blend into each other, for if, as Anglo culture seems to suggest, moral development stands at a higher evolutionary level of humanity, then the treacherous Italian can likewise be seen as a case of arrested development. To be violent, that is, is to be not only stupid, but also childlike. In fact, to be a great lover—as was the first Italian American film hero, Rudolph Valentino—is also to be at a lower stage of development, and, in the Italian case, dangerous besides. This made following Valentino with the Italian American as criminal and organized crime as his preeminent occupation a relatively simple segue (as movie jargon has it). From the FBI chasing Chicago mobsters in the smash TV hit, *The Untouchables*, to the near-adoration of mafia chieftains in *The Godfather* movies; to the slightly insane killer portrayed by Joe Pesci in *Goodfellas*, to the critically acclaimed portrayal of suburban mob activity in *The Sopranos*, Italian Americans have become so identified in the public mind with criminal behavior that almost no other role was, for decades, even conceivable. If another role did exist, it could be viewed as even worse—giving us the dumb but handsome TV-film characters played by Tony Danza and John Travolta, and more recently Matt LeBlanc's characterization of Joey Tribbiani on TV's top-rated hit, *Friends*. And though mafia mobsters may have receded slightly in recent years—thanks to the advent of Russian or Hispanic mobsters and Arab terrorists—the Italian American image fostered by Hollywood has so permeated American pop culture that it may never be totally erased in the American mind.

Selma: The Film and Actualities | David Henderson

Dr. Martin Luther King, Jr., the man who followed in the footsteps of Gandhi in bringing civil rights to a people, and in some ways went even further than Gandhi, is a towering figure in the recent history of the United States. For that matter, he ranks highly throughout the entire Western world, and perhaps everywhere on planet earth. His public denunciation of the Vietnam War contributed to the war's end, but—coupled with his support for the striking sanitation workers of Memphis and his protestations of the larger issue of widespread poverty—it also resulted in a diminution of his popularity and a certain disfavor promoted by the corporate-controlled press, and it may have contributed to his untimely and mysterious assassination.

His widow, Coretta Scott King, his children, and the famous entertainer Stevie Wonder combined forces with a broad swath of an approving public and fostered a public holiday in his name that became a reality in the late twentieth century. Now, in 2015, a new film, *Selma*, is based on one of his most important achievements: his leadership role in attaining the Voting Rights Act. He coordinated a protest that would bring together various civil rights organizations, church and religious groups, entertainers, and professional organizations, along with a public from all over the United States and countries across the world to march in Selma with the ordinary citizens of that small Southern town. These people endured great brutality in the hands of local Alabama police and state troopers in order to complete their march to the state capital in Montgomery to protest before the State House their inability to vote.

On March 7, 1965, with a few hundred locals, Dr. King formulated a strategy that resulted in thousands of supporters joining the locals and, despite the murder of some, would result in a successful march to Montgomery over a two-week period. The number of marchers swelled from 5,000 to 25,000, and they arrived in triumph to hear the speech by Dr. King that announced the Voting Rights Act that would become law in a few weeks—a verification of democracy that inspired the world.

Selma, a motion picture put together by Pathé UK, along with several other companies including Brad Pitt's Plan B Entertainment and Oprah Winfrey's Harpo, (those two personalities also became producers), was released during the Christmas holiday season, in time to qualify for participation in the Academy Awards of the

Motion Picture Association of America. The film continued in theaters through the celebration of Martin Luther King, Jr. Day, Monday, January 19, 2015.

The engineered mass resistance to the police repression of today, recalls those civil rights days that are so essential to Dr. King's legacy. *Selma* was one of those moments in history monumental to its time. This story, this civil rights triumph, could be told in any number of ways under any circumstances (from person to person or as a *Roots*-like television miniseries) and be compelling. Regardless of actors or scenery or vintage cars, one simply cannot go wrong with this high point in the life of the Reverend Dr. Martin Luther King, Jr.

The greatest actors in *Selma* are the marchers, the crowds, and the representation of that motley crew who marched through Alabama being brutalized and stressed on every level. Toward the end of the film, shots of those marchers dissolve into footage of vintage film of the original marchers, the technique making it possible for the footage of *Selma* to have the same vintage quality and adding an aura of verisimilitude.

On the other hand, to portray such a central figure in the history of Black America with an actor who is so far outside the culture is not only as close as one can get to cultural criminality, it also points to serious deficiencies of effectiveness within the film industry in Black America. It is also unfair to the careers of all the actors involved, from principals to supporting, because it involves them in distortions of history that extend from casting to a broad set of problems that range from calling it a biopic to a juggling of facts.

An African playing MLK could possibly be a descendant of those Africans who sold their own people centuries ago, now often called African Americans. Now an African plays our present-day Moses, however with no passion or understanding of the Black American spirit or the ways of being with one another. We are mocked in our beliefs of the time—that the system, the vote, would save us.

Selma begins just after MLK received his Nobel Prize in Oslo, Norway. Cut to the White House USA, where Dr. King is in the presence of President Lyndon Johnson, who congratulates him on that honorable achievement. But King wants the disenfranchised Blacks of the South to be able to vote. This harks back to the moment when Black Americans won their freedom via the Civil War, where they picked up guns and defeated the Confederacy. But after a few years of Reconstruction, where Blacks had been elected to public office all across America and often enjoyed the liberties of freedom that had been only dreams for centuries, a white racist government/corporate gentlemen's agreement reversed that situation. The resultant Jim Crow system of institutionalized racism continued on unabated until the time in history symbolized by Selma. There, the struggle amid violent repression would culminate in MLK's speech on the Voting Rights Act. As many believed then and continue to believe, the vote would bring true power to Black Americans. It is sadly ironic that today, with the election of a Black president, it has become clear that a basic lesson of democracy has been learned after so long and at such a great cost.

Be that as it may, the present times are reminiscent of Selma, but now masses from different backgrounds are marching to protest police brutality and the murder of unarmed Blacks, just as in the Old South the Civil Rights Movement was inspired

in large part by the lynching of Black men and boys.

The principal actors, David Oyelowo as MLK, and Carmen Ejogo as Coretta Scott King, however, pall next to the character actors who played the various SCLC and SNCC personages. Those Africans who play the central characters were trained in London. They are surrounded by Black Americans who know the public code of comradery that is an important aspect of Black American culture. Oyelowo's King comes off as absolutely cold. He does not have an aura of greatness, nor that playful modesty and majesty MLK was known for. Seeming more like a clerk or a small-town businessman, Oyelowo says his lines, but the rigor of Southern speech, not only in intonation but in emphasis and dialect, is beyond him. And the paraphrased speeches—as the King estate forbade verbatim quotations—lacked even further emphasis that was intrinsic to the soaring rhetoric and phrasemaking King was famous for. The writer could perhaps have spent more time on those speeches, as they were in essence the hallmark of King's connection with the public and the essential inspiration to his close followers. This aloof impersonation of MLK was contrasted by his screen wife, whose characterization was far from the staid and true Coretta. Nowhere near a mother figure, she was more like a high-priced model or perhaps an au pair, and the children had no lines at all, no screen time with either parent.

Oyelowo is also outdone by fellow British subjects who are Caucasian: Tom Wilkinson, who plays President Johnson, and, although not in a scene together with MLK, Tim Roth, who plays Alabama Governor George Wallace. He is electric, totally believable, and an excellent foil for Wilkinson.

Dylan Baker, the actor portraying FBI director J. Edgar Hoover, was a bit of a paradox and may as well have been portrayed by another actor representing the Crown, such as someone resembling the late Bob Hoskins. Baker had fairly brief screen time, but appears to be a tall, and rather fair-skinned WASP, far from the real-life diminutive, dark, and somewhat rotund Hoover. The collaboration with President Johnson is played in a straightforward manner. There should be no doubt about their complicity. The publicity-inspired outcry over the imagined unfair characterization of President Johnson would have us believe that a former cabinet official would know all the doings of the chief executive, and that all that President Johnson said was the absolute truth—as if a Robert Caro did not go to the trouble to write several volumes on his vagaries and victories.

There is a scene where King and Coretta sit listening to a threatening telephone message that ends with a purported recording of the sound effects of King having sex with another woman. That the tape could be a fake or an audio production based on or not based on a real happenstance is not considered. The act of bugging the King telephone was obviously one of the psychological techniques that would increase the anxiety, blood pressure, and stress of the entire family.

White typed letters across the screen throughout the film contain brief messages indicating close surveillance by the FBI and/or other intelligence agencies. Unlike subtitles, these are placed mid-screen, superimposed over continuing footage.

The costars of this film are the many character actors whose ensemble performances create an essential supportive emotional landscape. It is too bad that

none of the actors representing the Southern Christian Leadership Conference, or the Student Non-violent Coordinating Committee have enough screen time to qualify for a Best Supporting Actor Academy Award nomination.

The continuous presence of Oprah Winfrey, as a workaday, middle-aged woman who marches and gets beaten up several time—so it seems—is problematic. That character seems to be straight out of *The Color Purple*, a role she played in the early days of her film life. She is much too well known to be a bit player with a few lines but plenty of screen time. And since she is an executive producer and her production company has its logo displayed in the closing credits, one wonders whether her financial support was connected to her "face" time.

For real fact-checking concerning Selma and the legacy of Dr. King, one could start with the Pacifica Foundation radio documentary recorded in Selma during the days of the marches. The license the makers of *Selma* believe they have given rise to interpretations that can range from casting gaffs to historical distortion. One thing that saves the day is that the manipulation necessary in order to squeeze reality into two hours of screen time cannot change the actuality, the power of what happened. It might have been best for the director, Ava DuVernay, to insist on historical accuracy and thus build the drama accordingly. Whatever—*Selma* is in the can and will be available as is, for (probably) ever.

The first battle of Selma took place on March 7, 1965, with the bloody conclusion. The second battle went from March 9 to 24, culminating in the march from Selma to Montgomery. This documentary features recordings from those marches and recordings of MLK, James Forman, James Bevel, etc., including a plainspoken woman near the end of the documentary who was quite articulate.

One of the important points of this radio documentary is that the second march, on March 9, was halted by King as a result of an agreement between him and city, state, and federal officials. This was not known to SNCC's James Forman or the others in SNCC. Forman made a speech that made it obvious that he did not know. The film gives the impression that the halt, and then retreat, was owing to some seemingly mystical intuition on Dr. King's part. Perhaps that halt avoided injuries, saved lives, and built dramatic tension that made the concessions necessary to ensure the Voting Rights Act. That happens to be the way it turned out, thank goodness.

Despite my complaints seemingly to the contrary, I believe that Ava DuVernay did an admirable job as a rookie major motion picture director. I strongly disagree with her belief that she has the right to slightly alter history for dramatic purposes, but she does not hedge her point of view. The soundtrack, of *Selma* is nothing short of wonderful, led by the Common and John Legend's collaboration on the goose-bumpy "Glory"—with a rap from Common that says it's all good—with Legend's soaring vocal somehow paralleling MLK's oratory magic. The late, great Curtis Mayfield holds down the center with his long-underrated "Keep On Pushin'" that came out as a top-40 R&B hit of the time, inspiring many youths in the Movement across the country. And the brilliant jazz pianist and composer Jason Moran holds

* Pacifica Foundation's 90 minute documentary *The Second Battle of Selma* Pacifica foundation pacifica.org fromthevault.org

down the bottom with a viable semi-symphonic soundtrack that perfectly and often beautifully conveys the high points of dramatic intensity without intruding on the emotion. I believe *Selma* should win both categories of the Academy Awards for which it is nominated—best film and best song.[†] Although *Selma* may not be a *great* film, the power of the history it portrays dominates the category, and the truth it does convey, fused with its wonderful music, makes it a film that despite its contradictions will grow in acceptance.

[This essay originally appeared in *Tribes Online*, Steve Cannon, editor-in-chief.]

[†] *Selma* was nominated for Best Picture and won Best Original Song at the 87th Academy Awards.

Too Many Chiefs and Not Enough Indians: Native Americans in Recent Television Programming | Geary Hobson

Types of media have changed a great deal in the past century, but whether the popular culture message is dispensed through newspapers, dime novels, Wild West shows, movies or television, when it comes to depicting Native Americans the makers of media-message are still as antiquated in their outlook as high-button shoes and whalebone stays. Ever since Captain John Smith stepped off the boat and strove inland from the Jamestown colony, whacking down those Indians who got in his way and inducing others to go along with him, non-Indians have had an aggravating way of labeling Indians. Whenever an Indian helped a white man, as Pocahontas and Squanto and Sacajewea were supposed to have done, then they were Good Indians, even Noble Savages. Whenever they worked to hinder the white man, to stand in the way of his progress, they were then labeled Bad Indians, or Red Devils. Pocahontas' father Powhantan was one of these. So also were Geronimo and Crazy Horse and Sitting Bull.

In the nineteenth century when novels were the primary means of disseminating popular culture, James Fenimore Cooper continued the trend of creating Good Indians and Bad Indians. In the *Leatherstocking Tales*, Chingachgook and Uncas are clearly Noble Savages, while Magua and Rivenoak are definitely Red Devils. It even extended to tribes: Mohicans and other Algonquian tribes were Good Indians and Hurons and other Iroquians were bad Indians—this simply because of Cooper's animosity towards the French. The Hurons had been French allies, but never mind the fact that the English had slaughtered thousands of Algonquians—they were still Good Indians. Particularly because they had been nearly killed off and were no longer a threat to English and later American institutions, they could be remade into the image of the Good Indian. The same thing happened later on, after the end of the Indian wars, with Apaches and Sioux and others being restyled as Noble Savages, simply because they had been "good losers" and American guilt could be assuaged through such generosity.

Sankofa: Film as Cultural Memory | Haki R. Madhubuti

Haile Gerima, the award-winning Ethiopian film maker and Howard University professor, has always been a serious man. He knows America like he was born here. His double heritage, African and African living in America (he has lived and worked here twenty-five years), has prepared him to create a film of a life time. *Sankofa,* his new film about the enslavement of Africans and the psychological and violent liberation of a few of them, is a first in Western filmmaking. It is a riveting examination of a piece of history that is enormously powerful and prophetic in its telling of our story.

Gerima, as the brothers and sisters would say, "has been around the block." He has been making films for over twenty years. I first met him in the early seventies when I also taught at Howard University. His earlier films—*Bush Mama, Child of Resistance, Harvest 3000 Years,* and *Ashes* and *Embers*—have led the way in Pan-African/Black liberation filmmaking. His body of work demonstrates that he is not only consistent in theme, historical accuracy and political point of view, but that he is a visionary and an artist. As visionary, he must take chances; he must explore the world from his insides. As an artist, he not only crafts a film in the intricacy of his profession, but goes sub-surface looking for meaning, looking for the story within the story, not settling for the easy questions or answers. His work has always made us uncomfortable in our post enslavement existence.

Sankofa, from the Akan proverb, *se wo were fi na wo sankofa a yenkyi* (it is not forbidden to go back and claim what you've forgotten) is a spiritual film of memory and resistance. This is an African (Black) narrative that starts in the present on the coast of Ghana, which was known as the Gold Coast prior to the presidency of Kwame Nkrumah. *Sankofa* travels through the eyes of Mona/Shola (Oyafunmike Ogunlano), a high fashion model who dances to the lusty camera of a white photographer. The photographic shoot takes place on the grounds of Cape Coast Castles—the launching point of millions of African souls across the Atlantic into enslavement. Sankofa, the divine drummer and rememberer (griot), constantly interrupts the photographic shoot as well as the tours that takes place at the Castles. Sankofa, played by the musician/elder, Kofi Ghanaba, represents memory, pain, protector of hollowed grounds, and African strength. In his confrontation with Mona, he strongly demands that she return to the source and rediscovers her true self.

Mona, in a blonde wig and mini skirted, body displaying outfit is the best example

of a Negro, a sorry white invention, who hates herself and who has lost history only to be re-enslaved into a twentieth-century lifestyle that is embarrassing and degrading. The opening scenes are drum-filled with ancestral chants of "spirit of the dead rise up and claim your story." As Mona, on the urging of Sankofa, investigates the slave dungeons, she is literally kidnapped into her past. She is captured, stripped of her modern identity, profession, and memory, chained and taken back to an American plantation and reappears as a house slave named Shola.

This is where Gerima, writer, director, editor, and coproducer becomes filmmaker and story teller. He moves slowly and deliberately in introducing us to the film's characters. His is a studied style, reminding one of the novels of Ayi *Kwei Armah (Two Thousand Seasons* and *The Healers)*, the liberating historical works of Chancellor Williams *(The Destruction ofBlack Civilization)* and John Henrik Clarke *(Notes on an African World Revolution)*. In filmmaking, he is in the tradition of Ousmane Sembene, Med Hondo, Flora Gomes, and others. *Sankofa is* a story of oppression, but is not oppressive in its telling. It is an African-Black point of view that shames *the tradition of Mandingo, Superfly, Uncle Tom's Cabin,* and all the Black exploitation films of the 1960s to the 1980s.

We meet the rebellious and uncontrollable field slave Shango (Mutabaruka). There is the equally strong and insightful queen-mother Nunu (Alexandra Duah) and her half-white, self-hating son Joe (Nick Medley), a house slave captured by the enormous pull of Christianity and a white lifestyle. In fact, Christianity in the presence of a white, Catholic priest, Father Raphael (Reginald Carter) is the undying contradiction and "centering" conflict that haunts Joe and Shola, especially in her non-violent feelings that she fights throughout the film.

Sankofa, without apology or self-indulging, details the African side of enslavement in all of its inhumanity and brutality. This is not a Hollywood film. It took Gerima twenty years, with a budget of about one million dollars. As I write this essay, the film has not been picked up by a major distributor. Therefore, Haile Gerima has had to add to his credentials that of distributor. Why? Because *Sankofa is* not a victim-oppressive re-telling of how Lincoln freed the salves. It is not a retelling of how the white "master" was really a good man at heart, but caught up in the economic, political, and historical forces of his time and had few choices if he was to live well and in a privileged way. This is the first film I have ever viewed where there are no good white folks involved in the trading of African people. That in itself is progressive. It is simply naive at best and down right ignorant at worst to think that the horrible institution of slavery could have existed so long if there was not common agreement and compliancy among the majority of white people involved in it. Gerima's retelling of the African holocaust is not a sanitized version of suffering Negroes, but is a culturally focused, politically clear, non-romantic introduction to the strength, complexity, culture, humanity of enslaved African people. Gerima clearly presents the complexity of an institution that was organized to break the will and spirit of those it enslaved, while reaping the slaveowners and slave traders huge profits and power. He also depicts the genius with which the same institution simultaneously made enslaved Africans enemies to themselves. It reminds me of the words of the great poet Leon Damas warning us to be aware of the "plantation mentality, whether you are a plantation owner, plantation master, or plantation slave." *Sankofa* evokes such memories and makes it a film for today.

Throughout Western film history, there has always been the white point of view. There also exists the Negro slave point of view—which is actually white-colored Black. Now, in Sankofa, we have an African-Black point of view. This departure is powerful and believable in its articulation that African people are much more than what one sees. Gerima's use of narrative, flash backs, mythologies, non-linear story line, nature, poetry and African music—with the African drum as central as a heartbeat—puts him in the company of great filmmakers. Just as important, he does not fail us by lying or covering up our own weaknesses and complicity. He is a brave and culturally conscious African (Black) film maker who obviously loves his people. This love, this uninhibited attachment, (we call it family) is the spirit that moves and motivates this non-traditional masterpiece.

Sankofa makes us think. It brings water to our eyes. It forces us to reconsider our lives and those we love, live, work, and play with. It is a reflective mirror that positions us in a context and content which is not debilitating to our psyche, not a stop-sign to our future, but is revelation. It is a spiritual work of multiple possibilities that skillfully introduces a new film language. To most of us, such a language is foreign to our experience. This is a Pan-African-Black film of determination, insight, and liberating encouragement. Gerima sets a new standard of advocacy filmmaking. Re takes a position.

Gerima's perspective is a learned, experienced, and inspired one. Few could have made such an insightful film. He is in his element and like the recently published *Yurugu: An African Centered Critique of European Cultural Thought and Behavior,* by Marimba Ani, *Sankofa* will not receive the audience it deserves unless we help. One of the major indications of our powerlessness is the lack of Black film theaters owned by African Americans. In the entire nation, Black folks own less than five. For a population of forty million plus, whose major entertainment outlet outside of television is movie-going, this is embarrassing and pitiful. For a people whose gross national product is over $350 billion, this is inexcusable. After twenty five years of Black exploitation films which generated billions of dollars in profit, all Blacks have to show for the films' existence is the new life they are given at video rental outlets.

In *Sankofa,* the question of empowerment and of land ownership continues to speak to the condition of African (Black) people. It goes something like this: Europeans (whites) stole and colonized the Americas, committed genocide (Holocaust) against the indigenous peoples (in excess of forty million killed), and gained control of this vast continent and its untold riches. Europeans needed workers—indentured whites were not enough and the indigenous people continued to fight and die rather than work their land for others. Their next option, take the Africans from their land (African Holocaust), which was also being stolen by Europeans (whites), to work in the Americas for Europeans. The underlying message of *Sankofa* is that all life starts with the care, use, exploration, repair, fertilization, maintaining, and love of people and land. If you destroy the land, the destruction of its people will follow. Welcome to Black (African) USA. We are a landless people, begging the people who created our condition for jobs and a theatre to show an African-centered film.

Sankofa is a film of bright but horrible memory. *Sankofa* is Haile Gerima's liberating message in a medium which ninety-eight percent of our people watch and support. He is not alone in his understandings and messages. Many have preceded him. Because of

his work, many others will follow. *Sankofa* warns and prepares the listeners and viewers in a way that our best poets and fiction writers have been doing for generations. *Sankofa is* a spiritual and violent film. However, the violence is primarily off screen, while the spiritual nature of African people is highlighted and provides the core linkage between Blacks worldwide. Who among the culturally conscious can forget the urgent words of Ayi Kwei Armah's *Two Thousand Seasons:*

> The linking of those gone, ourselves here, those coming; our continuation, our flowing, not along any meretricious channel, but along our living way, the way: it is that remembrance that calls us. The eyes of seers should range far into purposes. The ears of hearers should listen far towards origins. The utterer's voices should make knowledge of the way, of heard sounds and visions seen, the voices of the utterers should make this knowledge inevitable, impossible to lose.
> A people losing sight of origins are dead. A people deaf to purposes are lost. Under fertile rain, in scorching sunshine there is no difference: their bodies are mere corpses, awaiting final burial.

Sankofa can be a wake-up call for sensitive viewers, listeners, and remembers. We, African people, Black diaspora people, are a part of this world too. Are we destined to be job seekers in the ideas and models of other people's worldviews? Haile Gerima has given us both questions and answers. As the brothers and sisters say, the ball is in our court. Will we learn their game or create new ones? It is not forbidden to go back and claim what you've forgotten: *Sankofa.* Can we build on that lesson?

This article was originally published in *Claiming Earth: Race, Rage, Rape, Redemption; Blacks Seeking a Culture of Enlightened Empowerment,* Third World Press, Chicago. Copyright 1994 by Haki R. Madhubuti. Used by permission.

Who or What Does *The Help* Help? | C. Liegh McInnis

Okay, so I finally finished the four hundred and forty-four pages that constitute Kathryn Stockett's *The Help*. An older African (American) female colleague gave me this book a year ago to thank me for providing a tutorial for a program that she coordinates. I could not believe that anyone who knew anything about me would give me a book written by a white woman, telling the story of African (American) maids working during the 1960s who collaborate with an aspiring white female writer to tell their stories of working for white women, essentially using African people as backdrop or troping material for her story in the way that Tennessee Williams did more than a few times. And for eleven months it sat on my shelf, not even in its correct alphabetized-by-authors place as I keep all my books but on the end where miscellaneous books reside. Even as I heard about the book being a *New York Times* Bestseller and then, of course, having a movie based on it, I was never once tempted to take it down and see just how much like *Gone with the Wind* it could be. Yet when my wife took me to see *Jumping the Broom* as an apology for dragging me to see the current *Madea* film (I like *Why Did I Get Married?*, *Family that Preys*, *Daddy's Little Girls*, and *For Colored Girls*, but the current one just doesn't do it for me.), one of the previews was for *The Help*. Often, of course, movie trailers lie well, including the best scenes or moments in the promo of a film that is a hour and a half dud. However, there are some trailers that when one sees them one knows that the studio has put all of its eggs, weight, and budget behind this film. It is obvious when a film has been given the first-class treatment. Again, a potential viewer may not be able to tell whether or not the film will be any good, but one can tell how much the studio believes in the film based on the trailer and additional promotion. It was that reality that said to me, "At some point someone who loves this book and movie will ask you about it; don't you want to have enough ammunition to dismiss it as more white fantasy with a white female protagonist bonding with African women over the brutality of men, especially African men, saving themselves from the oppression of men, especially African men?" So nine days ago, I opened to page one.

The Help is a well-written book by a well-schooled writer, Kathryn Stockett, who has a wonderful eye for detail (historical and cultural), a flare for imagery (descriptive and symbolic), and a wit that echoes three of my favorite storytellers: Richard Pryor, Bill Cosby, and Jerry Clower, especially in the notion that a story with interesting and

well-developed characters is always more rewarding than a work of fiction that is more concerned with showing the latest "new school" tricks of fiction, especially as it relates to East Coast minimalism. Further, well-crafted books are books that can be taught on two levels, and *The Help* achieves this. It can be used to teach the basic elements of fiction writing, and it can be used to show how creative writing is often crafted to enlighten or impact socio-political condition, proving DuBois to be right that in the final analysis "all art is propaganda" (757). *The Help* does not rise to the levels of James Baldwin, Toni Morrison, or James F. Cooper, but whose work does? Certainly, not mine. However, Stockett has mastered the weaving of the personal and communal narrative and the ability to paint the complexities of race rather than to pander to flat, one-dimensional ideologies and characters, which is achieved by her ability to craft characters in a storm of internal and external conflict, for the most part, on both sides of the race line. When I read any work, I am always trying to discover two elements: creative techniques that I can use and teach to students, which I have briefly discussed, and a central issue or several issues that can be used in the development of a paper. Stockett has presented at least twelve issues that can be discussed in a lit crit piece: the perpetuation of fantasy antebellum society for which whites are willing to lose their humanity to maintain (such as in Faulkner's *Sound and the Fury*), Christianity as a tool of white supremacy, Christianity as a linguistic battleground for Civil Rights, storytelling as socio-political activism (which includes Aibileen—a maid and co-narrator of the text—as a griot or the creative writer as shepherd and philosopher), the tragedy of an unfulfilled life due to embracing the physical over the metaphysical, African (American) maids as another "Nigger Jim" figure, a general commentary on poor and proper parenting or negligent white mothers having enough money to hide their poor parenting, white supremacy as schizophrenia passed to and manifested in African people as colorism or self-hatred, the manner in which African (American) intellect and culture has existed despite and beyond white culture and oppression as an example of African intellect and culture existing before white culture, the truth and importance of acknowledging African diversity as complex and layered beings (which speaks to their humanity as Margaret Walker does with and for the slaves in *Jubilee*), the struggle of good-intentioned whites to overcome their own racism, and (of course) the troping or connecting of African oppression with female oppression (allowing the book to be a manifesto on the plight of the female under male oppression). Each of these themes is well painted through intricate character development and creative plot weaving.

There seems to be only two flaws, and both can be considered major. The first issue is the use of faulty or flawed dialect, specifically Stockett's use of "Law" for "Lawd" as in "Lawd have mercy." I have been unable to finish a few books wherein I found flawed or inauthentic dialect, but in this case it does not seem to bother me as much, probably because there are no other glaring dialect issues. Also, I realize that I am reading a book through a white writer's eyes (even though the narrative is equally shared by two maids and a recent white female college graduate), and I can accept that to her ears she does not hear the "d" in "Lawd." Because there is not an abundance of flaws in the dialect, I am not distracted from the narrative though a few of my friends and colleagues have been too distracted to even finish chapter

one. Secondly, I agree with Ishmael Reed that, in most cases, white feminists use the African male as the face of sexism. And I cannot help but wonder if this is true in *The Help*. While she is clear, vivid, and precise about the horrors of racism that Afro-Southerners endure in the 1960s, Stockett presents two positive adult white males (Skeeter's father and Celia's husband) and not one positive adult African male. There are two male sons of maids that are portrayed in a positive manner, but neither achieves maturity as a sovereign adult male: one dies in an accident, and one is beaten until he is blind. In fact, the one African male whom Stockett develops as more than a symbol of the Civil Rights Movement is Leroy, the husband of Minny, and he beats Minny regularly. Is there not one maid whose husband does not beat her? Is there not one average African male who is not a threat to his community? And as a well-skilled craftsman, Stockett appropriates and connects Leroy's evil with the evil of white male sexism and schizophrenia, especially when Minny and Celia, Minny's boss, are attacked by an insane, naked white man. Yet, in combining the two events to develop her theme of universal or female oppression and struggle, Stockett seemingly paints Leroy and all African men with a broader, more stereotypical stroke than white men. The insane, naked white man in Celia's backyard is never equated with all other white men. However, just before the insane, naked white man appears, Stockett has Celia showing concern for Minny's plight, even attempting to come to Minny's aid:

> "Minny?" Miss Celia says, eyeing the cut again. "Are you sure you [cut your forehead] in the bathtub?" I run the water just to get some noise in the room. "I told you I did and I did. Alright?" She gives me a suspicious look and points her finger at me. "Alright, but I'm fixing you a cup of coffee and I want you to just take the day off, okay?...You know," she says kind of low, "You can talk to me about anything, Minny." (304-305)

During the attack by the insane, naked white man, Stockett connects Minny's beating from Leroy to the beating that she takes from the insane, naked white man: "It's like he knows me, Minny Jackson. He's staring with his lip curled like I deserved every bad day I've ever lived, every night I haven't slept, every blow Leroy's ever given. Deserved it and more" (305). And after Celia comes to Minny's aid, in the similar way that Skeeter, the book's white co-protagonist, comes to the aid of and provides voice to the maids, Stockett connects, once again, Minny's beating by Leroy to the beating by the insane, naked white man, but does so in a manner that can be seen as painting the majority of African males with this stereotypical brush: "'So what you gone do about it?' Aibileen asks and I know she means the eye. We don't talk about me leaving Leroy. Plenty of black men leave their families behind like trash in a dump, but it's just not something the colored women do" (310-311). Stockett is careful to have her character use "plenty" rather than most, but the message is received, especially since there are no white women who exist in physically abusive relationships in the novel. And because her own, childhood maid and caretaker was "married to a mean, abusive drinker," then that must be the lasting image of African

men in her novel. In fact, for all of the fear and potential consequence the African women face from providing stories for the book, it seems that the greatest threat comes from Leroy, as Minny states: "Look, Aibileen, I ain't gone lie. I'm scared Leroy gone kill me if he find out" (429). And when Leroy discovers that he has been fired from his job because of Minny contributing stories to the book, of course, all black savage Negro hell breaks out: "Minny panting and heaving. 'He throw the kids in the yard and lock me in the bathroom and say he gone light the house on fire with me locked inside!" (437). Thus, escaping life with Leroy, who by now has become the face of all African men, is as important as escaping white supremacy: "Still, what's important is, Minny's away from Leroy" (439). Whether Stockett knows it or not, this representation of African domestic violence is just one more use of writing as skin privilege, one more use of writing as a smokescreen to keep hidden the obscene abusive relationships that do exist in "white" marriages and partnerships. Stokett writes well, but she runs the risk of hopelessly reinforcing ideas of white supremacy, even if she does so unconsciously. Additionally, those who have profited from reading *Dessa Rose, Beloved,* and *The Autobiography of Miss Jane Pittman*—works that deal with recording someone else's story—may find that Stockett has consciously or unconsciously used the African male body as a symbol or smokescreen for all evil or merely to placate the supremacy of her white readers. Furthermore what Stockett seems to miss or forget is that the power of the maids' storytelling is the balance that their story brings to the American narrative. What was wrong with *Amos and Andy* is not that they existed but that they existed alone with no different narrative to balance or provide a well-rounded notion of African people. Accordingly, white people are not offended or threatened by *The Beverly Hillbillies* because Marcus Welby, Ward and June, and Ozzie and Harriet provided a counter-narrative to paint a holistic portrait of white Americans. In fact, within *The Beverly Hillbillies* exists the counter-narrative of Milburn Drysdale and Jane Hathaway. Yet, for *The Help*, one can leave with the notion that African women should fear African men as much as they should fear the evils of white supremacy.

As one who has engaged countless books, I have developed the ability to take what is well-done or beneficial from a work and ignore what is poorly done or what is not effective. For instance, I continue to enjoy two hundred and twenty-one of the two hundred and forty-two pages of African (American) poet and theorist Carl Phillips' book *Coin of the Realm: Essays on the Life and Art of Poetry*. Not only do I not agree with the twenty-one pages that constitute the chapter "Boon and Burden: Identity in Contemporary American Poetry," in which he provides his assessment of the poetry of the Black Arts Movement, I find his attempt to couch his subjective denouncement of the poetry of the Black Arts Movement as objective theory to be thin and flimsy. However, the rest of the book is a worthwhile read. In this same manner, Stockett's painting African men in such broad strokes does not completely destroy the narrative for me. There was no way to expect a southern white writer, even one self-exiled to New York, to indict solely white men or white culture for the evils of the South. Besides, the Negro boogeyman still sells as well as sex does. For chronological and cultural context she evokes the names of Medgar Evers and Martin Luther King, Jr., even as they are moreso flat, one-dimensional symbols of the

moment or the meaning of the moment, but there is no adult African male who rises to the humanity and goodness of Skeeter's father and Celia's husband. Still, what saves the narrative is her wonderful use of imagery, her ability to construct complex characters for complex times—especially the manner in which Skeeter is forced to realize and engage her own racist tendencies and sensibilities, the presentation of Aibileen and Minny as intellectual equals to Skeeter—especially their full development into storytellers, the novels biting humor, and the unflinching portrayal of the horrors endured by African people in America, showing the Klan and white southern culture to be equal to the Taliban. After completing the manuscript, Aibileen and Minny are finally able to impress on Skeeter the seriousness of their endeavor:

> The room grows quiet. It's dark outside the window. The post office is already closed so I brought [the manuscript] over to show to Aibileen and Minny one last time before I mail it…"What if they find out?" Aibileen says quietly…We haven't talked about this in a while…we haven't really discussed the actual consequences besides the maids losing their jobs. For the past eight months, all we've thought about is just getting it written… "Minny, you got your kids to think about," Aibileen says…[Skeeter says] "Aibileen, do you really think they'd…hurt us? I mean, like what's in the papers?" Aibileen cocks her head at me, confused. She wrinkles her forehead like we've had a misunderstanding. "They'd beat us. They'd come out here with baseball bats. Maybe they won't kill us but…" (365-366)

Stockett states in the postlude, "Too Little, Too Late," "In *The Help* there is one line that I truly prize: 'Wasn't that the point of the book? For women to realize, *We are just two people. Not that much separates us. Not nearly as much as I'd thought*'" (451). For Stockett, *The Help* seems to be a commentary and celebration of the "universality" of humanity, especially the plight of women in a sexist world. And while I agree more with Langston Hughes's notion of "universality" from his seminal essay, "The Negro Artist and the Racial Mountain," that "universality" is more of a trap or ploy to create within African people an "urge within the race toward whiteness, the desire to pour racial individuality into the mold of American standardization, and to be as little Negro and as much American as possible" (1267), I can applaud Stockett for attempting to tell her truth, which is another motif of the novel, and for having her protagonist struggle with that truth in much the same manner as Baldwin does in *Evidence of Things Not Seen*. Skeeter struggles with her relationship with Minny who is not as placating as Aibileen, and she struggles with just how much truth she tells about her own mother's relationship with their former maid, Constantine, who was like a mother to her. Yet, what makes Skeeter heroic is not that she single-handedly saves or leads Aibileen and Minny or becomes the lone wolf against the backlash of her white community but that she continues her journey toward self-discovery as she continues her journey to learn every aspect about the community that has birth and molded her, even when the journey does not promise anything but the truth, which

very well may be a truth that will disrupt the foundation of the life she knows.

The Help is already a *New York Times* Bestseller and will probably be a summer block buster. And while I wonder if this same book would be loved if written by an African woman, especially considering that even at so-called liberal MFA and PhD creative writing programs and literary journals white professors and editors are careful not to allow whites to be painted as the sole antagonist in African poetry and fiction, which makes it even more interesting that Stockett does not list Richard Wright, Margaret Walker Alexander, and Ellen Douglas as noteworthy Mississippians in her postlude, there is no denying that Stockett has crafted a well-told story that receives its tension from the layering of characterization and the conflict that Stockett battled as she wrote it:

> *The Help* is fiction, by and large. Still, as I wrote it, I wondered an awful lot what my family would think of it, and what Demetrie [the maid who helped raise her] would have thought too, even though she was long dead. I was scared, a lot of the time, that I was crossing a terrible line, writing in the voice of a black person. I was afraid I would fail to describe a relationship that was so intensely influential in my life, so loving, so grossly stereotyped in American history...Like my feelings for Mississippi, my feelings for *The Help* conflict greatly...I am afraid I have told too much...I am afraid I have told too little...What I am sure about is this: I don't presume to think that I know what it really felt like to be a black woman in Mississippi, especially in the 1960s. I don't think it is something any white woman on the other end of a black woman's paycheck could ever truly understand. But trying to understand is *vital* to our humanity. (450-451)

To be clear, I am a Black Nationalist who thinks that Jackie Robinson breaking the color barrier in professional baseball only served to limit greatly the number of black-owned businesses as integration has merely meant the perpetuation of African second-class citizenship. And for those quick to identify the election of President Obama as a great achievement of American integration I assert that he was only elected because Bush II drove the American Titanic into the economic iceberg and that the emergence of the Tea Party has the same historical significance of the emergence of the Klan after the Hayes-Tilden Compromise. However, the value in Stockett's writing is that she does not settle for the falsity of "Can't we all just get along?" but seeks to present difficult questions about the struggle of personal and communal concerns, showing that we all must make difficult decisions of how best to navigate those waters to achieve what is best for oneself, one's race, and others who seem different than us. Though not nearly as dense, Stockett uses the historical novel in much the same way as Walker uses *Jubilee*—to forecast, make commentary, and raise timely questions that the readers will be forced to ignore or answer. But, even if those questions are ignored, Stockett has fulfilled her artistic responsibility of painting a work that raises these uncomfortable questions.

Works Cited

DuBois, W. E. B. "The Criteria of Negro Art." *The Norton Anthology of African American Literature.* Ed. Henry Louis Gates. New York: W. W. Norton & Company, 1997.

Hughes, Langston. "The Negro Artist and the Racial Mountain." *The Norton Anthology of African American Literature.* Ed. Henry Louis Gates. New York: W. W. Norton & Company, 1997.

Stockett, Kathryn. *The Help.* New York: Amy Einhorn Books, 2009.

The Other Hollywood | Alejandro Murguía

I'm born in Hollywood but not the Hollywood you're thinking of. My Hollywood is just north of the one you imagine when someone mentions the town. Instead of stars on the sidewalks, this one has trash, instead of movie studios, this other Hollywood is factories and small businesses, and replacing the mansions you find small stucco houses with an occasional palm tree or citrus tree in the front yard. This is where I was born in an old barrio named Horacasitas, in the shadow of that other Hollywood and it appears on maps as North Hollywood.

But the other Hollywood, the one of movie stars and mythical theatres, the Chinese, the Egyptian, the Mayan has always intersected with my Hollywood—scenes from Mildred Pierce with Joan Crawford were filmed a few blocks away from where I was born. A neighbor bred and trained dogs for movies including Rin-Tin-Tin. Even my grandmother Ramona Lugo—a stern no-nonsense devout Catholic rubbed shoulders with Hollywood stars like Bing Crosby during Sunday Mass at the San Fernando Mission. It was there that Ramona talked the notoriously tight-fisted Crosby into donating $10,000 so that she could get her strong sons to build the chapel of Our Lady of Zapopán, which still stands today on Lankershim Boulevard.

Like everyone growing up in Southern California—you couldn't help but see the influence, good or bad, of Hollywood. It was common in most neighborhoods, including mine, to know someone whose parents worked in the film industry. The father of one friend ran the catering trucks for movie crews, and I remember a truck parked outside their house one summer evening advertising *It's a Mad, Mad, Mad, Mad World*. So there was that contact however tenuous with the film industry. Yet it was clear to me even then that Hollywood, the business of making movies, had many different levels to it. I used to wonder where did I fit in this world—so I was always looking for Mexicans or Chicanos or Latinos in the movies I watched—and even to this day, I read all the credits, looking for where Latino names might appear.

In those days, growing up in the shadow of Hollywood, one of the big televised events was the Oscars. There was all the glamour, the red carpet, the klieg lights. The anticipation building till finally the opening of that fateful envelope that seemed to hold all the ambition and glory of Hollywood sealed within it. I was naïve. Too bad the Oscars have now turned into a popularity contest amongst a small circle of friends—there's really no other way to put. The list of such "winners" is so long and

embarrassing that it is best not to take up space with it—but everyone knows who they are.

It was in 1963 while I was still in awe of the Oscars that I had my first view of the destructive aspects of Hollywood. How something as common as making a movie could in fact be deadly. I can clearly recall as I write this the shock of the news—a memory fifty years old—when the great Mexican actor Pedro Armendáriz committed suicide at UCLA Medical Center after being diagnosed with cancer. He had contracted the cancer while working on a Hollywood film named *The Conqueror* that had been filmed in large part in a Utah location, unknown to the crew the set toxic with radioactive sand. When he was told that the cancer was terminal he somehow had a Smith & Wesson .38 Special smuggled in and shot himself in the heart.

It would be years before I would learn of the radioactive sand that had caused Armendáriz to take the short good-bye and turn in his ticket to The Other Hollywood—the one that ends at Forest Lawn Memorial Cemetery.

Later I would also rediscover the history of Lupe Vélez—the first Mexican actress to make it big in Hollywood, and I mean really big. In her first Hollywood movie *The Gaucho* (1926) she steals scene after scene from Douglas Fairbanks Jr. and the only reason to view the movie now—otherwise forgettable—is for her performance. Her beautiful face would eventually grace the cover of every major movieland magazine, and she would have her share of marriages and whirlwind romances with some of the top stars of that era, but who are not worth mentioning here, just like the many lovers and husbands of Marilyn Monroe rightly deserve obscurity when recalling her name. Both Lupe Vélez and Marylyn Monroe, though great actresses, would be denied any Oscar consideration. And like an unfortunate heroine in a soap-opera telenovela, Lupe Vélez would also take her own life once Hollywood had used and abused her, squeezed the juice out of her like an orange.

When I think of Hollywood I don't think of the Oscars or what they might represent, I think of Pedro Armendáriz, Lupe Vélez, Rita Hayworth (Margarita Cansino) and how the industry took everything from them, heart, soul, and body, and returned only their images in celluloid and the memory of their talent and greatness. So when I turned on the Oscars this year—as a sort of exercise in nostalgia for a Hollywood that no longer exists and the host whose name I forget made a joke about there being only one Latino in this year's ceremonies—the stunningly beautiful Salma Hayek—I can't help but think of Hollywood as this exclusive mostly white country club, but I also wondered about Salma's own back story, coming to Hollywood and rising to the top, though she also admits having spent time here after her visa had run out—in other words undocumented, which I hate to say, is the story of Latinos in Hollywood, basically undocumented, their stories and contributions I mean.

Even now—as a group of independent producers and actors attempt to turn one of my short stories into a movie *The Other Barrio* about arson, gentrification, violence, murder, in the Mission District, the shadow of that other Hollywood looms quite large over the production. Hollywood is not interested in this story—and why should they be? The single most important issue affecting Latinos across the country, the gentrification of our neighborhoods, from Silver Lake to Echo Park to Austin to

the Mission is totally absent from the silver screen. Yet Los Angeles and Hollywood are cities mostly filled with Latinos and now a days California itself is over fifty percent Latino—so it is better for Hollywood to fantasize a world where Latinos are relegated as usual to the back rooms, editing rooms, the secondary roles, gangsters and other lowlifes, with an occasional positive figure, once in a blue moon.

But we are a tenacious community, and one way or another, sooner or later our stories will be told, and we will get our recognition as artists even if we have to create our own Oscars, or maybe we will call them Lupes, in honor of Lupe Vélez. And Hollywood, its Janus face, the smiling one that is presented to the bankers and the angry face that is directed at the rest of us will be forced to reveal what hides behind the mask, something we already know—Hollywood is a movie set, with just the facades and nothing behind it, a cardboard city, for cardboard people that make cardboard movies. And the Oscars of that other Hollywood, the one south of where I was born? Well it goes without saying.

Save Your Precious Time and Money,

Don't See *Precious* | Hariette Surovell

The Jews who ran Hollywood were racists. The celluloid presence of shiftless, stupid, lazy, greedy, sassy Blacks, featured exclusively as maids and butlers tainted major studio releases from the 30s to the 50s, rendering heartwarming family fare, cutting-edge comedy classics and edgy film noir expeditions into psychic cringe fests. What exactly was the purpose of including Black actors if only to cast them as bobbly-eyed cooks and butlers unable to follow the simplest commands, who frequently fell down (since they were also incapable of learning how to walk properly), and bug-eyed, big-bottomed maids who either sassed their employees, broke or stole things, or relayed misinformation? Their presence was usually irrelevant to the plot, yet always successful in interfering with cinematic suspension of disbelief. As soon as I became swept up in emotion, I began obsessing about why Louis B. Mayer, Harry Cohn, Jack Warner, et al, found it necessary to demean and ridicule Black people. These studio-owners were always kvetching about being deemed unfit to join the no-Jews-allowed Los Angeles Country Club, forcing them to create the Hillcrest, just one of many humiliations these multi-millionaires endured. Shouldn't they have understood prejudice on a personal level?

What a difference the decades make! Now, not only are Black people directing and producing movies filled with vile racist stereotypes, but they also fill them with good, kindly, benevolent Jews, whom they cast as the saviors of the bad, bad Black people. Consider the cynically-crafted *Precious: Based on the novel "Push" by Sapphire*. Executive-produced by Oprah Winfrey, who never met a high-profile incest abuse project she didn't embrace, and produced by Tyler Perry, (best known for his drag queen/fat suit incarnation of a crazy Black grandmother, "Madea"), it was directed, so to speak, by Lee Daniels, a gay Black man who claims to have suffered abuse from his bio-family. The novel *Push* was written by a gay woman, Sapphire (a reference to Sappho?). The double entendre implicit in Jones' title is that Precious, the book's main character, must push against the barriers of her life and forward into a meaningful existence, and she must literally push out the two babies to whom she gives birth. As a work of cinema, *Precious* functions as a means to an entirely different end…awards, kudos and advertisements about future projects for Oprah and her producing partners. Why else would this movie focus on evil ghetto-dwellers who perpetrate unspeakable atrocities on each other, yet who are ultimately saved by

empathic Jews who have the power to "heal" and the incentive and access to help? *Precious* is nothing more than an obvious ploy on the part of media whiz Oprah Winfrey to nab the movie, and it's cast of non-actor actors, multiple nominations. It is an overt a bid to get consideration from the predominantly Jewish members of the Academy of Motion Picture Arts and Sciences (AMPAS.) This is why "Precious" opens with a screen imprinted with words of wisdom not from the works of Toni Morrison, Harriet Tubman, Franz Fanon, W.E. B. Du Bois or the Reverend Martin Luther King, Jr. but *The Talmud*:

> Every blade of grass has its Angel
> that bends over it and whispers,
> "Grow, grow."

For anyone lucky enough not to have already seen it: "Precious" is the nickname for the ebonically-spelled Claireece Jones, played by a former unknown, Gabourey Sidibe. My favorite review of her performance comes from the website allvoices. com: "I was also very impressed by newcomer Gabourey Sidibe whose flat affect conveys a child severely abused." In other words, her non-acting constitutes acting. This kind of nonsensical doublespeak characterizes every aspect of the movie.

Precious is a morbidly obese (pushing 400 lbs.?) Black girl who lives in 1987 Harlem with her emotionally, physically and sexually abusive mother, Mary and, (in flashbacks), her sexually abusive father. She is pregnant with her second child, with the baby daddy being…her daddy! We see Precious' father zestfully raping her, in plain sight of Mary, and when Precious cries out, he covers her mouth with his hand. Mary is played by the comedian Mo'Nique, who is also obese, although not in Sidibe's league. She is almost always seen supine, disrobed and wigless on a couch. Mary demands many things of her only child: that she clean, shop and cook for her, that she depilate pig's-feet before deep-frying them, that she venture out 24/7 and buy her cigarettes, and that she perform oral sex on her (all these activities having the same, pun intended, emotional weight.) When Precious is slow to act on a command, her mother hurls ashtrays and skillets at her head or pours pots of water on her, calling her, "Little Piggy Cunt," "Lying Whore," "Fat Little Slut," "Stupid Mouth Bitch," and most offensive of all…"crafty Scorpio!"

Precious eventually relates the details of her first childbirth experience to a social worker. She lay down not in a hospital bed, or in any bed whatsoever, but on her own kitchen floor, with her mother kicking her "upside her head" throughout the ordeal. Yet she suffered no physical injuries from this combined home birth/physical assault, and is experiencing a second healthy pregnancy. Her first child, a girl with Down Syndrome (or, as Precious informs someone, " Sinder"—an arbitrary and completely false note—why would she not know the word "syndrome"?) is cared for by Precious' grandmother, a thin, passive but angry lady who brings the baby over on the days when a moronic Black caseworker comes to check in on the "family." This city official has been successfully scammed into believing that the baby lives there, so that Mary can collect its AFDC check. Despite a total absence of any children's toys, furniture, clothes or chachkas in the apartment, this ruse has worked effectively for

two years (although one wonders how the grandmother is able to financially support the child, since Mary appropriates the check money.) When the social worker leaves, and Mary throws the baby off her lap and onto the floor in disgust, Grandma merely shakes her head in puzzlement, as she does when observing all of her daughter's sadistic rages and torrential temper tantrums. We never learn why Mary has become a monster. Or why her own disapproving mother remains so passive in her presence.

Baby # 1 is named Mongo, a fact I found disturbing, mostly because of its implications about the mental capacity of legendary jazz musician Mongo Santamaria. His cover of Herbie Hancock's "Watermelon Man" was played constantly on the radio during my childhood, so I'm sentimental about him. Precious' daughter Mongo is a light-skinned, almost white child, which is puzzling, since both Precious and her father are dark-skinned—one of the many genetic anomalies presented in "Precious."

The apartment Precious and Mary inhabit is a huge duplex with a long staircase separating each level. Where, one wonders, can such an apartment be found in Harlem? I sure would love to live there when Mary gets evicted! It's not in a housing project, it's located in a place called Movie Fantasyland. Could Lee Daniels be a Woody Allen devotee? Allen houses his characters in Park Avenue triplexes, Daniels invents Harlem duplexes.

The apartment is appropriately dingy, and yet, in it there resides the Jones' family's heart and soul, the center of its hopes and dreams, the repository of all intellectual life …a large television set, usually tuned to a game show. Also sharing this apartment with Precious and Mary are two cats, Mary's pets. As I watched, I kept asking my friend, "Why would this woman have pets?" The answer is that she wouldn't, unless their presence is a visual reinforcement of the fact that there is pussy in this household, a fact hard to forget. Not only is Precious pregnant, but there is an explicit scene of Mary masturbating, then ordering her daughter to get her off ("Come take care of Mommy!" she demands.)

Despite being so illiterate that she is unable to read a sentence from a children's book, Precious is a "ninfe"-grader, who is "good with numbers" (except, apparently, the number "nine.") How do we know this? Because she herself informs us, in an epic Ebonic-al external monologue that opens the movie and only ends as the final credits roll. All the other students in Precious' math class are not only svelte, they are fashionable and attractive…and yet, in this part of Harlem, customers routinely purchase 10-piece fried chicken dinners with potato salad at greasy take-out joints.

Isn't there anyone as unattractive as Precious out there? Not even one other overweight person in Harlem, other than Mary? In 2001, a study showed that 33 percent of all African-American children in the U.S. are morbidly obese. Are they all living outside of Lee Daniels' version of Harlem? If so, then where are they?

The plot kicks into high gear when Mrs. Lichtenstein, the school's Jewish principal, summons Precious to her office to point out that Precious is apparently pregnant with her second child. The audience is confused…however could she tell? The house-sized Precious could do damage to an NFL linebacker. Precious is unresponsive, and becomes enraged when the principal suggests a parent-teacher conference. When Mrs. Lichtenstein threatens to suspend her, Precious lunges from her chair and reaches over the desk. Mrs. Lichenstein vaults backwards in terror

and tumbles to the floor, calling, "Security! Security!" Her cries are still audible as Precious leaves the building.

We hear Precious' thought process, such as it is. Not, "Oh no, I'm in real trouble now, I tried to attack the principal and she called the guards on me" but:

> Nosy
> ass white bitch mad 'cause
> she can't come over my house.
> I don't be coming to this
> bitch's house in Weschesser.

I didn't buy it. First of all, why would she think she would be entitled to visit the principal in her home under any circumstances? Second, how would she ascertain that Mrs. Lichtenstein lives in "Weschesser"? Precious doesn't know the word "syndrome", even though she is the mother to a Down Syndrome child. It's all illogical, arbitrary writing, i.e., bad writing. Precious' knowledge of "Weschesser" was as bogus a detail as was a group of little boys, presumably as uneducated as Precious, caling her "Orca," and not "whale."

And yet, despite Precious' violent outburst towards Mrs. Lichtenstein, the two of them experience miraculous simultaneous changes of heart just a few hours later! The cause of Mrs. Lichtenstein's complete 180—a teacher has confirmed that Precious is, indeed, good at "maffs." This so impresses Mrs. Lichtenstein that she becomes filled with hope for Precious. She is determined to change her life, and so, without being accompanied by the aforementioned security guards, she braves the mean streets of Harlem at night, standing alone in the dark mean streets in front of Precious' building. One would think she'd get robbed, or at the least, hassled, but by bumming a cigarette off a passerby, she shows these Harlem residents that she is not just cool, she's practically a sista! Her intention? Like all public school principals who exist exclusively in the imagination of filmmakers, she's making a nocturnal Harlem house-call to tell Precious, albeit over their apartment intercom system, to check out an alternative school. Precious doesn't know what the word "alternative" means (why not?), and Mary wants her to stay home and collect Welfare, but Precious is nonetheless inspired to go. We're not quite sure why she is so determined to take advice from a principal whose lily-white ass she so recently wanted to kick. The confusion mounts when about ten minutes of screen time is devoted to Precious making numerous attempts to discover the meaning of the word "alternative" (an office worker finally fills her in.) Why did she want to go there so badly if she didn't even know what it was?

The alternative school, "Reach One, Teach One" seems to exist in an alternate reality. It's 1987, yet Precious passes a bodega advertizing Metrocards, which debuted in 1993. A certificate is displayed in a teacher's office signed by "President of the United States, Bill Clinton." The school employee who finally explained "alternative" has a computer displaying graphical capabilities not yet invented. Despite Precious allegedly being "good with numbers," she takes the subway to the 167th Street stop, located in the Bronx, to reach her destination of 125th Street, Manhattan, Harlem.

As she runs for her train, kids sing Queen Latifah's "Come Into My House," a song released in 1989. Still, maybe it's a good thing that she has transferred to this school, since the teacher in her former school has written the word "Requirments" (sic) on the blackboard.

Precious finally reaches her classroom (albeit having gotten off the subway in another borough…) only to discover that the all-girl students are all beautiful, thin and stylin'. Why can't Precious find a peer? Even just someone moderately overweight? Precious' new teacher is a pretty, extremely light-skinned black woman with straightened hair in her 30's, who could impersonate a well-tanned white woman. Her name is Blu Rain, spelled just like that (but spelled "Blue" in the book) as in, as in, as in well, Blu-Ray discs! Is this barely-subliminal advertising? I wonder what percentage of Blu-Ray sales of this movie Oprah negotiated.

Ms. Rain asks everyone to tell their favorite color. A girl named Joanne says that hers is "fluorescent beige," a color which could only exist in an alternative reality school. Then Ms. Rain asks the class to write the letters of the alphabet on the board. The action ends when someone is stumped by "E." We discover that Precious is equally unfamiliar with the letters of the alphabet.

Despite the fact that most of the students are equally as illiterate, with Precious thinking that the word "at" is actually "ate" (she's not 400 lbs. because she starves herself), Ms. Rain informs them that they will be writing in their journals on a daily basis. Just as The Bard explored the concept of a play within a play, so "Precious" pretends that its subtext is the omniscient power of writing.

When Precious goes home, her mother insists that she stop attending this alternative school so that she can get Welfare, her main concern being affording her cigarettes. For Mary, Welfare is the one true way of life and should be every Black person's destiny. The next morning, Precious meets with her very own Welfare caseworker. This is no dumb Black lady! Since Precious' life is on an upswing, she has earned herself a Jew, Mrs. Weiss! An ostensible Jew, played by an oddly miscast oddly Hispanic-looking Mariah Carey, who phones in a performance with all the vitality, energy and natural acting ability she displayed in "Glitter." Mrs. Weiss asks Precious the identity of her children's father.

"My daddy," Precious replies. "He give me this baby comin and my other one before. Thas all I know. Don't see him."

Mrs. Weiss looks startled (as startled as Mariah Carey playing a social worker, or, well, playing anybody, can look), but does nothing. She doesn't make an effort to locate Precious' father, nor does she talk to the police or the district attorney's office about getting a warrant out for his arrest, because in Movieland Harlem, fathers can impregnate their daughters repeatedly without legal consequences.

Next we see Precious in the hospital, where she has given birth to a healthy baby boy. No birth defects, no "down sinder" for little Abdul, even though the baby was deprived of nutrition, pre-natal care, and was fathered by its grandfather.

We learn from the voice-over that a social worker (it's unclear whether by this she means Mrs. Weiss or a hospital social worker) is encouraging Precious to give up both Abdul and Mongo. Her grandmother informs Precious that "only a dog will drop its baby and walk off." Wow, what a guilt-trip! That one was worthy of the

stereotyped Jewish mothers invented by Hollywood scriptwriters. Not only does this grandmother enable Mary to defraud and deceive the government, and enforces a strict non-intervention policy about Precious' being physically, emotionally and sexually-abused, but she suffers from a bizarre species confusion. Dogs are, in fact, extremely devoted and protective mothers. It's the human bitches who neglect and abuse their offspring. Then again, who can blame Granny? Not one character in this celluloid fantasy-fest resembles an actual human being.

Only a few months have elapsed since Precious entered Ms. Rain's classroom, unable to read a sentence from a first-grade primer, but now, she is magically writing regular journal entries, filling entire pages with sentences and paragraphs! Ms. Rain is surely the most brilliant teacher in the entire history of education! Whatever her secret is, she needs to patent it! Precious has become so super-literate that she is asked to explain what Ms. Rain means when she discusses " a protagonist's unrelenting circumstances."

Ms. Rain addresses granny's guilt-trip in her notes to Precious:

"Dear Precious, You are not a dog. " (Whew! Whatta relief. I was worried for a while…) "You are a wonderful young woman who is trying to make something of her life.

I have some questions for you.

1. Where was your grandmother when your father was abusing you?

2. Where is Little Mongo now?"

I had some thoughts about this, too. I wondered, 'One, where has Ms. Rain been throughout all this?' and 'Two, why is Ms. Rain deliberately disobeying the New York City law mandating that teachers report suspected child abuse cases to the authorities?'

Eventually, Precious must leave the hospital, so she returns to her home, carrying Abdul. Mary greets her by screaming "Bitch!" Then she hurls a vase at daughter and grandson, followed by a plant (why would she have a plant? A plant, a pet…why, oh, why?). Next, she stands above Precious and hits her directly with the plant so that Precious is covered with dirt. This is the second time Daniels has attempted to employ symbolism. Quel auteur, he's a true maverick! When we first saw Precious being raped by her father, Daniels then cut to a visual of meat sizzling in a frying pan (she's a piece of meat, she's treated like dirt, get it?) Then, her fury only increasing, Mary attempts to "ram Precious and Abdul like a bull." This is taken verbatim from the shooting script. Rams, bulls, pigs, cats, dogs… either Daniels is obsessed with astrology (Eastern and Western), or he associates Black people with animals.

In her effort to escape, Precious overturns the television set and runs down the stairs to the lobby. Mary then throws the set down the steps, where it threatens the lives of Precious and Abdul! Is this (hopefully) meant to be a commentary about the evils of television, how it has killed Mary's desire to live and to be a part of the world, and almost ensnared Precious in its evil grip? Actually, no! Because soon afterwards, Precious ends up in Ms. Rain's apartment, where they all sit together and…watch television! Ms. Rain lives with her "wife", Katherine, who is also a light-skinned black woman. They insist to Precious that they are indeed married, despite the fact that gay marriage has yet to become legal in NYC in 2010.

And then comes an insidious barrage of advertising by the movie's producers, Winfrey and Perry. Plastered on the wall of Ms. Rain's home is a colorful, eye catching poster for the 1975 play, *For Colored Girls Who have Committed Suicide, When the Rainbow is Enough,* by Ntozake Shange. Producer Tyler Perry is currently in pre-production to make a movie of that play——it will be shown in theatres in 2011. Why not just paste an ad for the upcoming movie on the wall? Then executive producer Oprah gets plugged. Watching Ms. Rain dance with Katherine, Precious sorts through her confusion. "Are homos really (as she has always been taught) bad people?" she wonders. There is no reason for the teacher to be gay. It's irrelevant to the plot and adds nothing. It is, however, essential to leading Precious to contemplate the single most important question of the film: If 'Ms. Rain be a homo, and she nice' then, what's the truth about Oprah, whom Mary also dissed? Employing the single most creative product-placement technique in the cinema history, Precious muses, "I wonder what Oprah have to say about that? " And then she asks, "Y'all watch Oprah?"

Ms. Rain gives her a loving smile and extols Oprah's virtues. So convincing is she that when Precious moves into a halfway house, she decorates it with…a postcard of Oprah! Readers, Oprah executive-produced this movie! This is the ultimate in cinematic chutzpah! Precious, can you spell "conflict-of-interest" yet?

Well, I could go on and on, as the movie did, citing, for instance, Precious telling us, "I find out Mayor's office give me Literacy Award and check for progress!" which should make all viewers very nervous about what the criteria for winning was.

Or I could talk about how Precious moves to a halfway house, where Mary visits to inform her that her father has died from AIDS, but that she herself is HIV-negative because the sex she had with him was "not like faggots, in the ass and all." This news motivates Precious to get tested (naturally, she's positive), because although she gave birth to a child of incest in a city hospital, they never tested either her or her child (who is, unlike Precious, miraculously AIDS-free, yet another genetic anomaly.)

Or, I could tell you about how Precious attends an "Insect Survivor's Meeting." She may have won a mayoral literacy award, and she knows what a "protagonist'" is, and her life itself may be the very essence of "unrelenting circumstances" but somehow she never learned the term for the act which has defined her existence.

Or, I could go into detail about Precious' final visit with Mrs. Weiss, a session also attended by Mary, and the, no pun intended, climax of the movie. But then, I might be accused of leaking spoilers!

I did, however, wonder whether Precious had plans to re-christen "Mongo." I asked my friend, "What should she name her?"

My friend thought briefly, and replied, "Mango?"

When Oscar time comes, and the screeners are sent out to the members of AMPAS, I expect them to come in an envelope inscribed, "Shalom uv'racha leYisrael!"

ABOUT THE CONTRIBUTORS

J. Douglas Allen-Taylor is an Oakland-based novelist, journalist, and political and social commentator who spent many years as a Freedom Worker in the Deep South. He is the author of Sugaree Rising, a historical novel of spirit and struggle from South Carolina. He is the recipient of 2003 Reginald Lockett Lifetime Achievement for Literary Excellence Award from PEN Oakland.

Houston A. Baker Jr. was born in Louisville Kentucky. He received his BA from Howard, and his MA and Ph.D. from UCLA. He is currently Distinguished University Professor (English and African American Diaspora Studies) at Vanderbilt. His awards and honors include: Guggenheim and National Endowment for the Humanities Fellowships and honorary degrees from several US colleges and universities. He served as President of the MLA and authored articles, books, and essays devoted to African American Literary Criticism and Theory. His book Betrayal: How Black Intellectuals Have Abandoned the Ideals of the Civil Rights Era received an American Book Award for 2009.

Amiri Baraka (formerly LeRoi Jones) was born in Newark, New Jersey, on October 7, 1934. After three years in the U.S. Air Force, Jones joined the Beat movement in Greenwich Village. After the assassination of Malcolm X, he took the name Amiri Baraka and became involved in the Black Nationalist poetry and literature scenes. He later identified himself as a Marxist. A prolific writer, Baraka penned more than 50 books, including fiction, music criticism, essays, short stories, poetry and plays. Two books were published by Ishmael Reed, The Sidney Poet Heroical, and Un Poco Loco, which showed Baraka to be a brilliant cartoonist. In 1984, he published The Autobiography of LeRoi Jones/Amiri Baraka. He's taught at many universities, including the New School for Social Research, San Francisco State University and Yale University. Before retirement, he served as professor emeritus of Africana Studies at the State University of New York at Stony Brook for 20 years. Baraka died on January 9, 2014 in Newark, New Jersey at the age of 79. He is survived by his wife, Amina Baraka, two daughters from his first marriage and four children from his second.

Herb Boyd is an American journalist, educator, author, and activist. His articles appear regularly in the New York Amsterdam News. He teaches black studies at the City College of New York and the College of New Rochelle. Boyd was born in Birmingham, Alabama, and grew up in Detroit, Michigan. Boyd met Malcolm X in 1958 and credits him as an inspiration. Boyd attended Wayne State University. During the late 1960s, Boyd helped establish the first Black studies classes there. He went on to teach at the university for 12 years. Beside the Amsterdam News, Boyd's work has been published in The Black Scholar, The City Sun, Down Beat, Emerge, and Essence. He has been recognized with awards from the National Association of Black Journalists and the New York Association of Black Journalists. In 2014, the National Association of Black Journalists inducted Boyd into its Hall of Fame. Brotherman, which Boyd co-edited with Robert L. Allen, was given the 1995 American Book Award. His biography Baldwin's Harlem was nominated for an NAACP Image

Award in 2009. Boyd was managing editor of The Black World Today, a now-defunct online news service.

Playthell Benjamin is a freelance public intellectual and independent photo-journalist, broadcaster, commentator, cultural critic and publisher of Commentaries on the Times, www.commentariesonthetimes.wordpress.com, a series that addresses a wide range of issues in politics and culture-national and international. It began as a radio series on WBAI FM, New York, a Pacifica network affiliate. His writings on politics and culture have been published in a wide range of newspapers and journals including the Village Voice, New York Magazine, The World and I, Sunday Times of London, Guardian Observer of London, etc. and he has won several Journalistic awards and was twice nominated for the Pulitzer Prize for Feature Writing and Commentary. His essays and short fiction have appeared in several anthologies, and he co-authored a book with Stanley Crouch, Reconsidering the Souls of Black Folks. As part of the production team for The Midnight Ravers, Mr. Benjamin won a 2011 award for excellence in radio programming, given for The Curtis Mayfield Special.

Cecil Brown (born July 3, 1943), is a published novelist, short story writer, script writer, and college educator. His noted works include The Life and Loves of Mr. Jiveass Nigger and work as a screenwriter on the Richard Pryor film Which Way is Up? Born in rural Bolton, North Carolina, he attended North Carolina A and T College of Greensboro, North Carolina where he earned his B.A. in English in 1966. He later attended Columbia University and earned his M.A. degree from the University of Chicago in 1967. Brown while residing in Berkeley, California (to which he returned in the late 80s and still lives and works) earned his Ph.D. in African American Studies, Folklore and Narrative in 1993. He is a professor at UC Berkeley.

Ruth Elizabeth Burks graduated Phi Beta Kappa with Honors in the Major (Creative Writing) from the University of California at Berkeley. Prior to becoming the first African American woman to earn a Ph.D. in English from UCLA, where she specialized in film and literature, Ruth spent a year as a screenwriting fellow at the American Film Institute; she also holds an Ed.M. in administration, planning, and social policy from the Harvard Graduate School of Education. Publications include, "Intimations of Invisibility: Black Women and Contemporary Hollywood Cinema" in Mediated Messages and African American Culture; "Back to the Future: Forrest Gump and The Birth of a Nation in Harvard BlackLetter Law Journal; and "Gone with the Wind: Black and White in Technicolor" in the Quarterly Review of Film and Video.

Art T. Burton is a history professor at South Suburban College in South Holland, Illinois. He attended Governors State University and received a bachelor in Cultural Studies and went on to receive a Masters in Ethnic Studies. He received honors such as Who's Who in Black Chicago and he was a chairman for the Association for the Advancement of Creative Musicians. He has written three books: Black, Red

and Deadly: Black and Indian Gunfighters of the Indian Territory, 1870-1907; Black Buckskin and Blue: African American Scouts and Soldiers on the Western Frontier and Black Gun, Silver Star: The Life and Legend of Frontier Marshal Bass Reeves.

Stanley Crouch wrote a collection of essays and reviews, *Notes of a Hanging Judge* that was nominated for an award in criticism by the National Book Critics Circle and was selected by the Encyclopedia Britannica Yearbook as the best book of essays published in 1990. Crouch has since appeared on a number of talk shows—Nightline, Night Watch, The Tony Brown Show, Oprah Winfrey, Charlie Rose, and others. A collection of essays, *The All-American Skin Game*, was published in the fall of 1995. In 1996, *The All-American Skin Game* was nominated for an award in criticism by The National Book Critics Circle. In 2002, One Shot Harris: The Photographs of Charles "Teenie" Harris, appeared, which included a long essay by Crouch that examined the epic complexities of black urban Pittsburgh and how well they were captured in Harris's photograph. In June 2006 his first major collection of jazz criticism, *Considering Genius: Jazz Writings* was published. Once a week he writes an editorial page column for the *New York Daily News*.

Justin Desmangles is Chairman of the board of directors of the Before Columbus Foundation. He is the creator of the critically acclaimed radio program, New Day Jazz, now in its thirteenth year. Described by Ishmael Reed as one of the most important young black intellectuals in America (C-Span, April 3, 2011), his poetry and journalism have appeared in Americana, Black Renaissance Noire (NYU), Drumvoices Revue (SIUE), and Konch. He presently is collaborating with Roscoe Mitchell (Art Ensemble of Chicago), as librettist, for an opera on the life of poet Bob Kaufman.

Lawrence DiStasi has worked as a writer, editor, teacher and historian since graduating from Dartmouth College (BA) and New York University (ABD). He has taught literature and composition at Gettysburg College, the University of California at Berkeley, and most recently in the Fall Freshman Program at UC Berkeley Extension. Since 1994, he has been project director of the historical exhibit, Una Storia Segreta: When Italian Americans Were "Enemy Aliens," shepherding it to more than fifty sites nationwide, and spearheading the movement it generated to pass "The Wartime Violation of Italian American Civil Liberties Act", signed into Public Law #106-451 by President William Jefferson Clinton. His published books include: MAL OCCHIO: The Underside of Vision (North Point Press: 1981), Dream Streets: The Big Book of Italian American Culture (Harper & Row: 1989), and Una Storia Segreta: The Secret History of Italian American Evacuation and Internment during World War II (Heyday Books: 2001). He lives in Bolinas, CA.

Jack Foley has published 12 books of poetry, 5 books of criticism, and Visions and Affiliations, a "chronoencyclopedia" of California poetry from 1940 to 2005. His radio show, Cover to Cover, is heard on Berkeley station KPFA every Wednesday at 3; his column, "Foley's Books," appears in the online magazine, The Alsop Review.

In 2010 Foley was awarded the Lifetime Achievement Award by the Berkeley Poetry Festival, and June 5, 2010 was proclaimed "Jack Foley Day" in Berkeley. Eyes, Foley's selected poems, has appeared from Poetry Hotel Press, and a chapbook, Life, has appeared from Word Palace Press. Christopher Bernard has called Foley "a many-tongued master…one of American poetry's essential thinkers and practitioners." Michael McClure has called him "our firebrand experimentalist": "he holds his torch high so the reader can have more light." With his wife Adelle, Foley performs his work frequently in the San Francisco Bay Area. Their performances can be found on YouTube.

David Henderson was associated with the Black Arts Movement through the Umbra Workshop where he served as an editor of their magazine, and editor of the three Umbra Anthologies. Award winning De Mayor of Harlem, and Neo-California are among his best-known books of poetry. He has written the lyrics to Sun Ra's composition "Love in Outerspace," and has recorded with saxophonists and composers Ornette Coleman and David Murray, and the cornetist and composer, Butch Morris. He is the author of the widely acclaimed biography 'Scuse Me While I Kiss the Sky. Jimi Hendrix: Voodoo Child. His most recent publication is the poetry eBook, Obama, Obama.

Geary Hobson is the editor of *The Remembered Earth: An Anthology of Contemporary Native American Literature* (University of New Mexico Press, 1979) and *The People Who Stayed: Southeastern Indian Writing After Removal* (2010), author of *Deer Hunting and Other Poems* (Point Riders Press, 1990), *The Last of the Ofos* (University of Arizona Press, 2000), a novel, and P*lain of Jars and Other Stories* (2011). A book of essays, *The Rise of the White Shaman: Essays and Reviews, 1970-2000,* is currently in press. Professor Hobson teaches undergraduate and graduate courses in Native American and American literature. He believes that students learn more about literature when they consider the written works as products totally of the social and cultural milieu of which the works are a part.

Joyce A. Joyce, Chairperson of the Women's Studies Program and the English Department at Temple University and a 1995 recipient of an American Book Award for Literary Criticism for her collection of essays Warriors, Conjurers, and Priests: Defining African-centered Literary Criticism, Joyce A. Joyce is also the author of Richard Wright's Art of Tragedy, Ijala: Sonia Sanchez and the African Poetic Tradition, Black Studies as Human Studies: Critical Essays and Interviews, and editor of Conversations with Sonia Sanchez. Having received her Ph. D. from the University of Georgia in 1979, Professor Joyce taught for ten years at the University of Maryland—College Park, three years at the University of Nebraska—Lincoln, and five years at Chicago State University where she was professor of English, associate director of the Gwendolyn Brooks Center, coordinator of the Honors Program, and chairperson of the Black Studies Department. From 1997 to 2001, she was chairperson of the African-American Studies Department at Temple University. She has published articles on Richard Wright, Ishmael Reed, Toni Morrison, James Baldwin,

Gwendolyn Brooks, Nella Larsen, Zora Neale Hurston, Toni Morrison, Margaret Walker, Arthur P. Davis, Toni Cade Bambara, E. Ethelbert Miller, Askia Touré, Gil Scott-Heron, and Sonia Sanchez. Her fields of expertise include African-American literary criticism, African-American poetry and fiction, feminist theory, and Black lesbian writers.

Haki R. Madhubuti—poet, publisher, and educator—has published over thirty books including YellowBlack: The First Twenty-One Years of a Poet's Life; Liberation Narratives: New and Collected Poems 1967-2009; Honoring Genius, Gwendolyn Brooks: The Narrative of Craft, Art, Kindness and Justice; and the best-selling Black Men: Obsolete, Single, Dangerous? The African American Family in Transition. He founded Third World Press in 1967. He is a founder of the Institute of Positive Education/New Concept School, and a cofounder of Betty Shabazz International Charter School, Barbara A. Sizemore Middle School, and DuSable Leadership Academy, all of which are in Chicago. Among his many honors and awards, Professor Madhubuti received the Barnes & Noble Writers for Writers Award presented by Poets & Writers Magazine and was honored along with his wife at the 2014 DuSable Museum's Night of 100 Stars Celebration. Professor Madhubuti retired in 2011 after a distinguished teaching career that included Chicago State University and DePaul University where he served as the Ida B. Wells Barnett University Professor.

C. Liegh McInnis is an instructor of English at Jackson State University, the publisher and editor of Black Magnolias Literary Journal, the author of seven books, including four collections of poetry, one collection of short fiction (Scripts: Sketches and Tales of Urban Mississippi), and one work of literary criticism (The Lyrics of Prince: A Literary Look at a Creative, Musical Poet, Philosopher, and Storyteller), and the 2012 First Runner-Up of the Amiri Baraka/Sonia Sanchez Poetry Award sponsored by North Carolina State A&T. In January of 2009, C. Liegh, along with eight other poets, was invited by the NAACP to read poetry in Washington, DC, for their Inaugural Poetry Reading celebrating the election of President Barack Obama. He has also been invited by colleges and libraries all over the country to read his poetry and fiction and to lecture on various topics, such creative writing and various aspects of African American literature, music, and history. For more information, checkout his website www.psychedelicliterature.com<http://www.psychedelicliterature.com/.

Tony Medina, Professor of Creative Writing at Howard University, has taught English and creative writing at various universities and colleges, including Long Island University's Brooklyn campus, Borough of Manhattan Community College, City College of New York and Binghamton University, State University of New York. Dr. Medina is the author/editor of seventeen books for adults and young readers including Committed to Breathing, Follow-up Letters to Santa from Kids who Never Got a Response, I and I, Bob Marley, My Old Man was Always on the Lam, Broke on Ice, An Onion of Wars, Broke Baroque and The President Looks Like Me and Other Poems. His poetry, fiction, essays and reviews appear in over one

hundred publications and on a number of CD compilations. Tony Medina is a two-time recipient of the Patterson Prize for Books for Young People.

Alejandro Murguía is the author of Southern Front and This War Called Love (both winners of the American Book Award). Currently he is a professor in Latina Latino Studies at San Francisco State University. This year City Lights Books released his new book Stray Poems. In May 2014 the SF Weekly named him Best Local Author. He is the Sixth San Francisco Poet Laureate and the first Latino to hold the position. His short story "The Other Barrio" was recently filmed in the streets of the Mission District and will have its premiere at the San Francisco Independent Film Festival in February 2015.

Jill Nelson is a journalist and author of Volunteer Slavery, Sexual Healing, Finding Martha's Vineyard and other books. She edited the anthology, Police Brutality, which includes timeless essays by Robin D.G. Kelley, Patricia Williams, Flores A. Forbes and Ishmael Reed, among others. She has written for The New York Times, Essence, The Nation, Ebony, USA Today, and many other publications. Nelson is married to urban planner and writer Flores Alexander Forbes, author of Will You Die With Me? My Life and the Black Panther Party. She writes, gardens and creates collage in New York City.

Halifu Osumare is a full Professor and former Director of African American & African Studies at University of California, Davis. She has been involved with dance and black popular culture internationally for over thirty years as a dancer, choreographer, teacher, administrator and scholar. She holds a M.A. in Dance Ethnology from San Francisco State University and a Ph.D. in American Studies from the University of Hawai`i at Manoa. Her first book, The Africanist Aesthetic in Global Hip-Hop: Power Moves (2007) established her as one of the foremost authorities on hip-hop internationally. Her second book, The Hiplife in Ghana: West African Indigenization of Hip-Hop, grew from a 2008 Fulbright Fellowship and is one of the few full ethnographies of hip-hop in Africa. As a choreographer and director she is noted particularly for the theatrical works of poet and playwright, Ntozake Shange. Having taught and researched in Malawi, Kenya, Ghana, and Nigeria, Osumare's work has spanned traditional African performance and ritual to contemporary African American dance and performance. Her website is: www.halifuosumare.com.

Ishmael Reed is author of twenty-nine books, including his forthcoming eleventh non-fiction work, The Complete Muhammad Ali; his tenth novel, Juice! (2011); and New and Collected Poems, 1964-2007 (2007). In December 2013, his seventh play, The Final Version, premiered at the Nuyorican Poets Café, and his other six plays are collected in Ishmael Reed, THE PLAYS (2009). In addition he has edited numerous magazines and thirteen anthologies, of which the most recent is POW-WOW, Charting the Fault Lines in the American Experience-Short Fiction from Then to Now (2009), and he is a publisher, songwriter, public media commentator, and lecturer. Founder of the Before Columbus Foundation and PEN Oakland,

non-profit organizations run by writers for writers, he now teaches at California College of the Arts and taught at the University of California, Berkeley for over thirty years, retiring in 2005. He is a MacArthur Fellow, and among his other honors are the University of Buffalo's 2014 Distinguished Alumni Award, National Book Award and Pulitzer Prize nominations, a Lila Wallace-Reader's Digest Award, and San Francisco LitQuake's 2011 Barbary Coast Award. Awarded the 2008 Blues Songwriter of the Year from the West Coast Blues Hall of Fame, his collaborations with jazz musicians for the past forty years were also recognized by SFJazz Center with his appointment, since 2012, as San Francisco's first Jazz Poet Laureate. His author website is located at www.ishmaelreedpub.org<http://www.ishmaelreedpub.org.

Heather D. Russell examines narrative form and its relationship to configurations of racial and national identities in the African diaspora; and, Caribbean popular culture and globalization. Her recent book is: Legba's Crossing: Narratology in the African Atlantic (U of Georgia P, Nov 1, 2009). She has also published in Transition; African American Review; American Literature, Contours; The Massachusetts Review and has essays in several collections. She has a co-edited collection forthcoming on Barbadian pop icon Rihanna and is the lead scholar for the NEH/FHC Landmarks in American History seminar: Jump at the Sun: Zora Neale Hurston and her Eatonville Roots. Dr. Russell is currently graduate program director of African & African Diaspora Studies (AADS) at Florida International University.

Hariette Surovell was a critic, journalist, investigative reporter and fiction writer. Describing Hariette's literary career is a challenge because of the enormity of her talent and ambition. She grew up in Flushing, Queens, where she attended public school and read voraciously, following her mother's literary tastes. She was a prodigy who published her first piece, "Most Girls Just Pray," a comment on birth control, on The New York Times op-ed page at the age of 16. That publication led to an appearance on the Phil Donahue show and further publications by Hariette on the subject of teen sex, which was taboo at the time. She attended City College of New York on a fellowship, studying creative writing with the likes of Francine du Plesssix Gray, Kurt Vonnegut and Joseph Heller, who was her personal advisor. Hariette died in 2011.

Kathryn Waddell Takara, author of 6 books, is the owner and president of Pacific Raven Press. She received an American Book Award in 2010 for one of her books of poetry. She is a long time scholar of African American culture and politics, a retired professor, performance poet, community activist, and researcher who has lived in Hawai`i for more than forty years. Born and raised in Tuskegee, Alabama during the Jim Crow era, she was educated on the East Coast, France, the West Coast, and Hawai`i. Her writing reflects her keen and sensitive observations, her travels (in Africa, Europe, and China), research, philosophical inquiry, and poetic sensibilities. Her commitment to civil rights, service, and peace is fueled by her passion for justice and love of Nature.

Jerry W. Ward Jr., a literary critic and Richard Wright scholar, is the author of The Katrina Papers: A Journal of Trauma and Recovery (2008) and The China Lectures: African American Literary and Critical Issues (2014) and co-editor of The Richard Wright Encyclopedia (2008) and The Cambridge History of African American Literature (2011). His work-in-progress includes Reading Race Reading America: Social and Literary Essays and Richard Wright: One Reader's Responses.

Marvin X is one of the founders of the Black Arts Movement. His latest book is the Wisdom of Plato Negro, parables/fables published by Black Bird Press, Berkeley. He currently teaches at his Academy of da Corner, 14th and Broadway, downtown Oakland. Ishmael Reed says, "Marvin X is Plato teaching on the streets of Oakland." Bob Holman calls him the U.S.A. Rumi. For speaking and readings he can be reached at jmarvinx@yahoo.com.

Al Young. Widely translated, Al Young's many books include poetry, fiction, essays, anthologies, and musical memoirs. He has written screenplays for Sidney Poitier, Bill Cosby and Richard Pryor. From 2005 through 2008, he served as California's poet laureate. Other honors include NEA, Fulbright, and Guggenheim Fellowships, The Richard Wright Award for Literary Excellence and, most recently, the 2011 Thomas Wolfe Award. His poems have been broadcast nationally at NPR and locally at KQED's "The California Report" Magazine Young currently teaches imaginative writing and creativity at California College of the Arts, San Francisco. Offline Love, a new poem collection, sits press-ready. Find detailed information about this versatile author at www.AlYoung.org.

CPSIA information can be obtained
at www.ICGtesting.com
Printed in the USA
LVOW12s1721220316

480283LV00001B/168/P